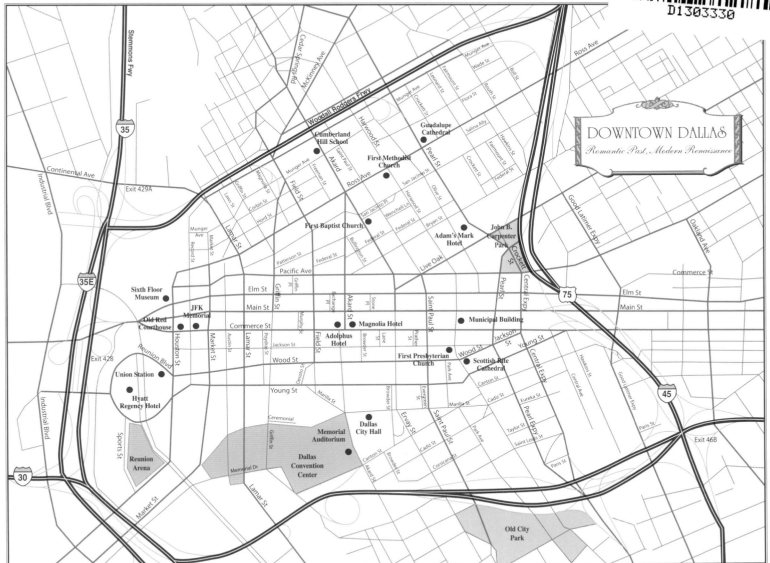

DOWNTOWN DALLAS

Romantic Past, Modern Renaissance

D1303330

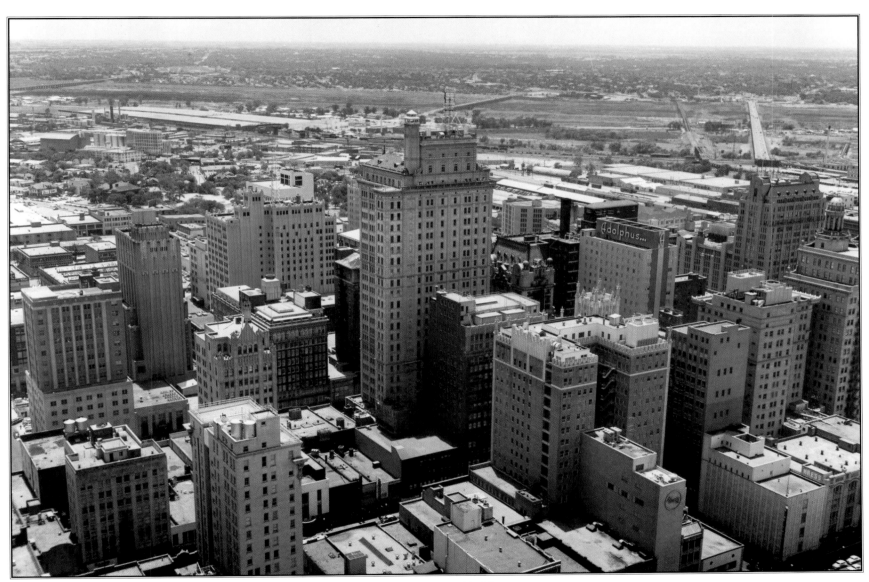

Heart of Dallas, 1955. From the Collection of the Texas/Dallas History and Archives Division, Dallas Public Library.

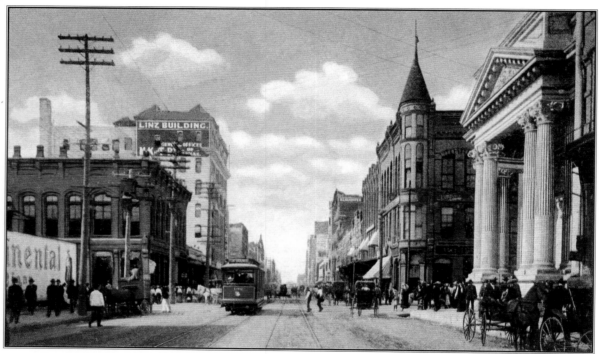

Main Street looking west, c. 1905. Linz Building, at left, dated from 1899. Across the street, the three-story building with turret was built in 1882. At far right, City National Bank dated from 1903.

DOWNTOWN DALLAS

DOWNTOWN DALLAS
Romantic Past, Modern Renaissance
© 2007 Mark Rice

Manufactured in China.

For information, please contact:
Brown Books Publishing Group
16200 North Dallas Parkway, Suite 170
Dallas, Texas 75248
www.brownbooks.com
972-381-0009
A New Era in Publishing™

ISBN-13: 978-1-933285-73-3
ISBN-10: 1-933285-73-7
LCCN 2006935894
1 2 3 4 5 6 7 8 9 10

Illustration Sources

From the Collection of the Texas/Dallas History & Archives Division, Dallas Public Library: pages 3, 5, 9, 11, 15, 17, 23,
27, 29, 37, 56, 57, 58, 59, 90, 106, 107, 113, 119, 121, 157, 163, 167, 170, 171, 184, 185, 187, 189, 200, 201, 207, 215
Courtesy Dallas Historical Society Archives: page 99
Courtesy, Squire Haskins Photograph Collection, Special Collections, University of Texas at Arlington Library: page 181
All other images from author's personal collection, unless otherwise identified.

DOWNTOWN DALLAS

Romantic Past, Modern Renaissance

Mark Rice

TABLE OF CONTENTS

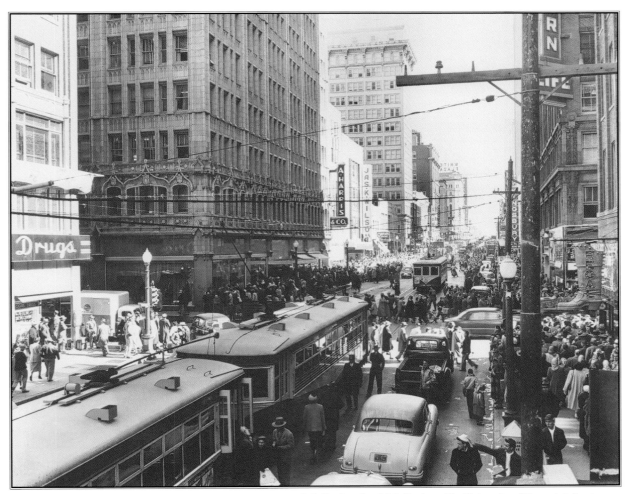

Main and Akard streets, 1951. Courtesy, Squire Haskins Photograph Collection, Special Collections, The University of Texas at Arlington Library, Arlington, TX.

DEDICATION

•

For my father, John W. Rice Jr. (1924–1994)

ACKNOWLEDGMENTS

•

This project required hundreds of hours of personal research, writing, and editing, but it also required the support of many people behind the scenes. Some brief words of gratitude are in order for those who contributed to the eventual realization of this dream.

First, I owe thanks to my wife, Diane, and my sons, Justin and Chris, for their encouragement and forbearance while I dominated the family computer on most evenings and weekends over the past eighteen months.

Furthermore, this book could not have been written without the invaluable assistance and helpful attitude of the highly competent staff at the Dallas Public Library, Texas/Dallas History Division. Many of the outstanding images in this book were found in the library's archives, and their online collection of the *Dallas Morning News* articles from 1885–1977 is a convenient treasure trove for researchers.

Next, I owe endless thanks to Jim Sowell for his belief and support and to his brother Tom for his friendship and helpful suggestions.

Finally, I would have been lost without the professional guidance of the wonderful staff at Brown Books Publishing Group. They expertly took my nucleus of a book and shaped it into a beautiful work of history.

FOREWORD

—by Dallas Mayor Laura Miller—

•

After my election in 2002 as mayor of the nation's ninth-largest city, I confronted an array of daunting challenges. Not least of these was the revitalization of our city center, which had deteriorated badly after the real estate and banking slump of the late eighties and early nineties. Despite a beautiful skyline and an enviable collection of world-class buildings erected during the 1980s, downtown Dallas was afflicted by a malaise that made it difficult to attract employers, employees, investors, and residents. Vacant older buildings, empty sidewalks, and a persistent homeless problem were everyday realities. The Trinity River, having skirted the city's western flank since its 1841 founding, remained an unexploited resource. Like all big cities, Dallas dreamed of a vibrant, unifying core that would ensure the city's long-term health.

Accordingly, the rebirth of downtown Dallas became a top priority for my administration. When I assumed office, only a handful of Dallasites made downtown their home. The streets and restaurants were largely empty after six o'clock every night. A significant number of historic buildings, many of them featured in this book, were ideal candidates for conversion to downtown housing, but there was no retail presence to support the residential community. Merchants were afraid to take a chance on a downtown marketplace that had been moribund for so long. Caught up in the stalemate, too many of our landmark structures remained empty and outdated. Worse, they were often boarded up, slowly deteriorating and serving as magnets for litter, graffiti, and vandalism. Important pieces of the city's history, such as the Mercantile National Bank complex, faced eventual destruction.

A staggering amount of creativity, energy, and teamwork between the city's governmental and business leadership was needed in order to reverse the sliding fortunes of a once-dynamic downtown area. Unique incentives were required to attract developers, restaurateurs, and residents to the city's core. Through a combination of salesmanship, tax incen-

tives, and public-private partnership the tide began to turn. Between 2002 and 2007, several major residential conversion projects were completed or begun, including the most difficult of all, the thirty-story Mercantile Bank tower. Several thousand Dallas citizens moved downtown. As downtown census numbers climbed, precious pieces of the city's architectural history were preserved.

Bold thinking by a previous administration led the city to engage the services of Spanish architect Santiago Calatrava, whose soaring bridge designs will help to transform the underutilized Trinity River green space into beautiful parks and biking paths that will draw thousands of Dallas citizens to the downtown area.

In May 2003, the Dallas City Council approved an ambitious new design for the Trinity River Project, complete with two large lakes, wetlands, trails, neighborhood parks, and the largest hardwood forest of any city in America. Lake construction is slated to begin in 2008.

In November 2006, voters approved a $1.35 billion bond package, the largest in the city's history. It includes nearly $200 million for downtown, including the last public building

block in the downtown Arts District—the largest in America and an architectural delight with buildings designed by Renzo Piano, Rem Koolhaas, Sir Norman Foster, and I.M. Pei.

I was privileged to be the Mayor of Dallas when the city celebrated the sesquicentennial of its 1856 incorporation. It was a time to reflect on the achievements of the men and women who built this great city and to honor their commitment to its growth and excellence. I hope that we have kept faith with their collective vision.

Mark Rice's work, which you are holding here, is reflective of a once-again vibrant city. All who call Dallas home or have ever visited will enjoy reading it, not only for the historical information in the text but also for the lovely photographs and illustrations in a timeless book. I am proud to be a part of Dallas's history and this beautiful edition.

November 18, 2006
Laura Miller

Mayor, City of Dallas

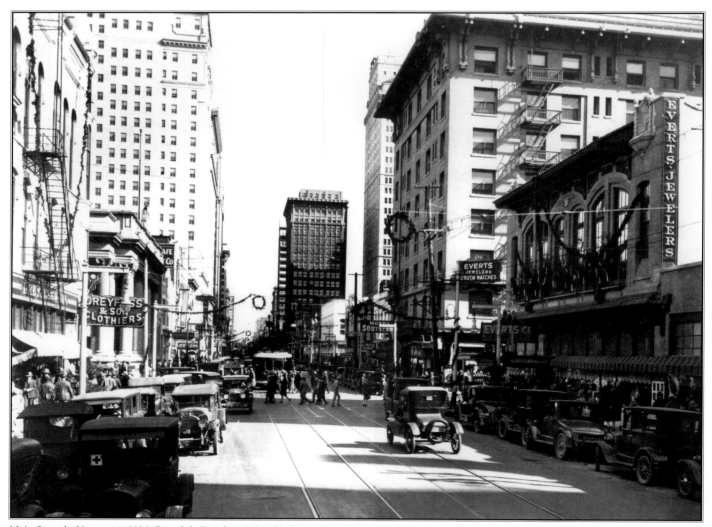

Main Street looking east c. 1926. From left, Dreyfuss & Son Clothiers, City National Bank, Republic National Bank, and the American Exchange National Bank line the north side of Main. From the right, Everts Jewelers, the Southland Hotel, the rear of the Magnolia building, and Southwestern Life Insurance are visible. From the collection of the Texas/Dallas History & Archives Division, Dallas Public Library.

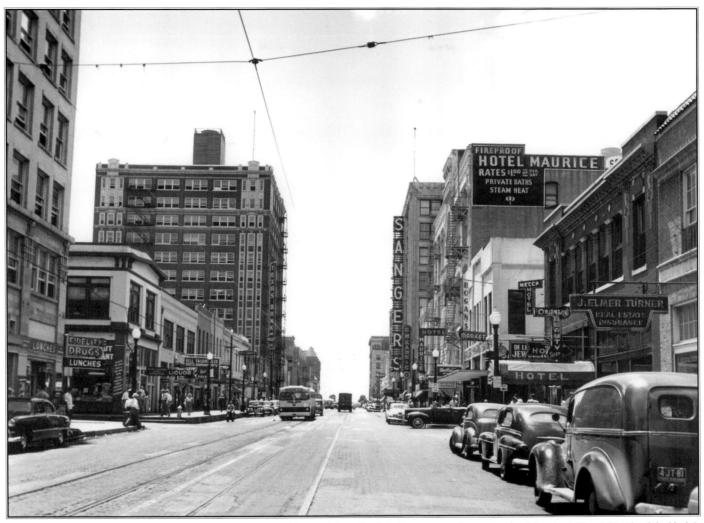

Main Street looking west c. 1950. From far left, the Fidelity Building and Texas Bank & Trust occupy the south side of the street. The right side of the block is dominated by the Hotel Maurice (North Texas Bank Building) and the Sanger Bros. store. From the collection of the Texas/Dallas History & Archives Division, Dallas Public Library.

On every visit to downtown Dallas, I am filled with a sense of awe. All great cities are steeped in history, and I find myself drawn to the old buildings with their colorful pasts and classic facades. Sometimes, despite the noise, the grime, and the graffiti, I am able to lose myself in a brief reverie, and become an observer as the past rushes by . . . a pair of prosperous oilmen in fedoras and trench coats duck into the Tower Petroleum Building for a morning meeting . . . a group of secretaries in dresses and heels step off a clanging trolley as they hurry back from lunch . . . a sore-footed cop, still trying to direct traffic at Main and Akard, blows his whistle . . . lonely servicemen, seated on the balcony outside Union Station, head for an embarkation port . . . a harried businessman rushes up the stairs at the Kirby Building, unwilling to wait on an elevator . . . and Lee Harvey Oswald hurries down the stairs at the Texas School Book Depository. I glimpse R. L. Thornton, President of Mercantile National Bank, hosting a meeting at his Magnolia Building office to plan a strategy for winning the right to host the 1936 Texas Centennial Exposition. With him are Fred Florence of Republic National, and Nathan Adams of First National.

I catch sight of E. R. Brown as he steps out onto the street below, and glances up at the revolving red horse that symbolizes his Magnolia Petroleum Company. Just down Commerce Street, Stanley Marcus is working in the family business, preparing to shoulder the responsibility for one of the world's great department stores.

This book has no pretensions of being a scholarly treatise, and no aspirations toward social history or cultural analysis. Instead, it is a visual tribute to the city where I grew up, the great buildings at its core, the merchants, bankers, architects, oilmen, and insurance salesmen who created its future. It seeks to trace the past and present history of downtown Dallas through several dozen of its most famous buildings. Writing this book has allowed me to indulge in three of my passions: history, photography, and a layman's appreciation of fine architecture.

I grew up in the Dallas of the 1950s and 1960s, and except for a couple of brief periods after college, I have spent my

entire adult life in the city. My father and his father before him were raised in Dallas, so my roots are deep. My grandfather worked downtown for Lone Star Gas Co. throughout his career, while my grandmother ran a Deep Ellum café. My father was an official and freelance court reporter, who traveled the streets of downtown for over thirty years, hurrying to various law offices. As a youngster and teenager, I spent endless hours at my dad's offices in the Dallas County Records Building, the Kirby Building, and the old Gulf States Building. I loved downtown, especially the older buildings that had grown outdated, become vacant, and were in various states of disrepair. I was fascinated by their marble stairways, vaulted ceilings, and art deco chandeliers. I was curious about their often glorious and romantic pasts, and I wondered about the people who had once made their lives and careers downtown.

In the first half of the twentieth century, Dallas was built on oil, cotton, insurance, and the banking houses that sprang up to store the newfound wealth and loan it to growing businesses. Dozens of masonry buildings were erected within the square mile that comprised the central business district. Some were forgettable, while others were outstanding architectural achievements that became famous throughout the Southwest. For many years, most of these structures were in constant use, but over time, their small floor plans and outdated mechanical systems made them obsolete. Despite beautiful stonework, ornate interiors, mural-covered walls, marble foyers, and brass fittings, the old buildings grew harder to lease and more expensive to maintain. The downtown workers thronging the streets hustled past them, excited about the city's future prospects.

From the 1960s through the late 1980s, Dallas was a city in a hurry. It was still a mecca for oil, banking, and insurance companies. New monuments to commercial success were planned, and older structures had to give way. Everyone was caught up in the city's progress, and older architectural treasures were sometimes heedlessly toppled. Space was required for newer, larger buildings and the parking lots to accommodate the workers inside them. Dallas lost its share of irreplaceable history during those years before a different set of sensibilities emerged. Preservationists dug in their heels, and many of the city's crown jewels were eventually spared. In the early 1980s, the downtown area reached its commercial zenith when many of the city's most prominent and expen-

sive modern buildings were completed, nestled side-by-side with the surviving icons from earlier epochs. Construction cranes abounded, and they were often referred to as "the state bird."

For most of the twentieth century, Dallas's status was that of a golden city, but in the late 1980s, it began to falter. Oil and gas, insurance, and banking, for decades the reliable under-pinnings of the city's economy, were no longer so dependable. Falling energy prices created weakness and consolidation among oil companies. Much of the Dallas energy community, which was so crucial to the city's early growth, was relocated to Houston, or elsewhere. Likewise, the insurance industry was subject to acquisitions and consolidation. Legendary companies, including Southland Life Insurance, Southwest-ern Life, and Fidelity Union Life, disappeared within other companies that pared back, or eliminated their Dallas pres-ence. Dallas banks were heavily invested in real estate, and the resulting instability in real estate values created havoc with their massive loan portfolios. Desperate attempts were made to avert failure, but by the end of the 1980s, none of Dallas's nationally-famous banking institutions still existed. First National Bank, Republic National Bank, Mercantile National

Bank, and National Bank of Commerce were all gone. At the same time, major companies were fleeing the downtown area for suburban campuses with cheaper land, plentiful parking, and skilled workforces.

The downtown area struggled with these unfamiliar cir-cumstances. Vacancy rates soared, and uncompetitive older buildings were closed. The last remaining major retailers, with the exception of Neiman Marcus, abandoned the cen-tral business district. The experience was disorienting to the citizens and business leaders of Dallas, who were justifiably proud of home-grown institutions that had attained national prominence. In the 1990s, this city that was accustomed to winning struggled to adapt. Many felt that the bloom had fallen from the rose. For a time, the burgeoning telecom-munications industry buoyed the city's fortunes, but even this hope faded as the new century approached. It looked as if the downtown area would be consigned to hosting governmental workers and service industry employees in the daytime, and then would be rolling up the sidewalks at night to abandon the streets to petty criminals and the homeless. The once-confident city was beset by financial challenges and racial tensions.

True to its character, Dallas fought back. The city's oft-referenced assets, including central geography, temperate climate, excellent transportation networks, affordable housing, and an attractive workforce, continued to have strong appeal for businesses and workers. New industries were courted and developed. Government and business leaders worked together to attract tenants and developers to the central business district through salesmanship, tax incentives, and creative financing. More than any other phenomenon, the downtown residential boom began to transform the city's downtown center. Older office buildings, once largely vacant and hopeless, lent themselves perfectly to redevelopment into lofts and luxury apartments. In 1995, the downtown area counted only 250 residential units, but by 2005, it had nearly 2,000, and hundreds more were under construction. The possibility of 5,000 or more residential units was suddenly within reach. The crucial retail presence needed to support the fledgling residential community began to develop in fits and starts. Construction activity reemerged all over the central business district, and ground was broken for the first sizable downtown buildings in two decades. A fragile recovery began to gain momentum. Santiago Calatrava, a Spanish architect, designed three magnificent bridges that are planned to span the Trinity River over the next few years. Urban lakes and extensive greenbelt development are scheduled to follow, giving Dallas residents another reason to venture downtown.

The physical attributes of Dallas are not always obvious to visitors or to those who grew up in more scenic locales. There is no oceanfront nearby, no picturesque river coursing through town, and no mountains looming in the distance. Summer weather is hot, and fall is often nonexistent, but the beauty is there for those who seek it and have an appreciative eye. It is for those people that this book is intended.

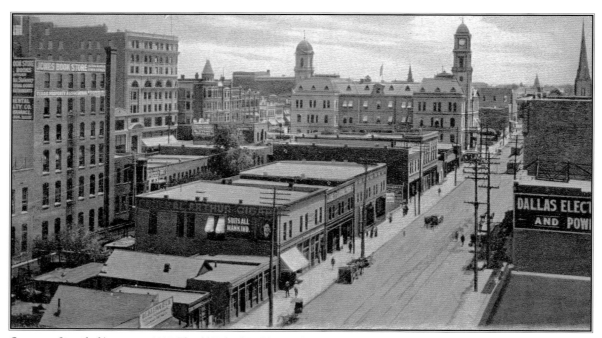

Commerce Street looking east, c. 1905. The old Federal Building and Post Office is the prominent twin-towered building at upper center. The Mercantile Bank building would later rise on this site.

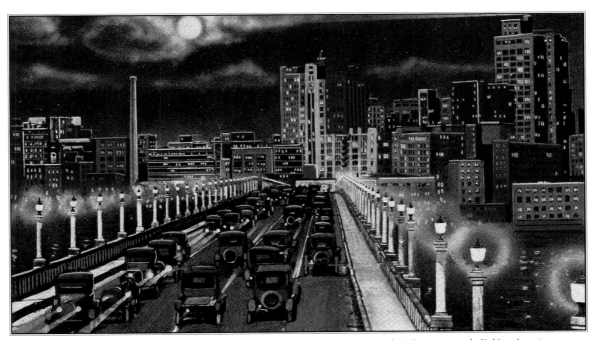

Oak Cliff Viaduct in the late 1920s. This important structure was built between 1910 and 1912, permanently linking downtown Dallas and Oak Cliff. Over a mile in length and costing over $700,000, the viaduct prevented the flooding Trinity River from isolating Oak Cliff in the future.

AUTHOR'S NOTE

For the sake of brevity, I have defined downtown Dallas as the area within the irregular loop formed by Woodall Rodgers Freeway, Stemmons Freeway, R. L. Thornton Freeway, and Central Expressway. This loop was not closed until the 1960s. I was tempted to include some structures just outside these boundaries, but I have refrained in order to be consistent. The terms *downtown* and *uptown* are somewhat subjective when they are used to describe Dallas. In the early part of the twentieth century, *downtown* was used to describe the areas closest to the courthouse, while anything east of Akard was likely to be called *uptown*. Today, the area north of Woodall Rodgers is referred to as *uptown*, while the area south of Woodall Rogers is referred to as *downtown*.

Other arbitrary decisions had to be made concerning which building histories would be presented. I have chosen to include structures completed by 1970; anything built after that may be presented photographically, but without historic detail. Even with that restriction, I did not attempt to include every building of significance. Some buildings were short-lived despite being relative latecomers, such as the Rio Grande Building and the Gibraltar Life Building. Other buildings within the period may not have achieved architectural significance or may not be historically prominent like the buildings that were selected for this book. I do not claim to have provided a comprehensive listing of all important downtown structures because some were missed or ignored. My hope is that the histories presented within this book will provide the reader with a rich panorama of downtown Dallas and its past and may provoke the reader to further exploration.

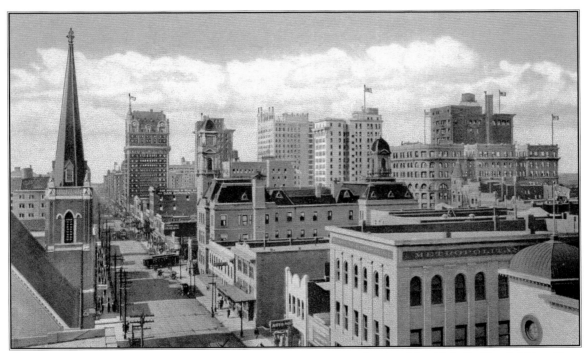

Downtown panorama, c. 1915. Tall steeple at left marks an early Commerce Street location of First Methodist Church. Metropolitan Business College is across the street, with the original Majestic Theater shown in the lower right corner. The old Post Office is at center of picture, with the Adolphus Hotel far down Commerce Street to the west.

Early Dallas

In 1841, the future city of Dallas had its beginnings when John Neely Bryan, a Tennessee lawyer, ventured to Texas in search of the rich lands that he had heard described while living in Arkansas. Bryan arrived on horseback, accompanied by his dog and a Cherokee Indian called Ned. They set up camp on the eastern bank of the Trinity River at a site that would later be occupied by Main, Elm, and Commerce streets, where they converge beneath the triple underpass on the western edge of downtown. Bryan had not chosen the place without thought. His campsite was near a natural crossing point of the Trinity River, which Bryan undoubtedly believed to be navigable. The soil in the area was also fertile.

Bryan quickly laid out a town site and advertised for prospective settlers. Indian raids were still common, so some measure of security was realized through sheer numbers. The little town grew slowly, and times were hard. Bryan and the other settlers hunted for game and began cultivating crops. The men often dressed in deerskin outfits. The town's progress was momentarily delayed when many of the men, including Bryan, left for California during the 1849 Gold Rush. Most of the settlers soon returned and began building a community. In 1850, the town was designated as the county seat and, like the surrounding county, was named for George Mifflin Dallas, vice president of the United States under James K. Polk (1845–1849).

In 1855, the population of the area received a considerable boost when a contingent of two hundred French-speaking socialist utopians arrived and established La Reunion settlement. The socialist enclave eventually failed, but many of the French, Swiss, and Belgian settlers stayed.

Despite efforts to prove otherwise, the Trinity River proved impossible to navigate so far north, so local inhabitants set their sights on securing a railroad connection with the outside world. Following the Civil War, the Houston and Texas Central Railroad (H&TC) was inching its way northward from Houston, and Dallas leaders were determined to see that it passed through their small town. Special inducements in the form of land and cash won the day, and in 1872, the H&TC reached Dallas. An even greater prize awaited when the larger Texas and Pacific Railway (T&P) was routed through the Dallas area due to some legislative chicanery on the part of Dallas's representative to the state legislature in Austin. Further cash inducements convinced the railroad to locate its depot in close proximity to the town square. The railroad tracks were laid through the heart of town along a route that became known as Pacific Avenue. Along with being named the county seat, securing the two railroads put Dallas on an ambitious course that would dynamically accelerate growth in the years to come.

As the turn of the century approached, the population of Dallas surpassed forty thousand people. In 1893, a magnificent county courthouse had been completed, and other fine structures, including the Oriental Hotel (1893), the North Texas Bank Building (1888), and the Linz Building (1899), gave the city a certain air of sophistication.

Within a few years, Dallas would play host to Ignacy Paderewski, a Polish classical pianist, but it still featured narrow, unpaved streets running between two-story brick buildings. Horses were commonplace, as was their refuse. Anti-spitting ordinances were proposed so that proper ladies would not soil their long skirts with tobacco juice. Many restaurants and bars were little more than wild-west saloons. An electric streetcar system had only recently replaced mule-drawn conveyances.

It was within this atmosphere that Bert Rawlins and Charlie Daniels crossed paths in the early morning of August 13, 1899. Rawlins was a mounted police officer, and Daniels was a former policeman working as an armed nightwatchman for several banks. Both carried large-caliber six-shooters. There was bad blood between the two men, and on that morning, it erupted into spectacular violence.

The incident began at the corner of Main and Poydras in the heart of downtown. Despite the early hour, there were several witnesses present. Rawlins initiated the confrontation by cursing Daniels loudly and repeatedly. Daniels, who was seated across the street, crossed toward the jewelry store in front of which Rawlins was standing. He asked Rawlins to repeat his words, and Rawlins obliged but pulled his pistol as he replied. An acquaintance who accompanied Rawlins tried to restrain him, but it was too late. Daniels quickly pulled his own gun, and both men opened fire as bystanders scattered. A large clock was mounted on an iron post outside the jewelry store, and both men tried to dodge around it as they fired. For safety, each man carried his gun with the hammer snapped on an empty chamber, so they each had five shots. All but one shot was needed. The whole gunfight lasted about ten seconds, but according to the *Dallas Morning News*, it was "fierce in the extreme." The range was ten feet or less. The faces of both men were powder-burned, and stray bullets entered several buildings. Rawlins, struck by two rounds, leaned heavily against the clock post before falling into the street. He never spoke another word. Daniels was hit by his adversary's last bullet. He screamed in pain and staggered off down the street, running into Police Captain John Keehan. After telling Keehan that Rawlins had cursed him and shot him, he stumbled into Apperson's Drug Store and collapsed into the arms of Warren Diamond, a night clerk, and died shortly afterward.

Stanley Amos, a hack driver, recounted the events for a newspaper reporter. "Daniels and Rawlins were two as game men as ever pulled a gun. Neither of them flinched a bit. It was give and take mighty hard and fast, I can tell you."

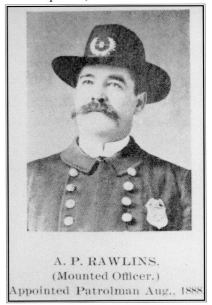

A. P. RAWLINS.
(Mounted Officer.)
Appointed Patrolman Aug., 1888

E. M. Kahn & Company

—Elm, Lamar, and Main Streets—

•

Emanuel Meyer Kahn was a young Alsatian hoping to make his fortune in America. Kahn's parents died when he was young, so there was little to hold him in Europe. After arriving in America, he became one of the "terminus merchants" following the railroad northward and establishing stores along the way. In 1871, he arrived in Dallas at the age of twenty-one and the next year founded a clothing business. Years later, when he was asked why he had chosen Dallas, Kahn answered that in his travels through the South, he had sensed a special energy in his chosen city that guaranteed growth. Growth was needed, as the city's 1871 population was only two thousand people. After setting up shop in a couple of early locations, he settled at the corner of Elm and Lamar in 1874. This location operated continuously for the next ninety-four years and owned the distinction of being the oldest retail store in the city. Girard and Sol Dreyfuss would later learn the retail clothing trade at E. M. Kahn before striking out on their own.

Kahn started out by selling clothing for men and boys, and his success in these lines encouraged him to enlarge his business several times. First, he expanded down Elm Street to the east. Then, he added space on Lamar Street to the south. Eventually, he occupied a three-story building on the corner of Main and Lamar, unifying it with the other structures and dominating the entire western end of this important city block. At this point, the store had thirty-five thousand square feet of floor space and featured three hundred feet of window space devoted to men's and boy's apparel. Directly across Lamar, the Sanger Bros. store was Kahn's neighbor and competitor. Kahn served as company president for fifty years, presiding over his business from a raised dais in the center of the store. He became a leading civic booster, helping to found the State Fair of Texas and Temple Emanu-El.

On a hot August day in 1923, the still-active, seventy-three-year-old Kahn walked the few blocks from his store down to his barber shop for a haircut. Other patrons of the shop noticed that he was not himself and thought that perhaps he was oppressed by the heat. Following his haircut, Mr. Kahn

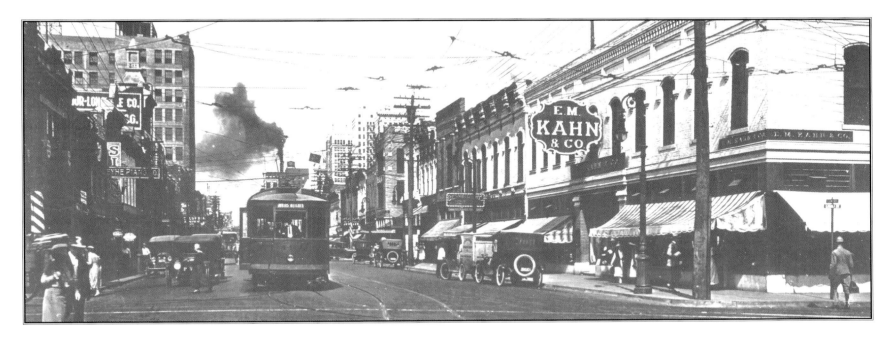

walked home to his apartment in the Hotel Jefferson. Shortly after arriving, he stretched out on the bed and soon died of a heart attack. His son Laurence took over the business and continued to grow it. In 1936, the store was air-conditioned, and women's clothing was added.

In 1947, Laurence passed away at an early age, and E. M. Kahn's grandson became president. The prosperous, family-owned business eventually opened an uptown location and several suburban branches. In 1968, the flagship store was doomed by the emergence of the Two Main Place development. The historic old building, which held cherished memories for thousands of Dallas residents, was razed. Unfortunately, Two Main Place was never built, and another parking lot replaced E. M. Kahn & Co. In 1969, the company's surviving locations were sold to Eagle Clothes.

Today, the seventy-story Bank of America Plaza stands on the former site of E. M. Kahn & Co.

St. George Hotel

—Commerce, Main, and Martin Streets—

•

One of the earliest hotels constructed in Dallas was the St. George. Around 1875, it was erected near the corner of Commerce and Martin. This occurred in an era when guests arrived on trains or by horse-drawn carriages. Water was carried to their rooms from the first floor, bathing was in public bath houses, and lighting was by oil lamps. The hotel was originally called the Lamar, but within a few years, it was known as the St. George. It was a contemporary of the Oriental and Grand Windsor hotels, and was considered their equal.

During nearly one hundred years of operation, the hotel was the scene of many remarkable events. One of the first came in 1907 when W. O. Brown, president of a buggy company, fought with a traveling salesman named Albert S. Johnson. Brown pulled his pistol and critically wounded Johnson at close range. The lobby was crowded with guests, who quickly scattered. To quote the next day's *Dallas Morning News*, "there was a general exodus of those who were in close proximity." The lethal slug from a .38-caliber revolver "took effect in

the abdominal region." Through the years, the hotel rooms became the sites of several suicides, in which carbolic acid seems to have been the instrument of choice.

In 1909, an eight-story annex was placed on the corner of Commerce and Martin, connecting with the earlier structure. An arcade entrance allowed entry from Main Street. Each room was furnished with a private bath, quite an innovation at the time. The annex provided sixty additional rooms, and the older portion of the hotel received a remodeling at the same time. The St. George became notorious during the 1920s as a prominent site for high-stakes gambling activities.

In 1930, Rex "Wingy" Brooks fell six stories to his death, apparently with some assistance. Brooks was a very capable hired driver and had evidently received his nickname after he had an arm amputated at the elbow. A desperate fight had occurred in the room prior to Brooks's fall, and the room was badly torn up. Several empty whiskey bottles were in evidence. Two men were arrested at the scene. Four years later, an insurance agent took the same plunge from the sixth

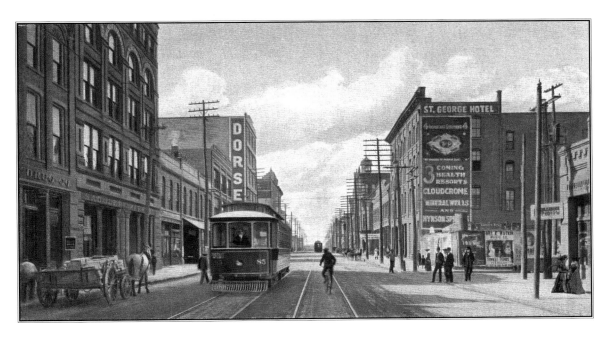

floor. A guest in the adjoining room heard the agent muttering loudly before he smashed a glass against the wall and leapt from the window. In 1935, another misfortune occurred when the hotel manager was shot to death when he went to the basement to investigate a disturbance. The shooter was the hotel engineer, who later said that he was drunk at the time and could not remember the circumstances.

The hotel changed hands just in time for the 1936 Texas Centennial Exposition. Under B. F. Whittaker, the new owner, a major reconstruction was undertaken. Following the plans of architect J. A. Pitzinger, the building was stripped down to the bare walls, modernized, and then renamed the Hotel Whitmore. The $125,000 refurbishing was the last the old building would receive. It remained an aging fixture downtown until 1970 when it was demolished for the planned Three Main Place. The St. George/Whitmore site was directly in front of the current Earle Cabell Federal Building.

National Bank of Commerce

—914 Elm Street—

•

The National Bank of Commerce dated from 1878 when the private banking firm of Flippen, Adoue, and Lobit was created. Two years later, the institution became known as the National Bank of Commerce, situated at the southwest corner of Elm and Poydras Streets. In 1846, Jean Baptiste Adoue, the first president of the new institution, was born in southern France. He immigrated to the United States with Jacques, his fifteen-year-old younger brother. Crossing the Atlantic in a small sailboat required several months. The brothers were following in the wake of their older brother, Bertrand, who had already arrived in the United States, becoming a prominent Galveston businessman. Jacques Adoue settled in Corsicana and also rose to prominence, while Jean Baptiste followed the railroad north to Dallas and entered the banking business.

The new bank prospered, and J. B. Adoue became a wealthy man. He lost a son in France during World War I, and in 1924, suffered a stroke that left him partially disabled and blind. Unwilling to accept his diminished physical capacities, Adoue entered the bathroom of his McKinney Avenue home and shot himself. His son, J. B. Adoue Jr., a former state tennis champion,

took over the presidency of the bank. He led the bank for the next thirty-two years. In the early 1950s, he served as mayor of Dallas.

The original 1878 bank building had been remodeled in 1903, and in 1949, it was remodeled again. This last remodeling included an expansion that doubled the size of the bank and increased the property's twenty-five-foot frontage to fifty feet. An architecturally compatible addition to the old structure was completed on the west side of the building and unified with the original structure. The remodeling also allowed air conditioning to be introduced into the bank.

In 1956, following J. B. Adoue Jr.'s death, the presidency was officially assumed by Maurine Jacobs. She had started out long before as a secretary and been promoted through the ranks. In 1958, the bank celebrated its eightieth anniversary, and was soon acquired by the triumvirate of James J. Ling, James Bond, and Troy Post. In 1964, they relocated the old institution to their new LTV Tower. Today, the Bank of America Tower occupies the former site of the original National Bank of Commerce.

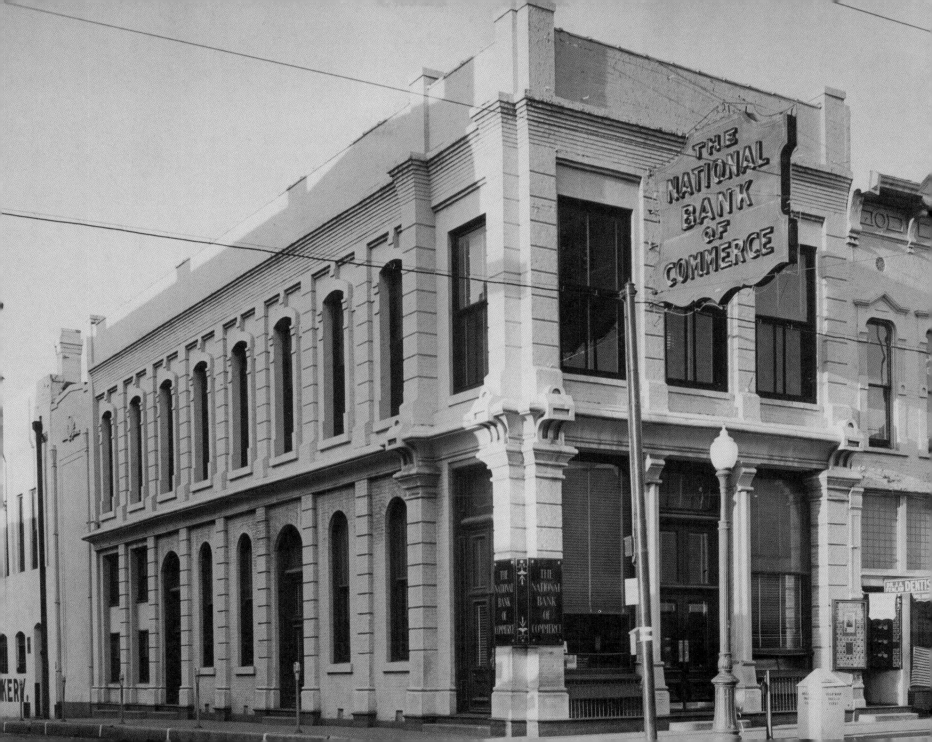

Gaston Building

—Commerce and Lamar Streets—

•

William H. Gaston was born in Alabama, and in 1849, when he was nine years old, he accompanied his family to Texas. The family moved to rural east Texas where William attended a log schoolhouse three miles from his home. When the Civil War broke out, Gaston enlisted in Hood's Texas brigade along with two of his brothers. William was the only brother to survive and return home. Leading his men during the battle of Sharpsburg, Captain Gaston lost most of his company. Casualties ran over 80 percent. Gaston returned to Texas after the war, arriving in Dallas by horseback in 1868. The town counted twelve hundred citizens and was 150 miles from the nearest railroad.

Gaston immediately established a rudimentary bank, which eventually became the Exchange Bank, a forerunner of First National Bank. The institution prospered, and Gaston later became involved in real estate and civic affairs. He was largely responsible for attracting the Houston and Texas Central Railroad to Dallas and after that, the Texas and Pacific Railroad. Gaston was also the father of the Texas State Fair, donating most of the land where the Fairgrounds are located.

In 1894, Gaston acquired the Merchants' Exchange Building at the northeast corner of Commerce and Lamar, which had been completed ten years earlier. The Merchants' Exchange was an early day version of the Chamber of Commerce. The building featured three stories and a basement, and had walls that were a foot-and-a-half thick. A third-floor auditorium hosted conventions, balls, meetings, and a cotton exchange. For years after its construction, the Gaston Building was considered the finest office building in the city. Its stylish design boasted elaborate stonework details around the windows and the corner entrance. When the Merchants' Exchange defaulted on the steep mortgage payments, Captain Gaston was able to acquire the structure.

In 1927, Gaston passed away at the age of eighty-six. A few years later, the Gaston heirs leased the historic building to Lorch Manufacturing, an upscale clothing maker. Under the guidance of architect Charles Dilbeck, the beautiful old facade was stripped away in order to modernize the building. White pilasters with contrasting black metal spandrels replaced the stonework in the original structure. In 1935, the remodeled building opened. Many years later, it was razed. A parking lot across the street from the Federal Courthouse marks the former site of the Gaston Building.

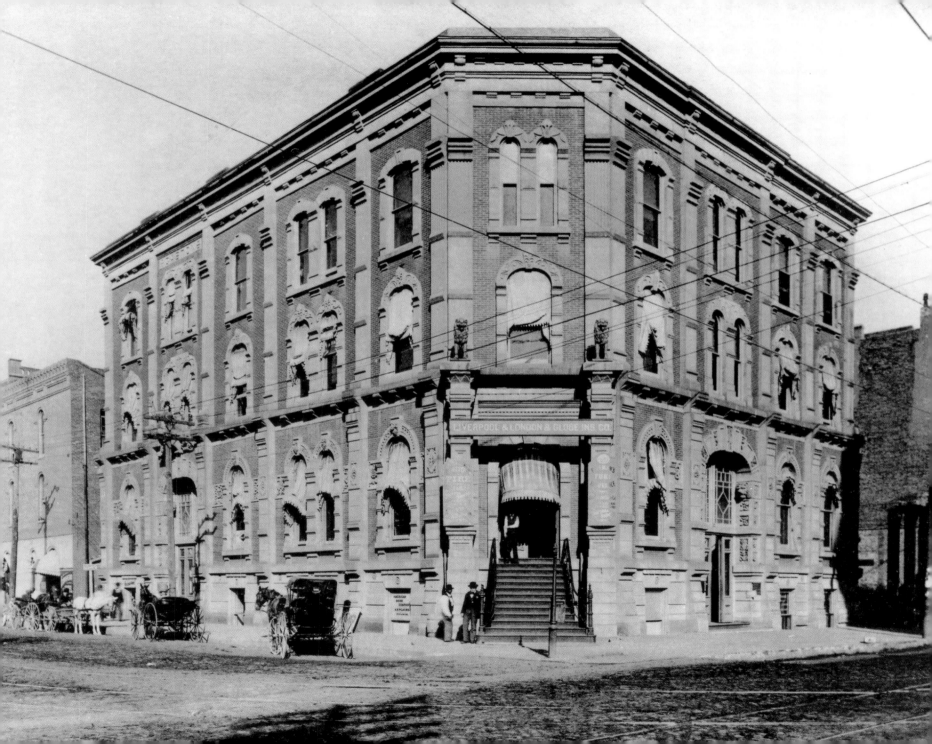

Cumberland Hill School

—N. Akard Street and Munger Ave.—

•

Atop a small hill on the northern edge of downtown Dallas, an ocher-colored schoolhouse represents one of the first acts of historic preservation in the central business district. The Cumberland Hill School dates back to 1887 when it replaced an earlier frame structure built by the Cumberland Presbyterian Church.

The area around the old school was named for a group of settlers from the Cumberland area of Tennessee. They soon erected a church and a day school known as Cumberland Presbyterian School. In 1884, the city purchased the building and then replaced it with the nucleus of the larger brick structure seen today. Dallas architect A. B. Bristol designed the original building. When it opened, the little school boasted a daily attendance of approximately 175 children, many of whom arrived at the school in mule-drawn cars. The school was known as the "melting pot" due to the many immigrant children from all over the world who attended. One teacher who began in 1917 recalled an informal census counting children of twenty-eight nationalities within the school, including Chinese, Poles, Russians, Italians, and French.

The building featured twenty-foot ceilings and sixteen-foot doors, a blessing during the frequent hot spells but a trial during cold winters when only potbellied stoves warmed the classrooms.

The Cumberland Hill area was part of the "silk-stocking" district that extended along Ross Avenue just to the south. Through the years, the school was enlarged several times as commercial buildings encroached from the downtown area. As homeowners abandoned the area, saloons abounded. The area was considered unsafe for women to walk down the street. In 1958, the William B. Travis Elementary School on McKinney Avenue replaced Cumberland Hill, and the old school was converted to a vocational education center for the construction trades. It was later put up for sale as prime commercial property. One estimate put the number of children graduated from Cumberland Hill Elementary School during its seventy years of service at over forty-seven thousand.

In 1972, Bill Clements, an oilman and future Texas governor, saved and renovated the old schoolhouse, integrating it into his SEDCO complex.

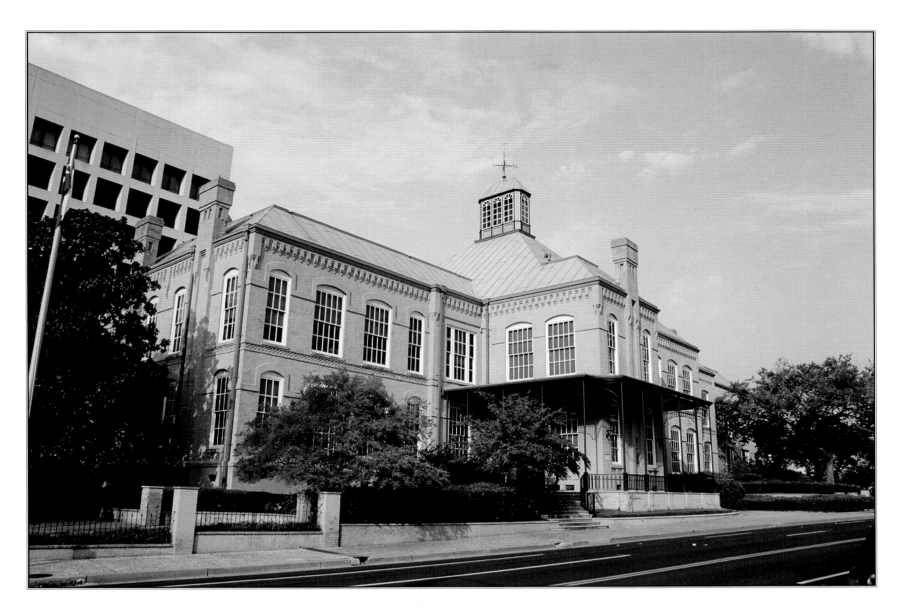

Dallas Club

—Commerce and Poydras Streets—

•

In the city's early days, Dallas's business elite often formed private clubs to satisfy their need for exclusivity and cultured, social interaction. In a city of muddy streets with tethered horses, armed men, and plentiful red-light districts, it was comforting for a banker or wealthy merchant to enter the relatively dignified sanctuary of his own club. There, they found literate conversation over cigars, followed by a gentleman's game of cards or billiards. One such institution was the Dallas Club, founded in 1887.

Dallas Club members soon erected a grand building at the northeast corner of Commerce and Poydras Streets. Opened in November 1888, the red brick structure boasted four stories above the basement level and an imposing facade with terra-cotta trimmings. It also boasted a membership that included merchant Alex Sanger, railway executive George Toland, railroad builder and banker J. C. O'Connor, and lawyer Henry Coke. The basement housed a grill room, baths, and bowling alleys, while the ground floor featured a restaurant, bar, and offices for rent. Upper floors were occupied by card rooms,

billiard rooms, a library, and sleeping apartments. Total cost for the structure was $75,000, including $800 for stained glass and over $2,000 for fireplace mantels.

In 1910, the club was remodeled with a wide stairway leading to the second floor. A basement tavern, or rathskeller, replaced the bowling alleys. The Dallas Club was the scene of constant activity as the city attracted its first convention crowds, including the United Confederate Veterans, the Elks, and the Association of Advertising Clubs. The old club faced increasing competition through the years from newer organizations. In 1918, the opening of the City Club in the Southland Life Building siphoned off much of the membership from the Dallas Club. The club soldiered on for a few years, eventually selling its building. In 1929, the historic structure was demolished to make way for the wholesale loft of the Fox-Coffey hat-making firm, which was demolished in future years. The site is occupied today by a parking lot.

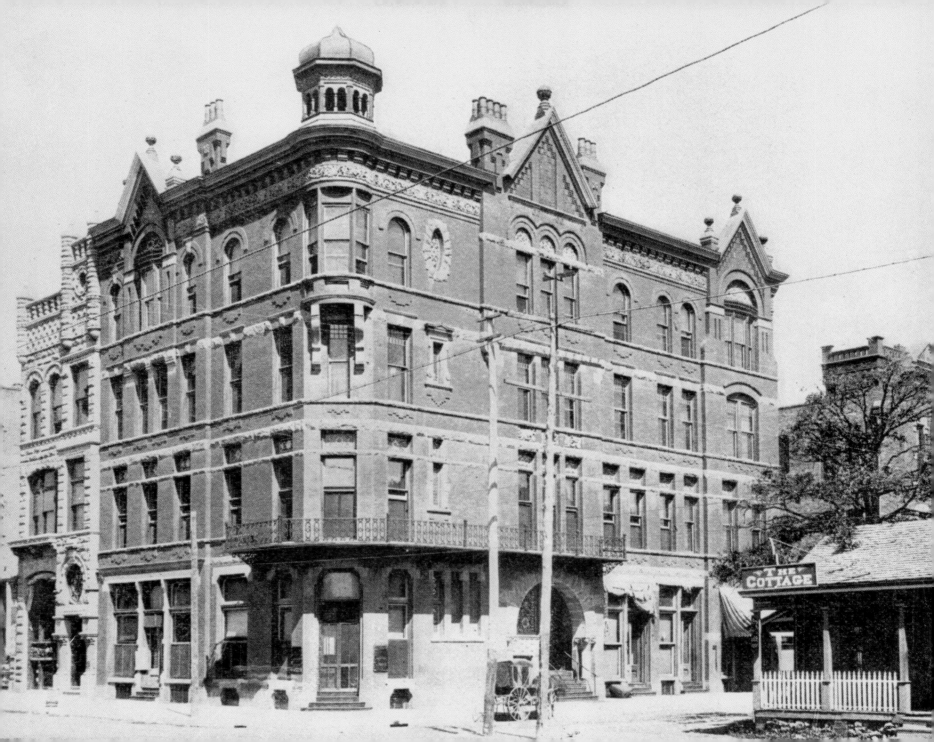

Middleton Building

—Main and Ervay Streets—

•

At one time, William H. Middleton owned most of Main Street between Akard and Murphy. In 1867, after serving the Union cause during the Civil War, Middleton arrived in Dallas along with several flatcars of marble from his previous, short-lived business in Illinois. Middleton and his brother set up their marble yard on Main Street, not far from the future site of the Old Red Courthouse. As the brothers prospered, they started buying up lots along Main Street including the future sites of the First National Bank, the Republic National Bank, and the Gulf States buildings.

In 1889, Middleton erected a four-story Victorian building at the northeast corner of Main and Ervay. The red sandstone building featured elaborate stonework and a gingerbread turret on the southwest corner. The building changed hands several times over the years, and in 1904, it was remodeled with an elevator, and ground-floor show windows were installed. A Marvin's Drug location occupied a portion of the first floor, and the building eventually passed into the hands of Z. E. Marvin, who rechristened it the Marvin Building. In 1922, the old building was swept by a serious fire and then repaired at a cost of $100,000. The corner turret was not restored after the fire.

In 1927, when Marvin erected a new ten-story building at Main and Akard, his old building became the Lansing Building. The new appellation did not last long. In June 1929, Dreyfuss & Son Clothiers secured the Lansing property from Z. E. Marvin and partners for the construction of their magnificent new store, sealing the fate of the aged building. In 1930, the new Dreyfuss store opened on the site.

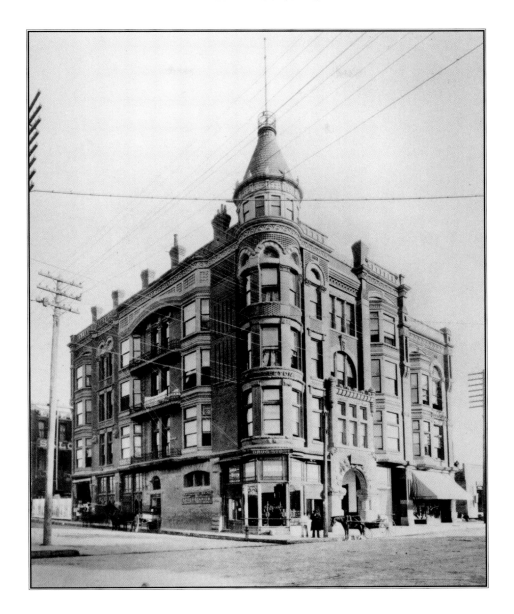

Old City Hall

—Commerce and Akard Streets—

•

By 1888, Dallas owned bragging rights as the most populous city in Texas, counting nearly forty thousand inhabitants. The city had grown at a frenetic pace over the previous fifteen years. Railroads stretched out in twelve different directions, and the city had completed thirty-one miles of paved roads. Taxes were low, and business was good.

A city so prosperous required a proper city hall, leading the city fathers to contract for a new one. Construction soon began at the corner of Commerce and Akard. Seventeen months and $80,000 later, the structure was substantially complete. In June 1889, the building was occupied.

The new city hall had three full stories and a basement. It was constructed of red brick and Palo Pinto buff sandstone. A peaked roof rose 126 feet above the pavement below. Described at the time as "leaning slightly toward Gothic," the structure featured arched windows and elaborate finials mounted on a series of parapets ringing the roof. Both entrances to the building were flanked by carved sandstone pillars.

The interior featured a two-story council chamber with stained glass windows and elaborate woodwork of ash and walnut. An immense chandelier was suspended in the center of the council room. The mayor's office was finished with cherry and oak woodwork and Brussels carpeting. The city secretary's office included a paneled cherry wood counter with stained glass ornamentation. Other offices featured woodwork of checkered black walnut. On the third floor, an auditorium was capable of seating one thousand people. Roof-level rooms actually extended the structure to a fourth story above ground. The basement housed the city court and judge's room, the city marshal's office, and prisoner cells.

City leaders voiced the hope that the magnificent new structure would represent the greatness of the young city for posterity, but it lasted for just over two decades. By 1910, the structure was too small for the quickly growing city. An offer to sell the property to Adolphus Busch, the beer baron, provided the opportunity to build elsewhere. Busch wanted the prime spot to erect his opulent Adolphus Hotel, and the

ambitious city wanted the new hotel just as badly. A search for a new city hall site began immediately while various city departments relocated to temporary quarters. In October 1910, demolition crews began ripping the slate roof from the old city hall. Seventeen months of painstaking craftsmanship disappeared in a matter of days. A search for a cornerstone and its customary contents was undertaken, but nothing was ever found. Exactly four years later, in October 1914, the new city hall at Main and Harwood opened.

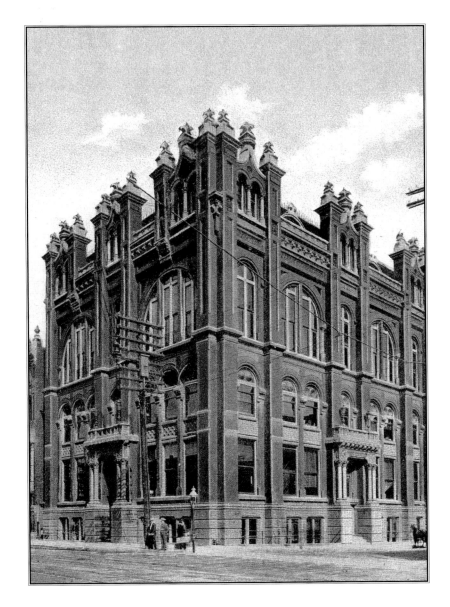

19

Old Post Office & Federal Building

—Main, Ervay, and Commerce Streets—

•

The first substantial post office and federal courthouse for Dallas was located on the corners of Main, Ervay, and Commerce, precisely where the old Mercantile National Bank tower stands today. In 1884, work on the Main Street portion of the structure began, reaching completion in 1889. Due to the fast growth of Dallas and the slow nature of federal appropriations in that era, the building was already outgrown by the time it was finished. Upon occupying the new location, even the postmaster groused about the cramped space. To make matters worse, there was not enough interior light. According to the *Dallas Morning News*, the counters contained so much stained glass that a clerk could not see his customers "without scrunching on his stomach like a setter." In 1892, a Commerce Street wing was added along with a clock tower. Between 1894 and 1904, two more additions were made. The most admired feature of the building was its clock tower and huge clock, long celebrated for its accuracy. The clock contained four faces, each face four feet in diameter with two-foot long hands that could be seen for quite a distance. It was wound every Saturday. The only factors able to affect the clock's accuracy seem to have been advancing age, extremely cold weather, and a flock of pigeons that insisted on roosting in the tower. After the building was abandoned for a new post office, there was much concern over the faithful old clock, and several suggestions were considered for relocating the entire tower, or at least the clock, to another site. In 1939, when the structure was eventually razed, the clock was taken down and stored, pending installation elsewhere. The ultimate resting place for this clock is still somewhat of a mystery. The old building's bell, marble fireplaces, mantels, and gaslight chandeliers were salvaged and sold.

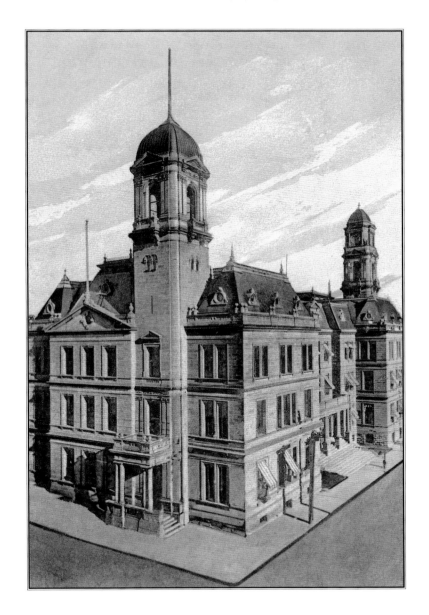

First Baptist Church

—Ervay and Patterson Streets—

•

The sprawling First Baptist Church complex includes at least eleven different structures and occupies six city blocks roughly bounded by Ross Avenue to the north, Federal Street to the south, St. Paul Street on the east, and Ervay Street to the west. Viewing the grounds today, it is difficult to comprehend that the present church properties started out in 1891 with a single sanctuary building.

In 1868, the First Baptist Church was founded on the west side of downtown. By 1872, the congregation was meeting in a church at Akard and Patterson. Soon outgrown, the facility was replaced by the famous red brick sanctuary that stands at Ervay and Patterson today. In 1890, groundbreaking took place, and in 1891, it was completed. Designed by Albert Ulrich, the Victorian structure included elements of Gothic Revival and Romanesque design. A polychrome wooden steeple adorned the southwest corner of the church. In 1908, the sanctuary was enlarged and then it was enlarged again in 1924 after a design by R. H. Hunt. At the same time, a six-story educational building was added to the rear of the sanctuary along St. Paul Street. This structure later became known as the Truett Building.

Another historic structure on the First Baptist campus is the Burt Building, which faces the sanctuary on the south. Erected in 1927 by R. E. Burt, a businessman and mayor-elect, the eleven-story building

was designed for office use and cotton storage. By 1934, it was also housing teletype machines, a printing press, and racing forms for an active bookie operation on the sixth floor. Bets on various horse races were coming in at a feverish pace until Dallas police raided the operation and shut it down. In 1945, Leo F. Corrigan, a real estate mogul, bought the building at a cost of $500,000. The building housed offices of the Internal Revenue Service and the Southern Union Gas Company through the years, and was also used by First Baptist for overflow classroom space. In 1953, Corrigan added an eleven-story annex to the building. Five years later, the church voted to buy the building from Corrigan and use it for educational purposes.

Eight different ministers led the church over the first three decades, but the next two occupied the pulpit for nearly a century. In 1897, Dr. George W. Truett was called from Waco to step into the pulpit and lead the church. Only months after beginning his Dallas ministry, Truett was involved in a tragedy that marked his entire life. Hunting quail near Cleburne with police chief, church member, and close friend, James Arnold, Truett fired at a group of birds but instead hit Chief Arnold, who was hidden by some brush. The load of shot struck Arnold in the lower leg, tearing away most of the flesh and bone. When Truett saw the horrific injury that had been inflicted on his friend, he fainted. Arnold remained conscious long enough to fashion a tourniquet from

a handkerchief and his gun barrel, but the loss of blood was too great. He died hours later. The entire city mourned the popular and respected chief, and Truett was devastated. He eventually overcame the searing experience to become one of the most beloved ministers in the world. Dr. Truett was instrumental in the growth of Baylor University and Baylor Hospital. He held the pastorate at First Baptist for nearly fifty years. In 1897, the church membership counted seven hundred members. At his death in 1944, the membership was well over seven thousand. More than five thousand of them attended his funeral.

After Truett's death, the church wasted no time in calling Dr. W. A. Criswell from Oklahoma. Criswell was a perfect fit for the world's largest Baptist congregation, and like Dr. Truett, he enjoyed an incredibly long tenure. W. A. Criswell served as pastor of First Baptist from 1944 to 1995, when he became pastor emeritus. During Criswell's tenure, the church reached a membership milestone of twenty-eight thousand, making it the largest church in the United States.

Over the decades, the church has undergone continuous expansion and remodeling. By 1968, the colorful and historic wooden steeple had badly deteriorated. It was replaced by a modern steel version that pales in comparison to the original. In 2005, one of the church's landmark structures from 1953, the Criswell Building with its Slaughter Chapel, was demolished amid some controversy and then replaced by a modern, eight-story building. Despite the challenges of attracting worshippers downtown, First Baptist has continued to thrive and takes an active role in downtown ministries to the disadvantaged, the homeless, and those who are incarcerated.

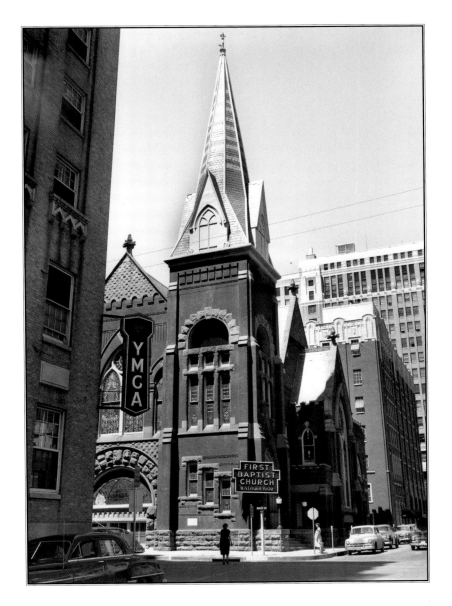

Old Red Courthouse

—Main, Houston, and Commerce Streets—

•

On a chilly February day in 1890, a Dallas jury had just finished deliberations in the case of Harry Patridge, an eighteen-year-old horse thief. The jury returned to the third-floor courtroom in the Dallas County Courthouse to render a guilty verdict and sentence Patridge to five years in prison. Just as the verdict was being read, someone shouted out a fire alarm, and all of the inhabitants in the largely wooden structure scrambled for the doors as smoke welled up around them. As hundreds gathered around the courthouse square, the conflagration quickly consumed the building. It was a total loss. The fire was found to have started in the wooden-encased, asbestos-wrapped zinc pipes that carried heat from the furnaces in the basement.

The burned courthouse had been erected in 1880 using the brick walls still standing from an 1872 courthouse that had also burned. The 1880 structure was three stories and was surmounted by a wooden clock tower. With a history of two successive courthouses destroyed by fire, the county commissioners resolved to build a grand new courthouse that would be virtually fireproof. They further resolved that the new courthouse should not be inferior to the new courthouse at Denver, which had been designed by the same architect as the state capitol in Austin.

Architect M. A. Orlopp of Little Rock was engaged for the sum of $5,000 and plans were drawn immediately. A $250,000 brick and stone structure was envisioned. A four-story Romanesque Revival building was designed with county offices on the first floor, four courtrooms on the second floor, and additional courts and jury rooms on the third. Some thought was given to housing the jail in the top of the building because it afforded protection against escapes and mob violence. However, the threat of fire to trapped prisoners argued against the jail idea.

Materials were debated until everyone agreed on Pecos red sandstone with a base of Arkansas blue granite. The arched openings and windows were also trimmed in blue granite. Two hundred railcar loads of red sandstone were required to complete the job. In March of 1890, work got under way. During construction, Alexander Ross, the forty-year-old foreman of the masonry crew, missed his footing and fell sixty feet from the third story to the basement. His body struck two beams on the way down, performing a complete somersault. He landed face down, lying motionless for a minute or two.

The horrified workmen surrounding him were astonished when he suddenly sprang up, apparently unhurt. His face was bruised and bleeding, but not a single bone was broken and no internal injuries were received. Ross was described as "a man of remarkable strength and endurance."

At completion, the new courthouse had cost $350,000. There was some consternation about the overall expenditure, but the structure was quickly proclaimed the finest courthouse between the Mississippi River and the Rocky Mountains. The finished building was a Victorian swirl of turrets, gables, and gargoyles. A clock tower rose 205 feet above the streets below, supporting a massive clock with illuminated glass dials nearly ten feet in diameter. The clock's bell weighed forty-five hundred pounds. Inside the structure, corridors were lined with Tennessee marble, and corridor floors were tiled. A twelve-foot-wide grand staircase led to the second floor. Two hydraulic elevators were also available.

By early 1919, structural concerns had developed about the condition and weight of the tower, clock, and bell atop the courthouse. The sandstone tower was beginning to deteriorate, and the material in it was estimated to weigh about seventy-five tons. There were fears that a high wind might bring the tower down and through the roof. Architect H. A. Overbeck was chosen to evaluate the situation, and he recommended the removal of the tower. The task was accomplished a few months later at a cost of $10,000. The grand staircase was removed a few years after the clock tower.

By the late 1920s, the growth of county business offices within the old courthouse had caused shotgun remodeling and severe overcrowding, so an additional administrative facility was planned. Completed in 1928, the Dallas County Records building became the headquarters for most of the business departments of the county government. The Old Red Courthouse reverted to functioning as a courthouse in the strictest sense of the term. Accordingly, the building received a thorough renovation, restoring it to its original configuration before the encroachment of the business offices.

In 1938, the structure survived a demolition and replacement initiative. In 1965, the completion of the George L. Allen Courts Building finally rendered the Old Red Courthouse completely superfluous for county use. Predictably, many people once again advocated the destruction of the historic landmark, citing the expense of maintaining it. Preservationists advocated its ongoing use as a museum. Fortunately, the preservation advocates prevailed, and "Old Red" survived into the twenty-first century. Beginning in 2001, major restoration efforts were undertaken, including the re-creation of the original clock tower and grand staircase. When complete in 2007, the building will serve as the Old Red Museum of Dallas County History and Culture.

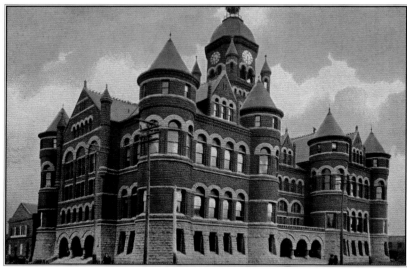

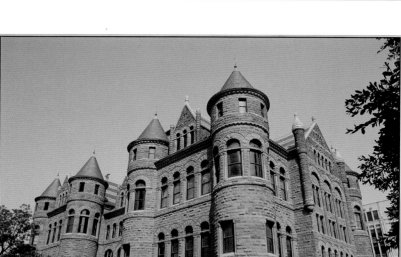

Left: *Historic and modern photographs of the Old Red Courthouse.*

Right: *Turn-of-the-twentieth-century view of Main Street looking west. Old Red Courthouse is visible at the end of Main Street with clock tower still intact. On the right side of the street are the North Texas Bank Building and the Trust Building.*

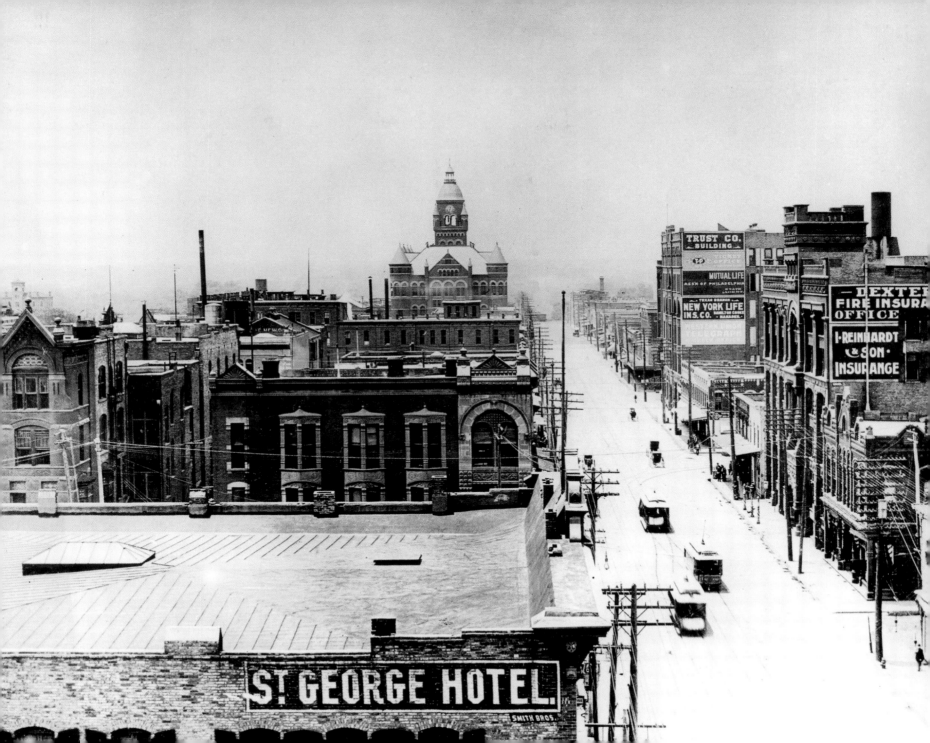

Slaughter Building

—Main and Poydras Streets—

•

In 1836, after the battle of San Jacinto, Christopher Columbus "C. C." Slaughter became the first white male child born in the new republic of Texas. He was the son of a Baptist minister and dedicated much of his life to Baptist service. He later became a cattle raiser, Indian fighter, Texas Ranger, and a colonel in the Confederate army. In 1870, after arriving in Dallas, he worked as a banker, but it was as a cattleman that he made his mark. At one point, he owned over half a million acres in west Texas. He served as president of the Baptist General Convention of Texas, and president of Baylor University Hospital.

In the late 1890s, Colonel Slaughter's office occupied a narrow, two-story structure on Main Street between Poydras and Murphy. He and his partner added a third story to the structure in which they published the *Baptist Standard*. In 1903, Slaughter bought the five-story building adjacent to him on the east, occupied first by the National Exchange Bank, and later by Union Bank & Trust. The two buildings, now fronting seventy-five feet on Main Street, were unified and then remodeled with hard maple and white marble flooring. Six years later, another narrow addition of seven stories on the eastern side of the joined structure was erected. The western portion of the building was then raised to seven stories, giving the finished structure a consistent appearance, a Main Street frontage of one hundred feet, and 168 offices. Photographs from the era show an elegant building

with two vertical rows of barrel-front windows gracing the Main Street façade. Constructed of Pecos red sandstone and brick, the building was designed by architect Clarence W. Bulger, whose work also included the Praetorian Building. In later years, the structure was given a finish of light yellow paint.

The Slaughter Building later became the scene of a shocking killing when a man entered the office of an attorney, G. H. (Bud) Crane, and demanded an apology for a supposed slight to his sister. In the ensuing scuffle, Crane stabbed the man, killing him almost instantly. A grand jury pronounced the slaying a case of self-defense. Crane later defended a brother of Clyde Barrow, the notorious bank robber.

Six years later in 1939, the building was the site of more violence. Brooks Coffman, a criminal attorney, had made advances on Corrine Maddox, a twenty-six-year-old stenographer. Miss Maddox had refused the lawyer's advances, so Coffman stabbed Miss Maddox several times with an ice pick, puncturing both of her lungs, and leaving her to die in a gravel pit off Industrial Boulevard, where they had met. She remained in critical condition for several weeks, while allegedly receiving death threats in the hospital from Coffman, who had been freed after posting bond.

On a Monday morning shortly before Thanksgiving, Corrine waited outside the Slaughter Building at eight o'clock, watched the swarm

of office workers enter the building, and patiently stalked Coffman, who was awaiting trial. He soon appeared in the company of another female. Miss Maddox waited until Coffman had parted company with the other woman before making her move. Stepping forward, she pulled two pistols from her coat and then opened fire on her prey. Surprised, Coffman took her first shot in the arm and was knocked to the sidewalk, screaming, "Don't kill me, Corrine!" He rose to his feet, fled across Main Street, and ran down Martin toward the St. George Hotel entrance. Miss Maddox followed, firing shot after shot at Coffman, as pedestrians scattered. Most of the bullets went wide of their mark, but one struck his other arm, and then another hit him in the leg, dropping him in his tracks. As Coffman lay face down on the sidewalk, Corrine Maddox stood over him and fired a fatal shot into his back. A total of twelve shots had been fired from the .32-caliber and .38-caliber pistols she used in the killing. Miss Maddox indicated that she had gone to some pains to secure lead-nosed bullets rather than steel-jacketed bullets, in hope of avoiding ricochets that might wound innocent bystanders. She also told police that she had made two previous attempts on Coffman's life, but was thwarted once by crowded sidewalks and a second time by a misfiring pistol.

The 1939 Coffman killing was the last excitement witnessed by the tenants of the fifty-year-old Slaughter Building. By 1940, the old building was no longer paying for itself. Rents were less than the costs of maintenance, remodeling, and taxes. Some consideration had been given to modernization a few years earlier, but the plan was never carried out. Instead, the historic structure was razed in 1942 and replaced with a parking lot. Today, the One Main Place development stands on the site.

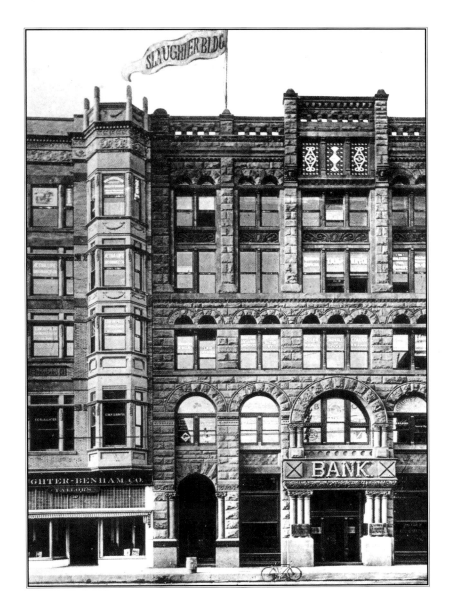

Oriental Hotel

Commerce and Akard Streets

Before the Adolphus was built, the Oriental Hotel was the city s premier hostelry. In 1891, Thomas Field began the project, but a hotel at Commerce and Akard was considered too far from the courthouse square to be a success, and Field ran out of investment money. St. Louis brewer Adolphus Busch ended up taking over the property and completing it at a cost of $600,000.

The hotel finally opened in October 1893, occupying the southeast corner of the Commerce Akard intersection. The six story hotel was constructed of dark red brick and roofed with green glazed tile. A vaguely oriental cupola dominated the northwest corner. The elaborate interior featured vaulted ceilings, arched entryways, marble floors and columns, and a grand stairway. The hotel had only a rudimentary central heating system, and only corner rooms had fireplaces, so a wintertime guest without a fireplace often had to go to bed in order to keep warm.

In April 1905, the Oriental was chosen to host President Theodore Roosevelt for his brief visit to Dallas. Roosevelt, the first US president to visit the city, was en route to San Antonio for a Rough Riders reunion when his train made an evening stop in Dallas. A speaker s stand was erected just east of the Oriental Hotel, and a crowd of twenty-five thousand was on hand to hear his thirty minute address. Civil war veterans were given a place of honor in front of the platform. Hun dreds of onlookers crowded the rooftops in all directions. After the address, the President rested before attending a banquet inside the hotel. Each of the three hundred promi nent guests received a personal introduction to the President. Governor James Hogg, seated next to President Roosevelt, proclaimed the greatness of the country and its people before the President s address. In 1909, President William Howard Taft was a guest in the hotel, addressing a crowded lobby from the second floor landing.

Manager Otto Herold was a stockholding partner with the Busch interests of St. Louis, and in 1912, he initiated a complete remodeling of the facility. Under the direction of architect C. D. Hill, the hotel received a thorough renovation,

including the installation of a "white palace" Turkish bath in the basement. For many years, the Oriental was the hotel of choice for prominent visitors and the favored meeting site for the city's elite.

The Oriental's storied history came to a close in the spring of 1924 when hotel operator T. B. Baker of San Antonio bought the property. He announced his intention to tear it down and replace it with a larger and more modern facility. Scaffolding was erected at the end of the summer, and then the task of demolishing the Oriental Hotel began. The Baker Hotel, equally significant in Dallas history, soon rose in its place.

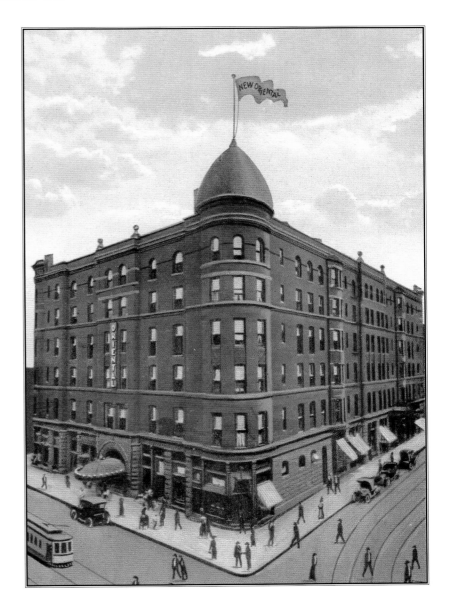

St. Matthew's Cathedral

—S. Ervay at Canton Streets—

•

In the early 1900s, the city of Dallas boasted some impressive church structures representing most of the major faiths. The Episcopal Church was well represented by St. Matthew's Cathedral on the northeast corner of South Ervay and Canton.

The congregation predated the Civil War and had occupied several structures over three decades. In 1893, a large church that would accommodate one thousand people was erected under the leadership of Bishop Alexander Garrett. The lofty building was designed by Sanguinet & Messer in a style described as "Norman Gothic," with an imposing corner tower ringed by parapets. Walls of gray sandstone were surmounted by a roof of slate.

This pretty cathedral sufficed for over three decades until the congregation had the opportunity to erect a magnificent building on the former campus of St. Mary's College, a few miles east of downtown. In 1927, work began, and in 1929, the church was occupied. The old sandstone structure on Ervay Street was already showing the ravages of time, and it deteriorated rapidly after it was vacated. In 1937, the decision to raze the building was made. Contents of the cornerstone were removed, and then workmen began ripping the roof off. No trace of the building remains today.

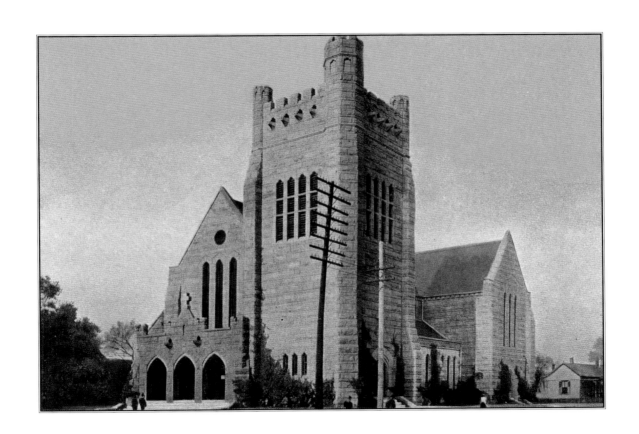

Linz Building

—1104 Main Street—

•

The creation of the landmark Linz Building was foreshadowed in the 1870s when St. Louis watchmaker Joseph Linz decided to follow the railroad to Denison, Texas. Linz made a living by repairing watches for the conductors of the M. K. & T. Railroad. In 1877, his brother Elias joined him, creating the partnership of Joseph Linz & Brother. Within a few years, his other brothers, Simon, Ben, and Albert, joined the firm.

In 1891, after a brief period in Sherman, the family business moved to Dallas. The company operated in rented spaces for several years, growing at a rapid pace along the way. In 1898, the Linz brothers undertook the construction of their own home at the corner of Main and Martin Streets, across from today's One Main Place. A structure of six stories plus a basement was planned under the direction of architects James Riely Gordon and H. A. Overbeck. Gordon had just completed the magnificent Ellis County Courthouse in Waxahachie.

Gordon and Overbeck designed a six-story, Second Empire-derived structure in buff brick and gray granite. The sidewalks on Main and Martin were finished with gray granite, as was the building base. Semicircular glass awnings covered the show windows and entrances. The main entrance was through a large, Romanesque archway leading to massive, silver-trimmed oaken doors with beveled glass panels. The vestibule was floored and wainscoted in marble, with marble shafts and plate mirrors to each side. The vestibule ceiling was domed and decorated in gold and hand-painted colors. Another set of mahogany, glass-paneled doors led from the vestibule to the rotunda, which was surrounded by polished scagliola marble pilasters with gilded Corinthian capitals. The domed ceiling featured bold Italian relief work decorated in gold leaf. Mirrors and massive chandeliers completed the rich effect. At the rear of the rotunda, the elevator lobby was reached through another archway that was decorated with polished bronze scrolls encircling an ornamental clock. The elevator gates were of highly ornamented polished bronze. A marble stairway at the rear led to all stories and to the roof garden atop the building. The six thousand-square-foot roof garden was paved with stone and equipped with a full stage,

dressing rooms, and toilets. Tall plants surrounded the garden. Among the building's interesting mechanical features was the hydraulic elevator system, chosen over electric versions due to the greater reliability offered.

The Linz store on the ground floor was finished in polished marble, highly figured mahogany, plate glass, and mirrors, with green scagliola marble columns supporting a massive, paneled ceiling. The store featured a long, horseshoe-shaped mahogany display counter filled with a fortune in gems that would become famous as the "diamond horseshoe."

Joseph Linz's old contacts at the M. K. & T. Railroad soon became a prime tenant in the building. Until 1912, they occupied the ground floor space for their city ticket office as well as the two top floors. In 1899, the sumptuous new building was completed, and it was the hit of that year's state fair. As the tallest building in the Southwest and the city's first skyscraper, the structure drew large crowds wanting to ride to the top for a view of the burgeoning city of 38,500 inhabitants. In 1926, the craftsmen from Linz Bros. created a jeweled replica of the building for the state fair.

In 1907, Joseph Linz retired. He passed away the following year. His brother, Elias, had passed away years before, but his surviving brothers, Simon, Albert, and Ben, continued to manage the business. Soon, they added a seventh story to the successful building. The company name was changed to Linz Bros. Jewelers. They operated from their flagship building for forty years before selling it in 1939 to the Rio Grande National Life Insurance Company. Then, Linz Bros. Jewelers announced plans to relocate farther to the east on Main Street, and the insurance company planned an extensive remodeling of the Linz Building, which became the Rio Grande Building.

The new Linz Bros. Jewelers location was at 1608 Main Street, just east of Stone. Lang & Witchell designed an impressive new home for the jewelry company, while Grayson Gill was specifying plans for the remodeling of the Rio Grande Building. The new Linz Bros. Jewelers store was a three-story building with the front finished in cream-colored limestone, Colorado marble, and red granite. The interior was floored with Italian terrazzo marble, procured just before the war stopped importation of the material. Rare woods were featured throughout the store, and the Linz Bros. Jewelers crest occupied the face of the structure. In the fall of 1940, it was occupied. Linz continued to operate from this location for decades.

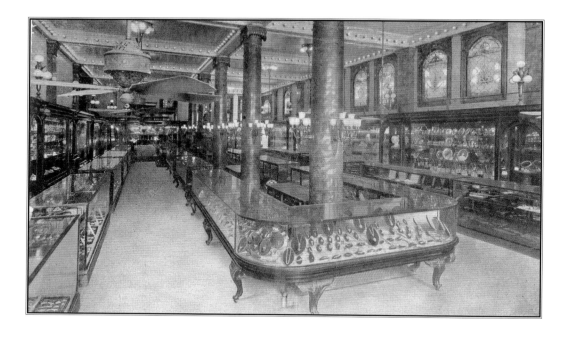

Rio Grande Life spent over $150,000 on remodeling and updates to their building before wartime restrictions put a halt to construction activity. In 1947, Rio Grande Life sold the building in order to build a new headquarters at Elm and Field. In 1949, on the occasion of the building's fiftieth anniversary, Cox Interests, the new owner, rechristened the structure. For the remainder of its life, the old Linz Building carried the nondescript moniker of the Commercial Building. The owner of the nearby Commerce Building sued over the similarity in names but lost the case in court.

Cox added a penthouse and adjoining apartment to the rooftop, complete with a sod lawn and sprinkler system. One more ownership transfer occurred before the decision was made to raze the historic building in the early '60s. In the summer of 1962, wreckers became the building's last occupants. During the demolition process, a huge chunk of the brick facade became unstable and crashed to the street below. Bouncing bricks shattered plate glass in buildings across the street. Fortunately, no one was injured, but the Linz Building had not gone quietly.

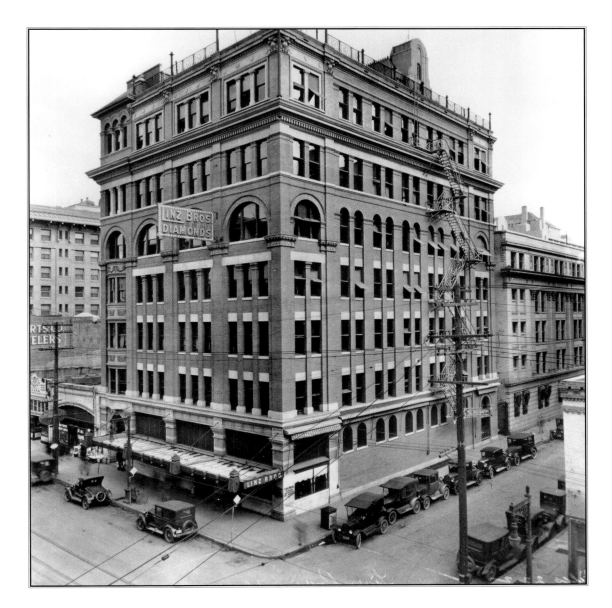

Dallas Morning News Building

—Commerce and Lamar Streets—

•

George Bannerman Dealey was only eleven years of age when he came to Texas from England. Landing in Galveston in 1870, Dealey soon found himself working as an office boy for the local newspaper, owned by Colonel Alfred Belo. In 1885, after Belo dispatched him to Dallas to start another paper, Dealey became the twenty-six-year-old founder of the *Dallas Morning News*.

Even at such a young age, Dealey oversaw all aspects of establishing the paper in Dallas, including the acquisition of temporary space on the north side of Commerce Street between Lamar and Austin. As the city and newspaper grew, construction began during the summer of 1899 on a permanent home for the *Dallas Morning News*. The three-story structure of stone and brick occupied the northwest corner of Commerce and Lamar where a parking garage now stands. Herbert M. Greene designed the handsome building, which faced Lamar Street. It featured a distinctive rooftop balustrade surmounted by stonework eagles. In the first months of 1900, the new building was occupied.

Upon the death of Colonel Belo in 1906, George B. Dealey was made vice president and general manager of both the Dallas and Galveston operations. In 1913, a new four-story building at Commerce and Austin was added to the west side of the *Dallas Morning News* complex to house the mechanical equipment and presses, giving the paper the entire north side of Commerce Street between Lamar and Austin.

Dealey's son, Ted, soon joined the paper as a young reporter, leading a courageous campaign against the growing power of the Ku Klux Klan in Dallas. At that time, the Klan wielded enormous influence in the city. Many Dallas citizens had mixed emotions about the Klan's message of patriotism and Christian virtue mixed with liberal helpings of racial, religious, and ethnic bigotry. Klan leaders were not uneducated street toughs, but rather prominent businessmen, lawmen, and even members of the local clergy. Z. E. Marvin, a wealthy Dallas druggist, served as grand titan of the Texas Klan while providing free prescriptions for the poor and founding Hope Cottage for abandoned children. On a May evening in 1921,

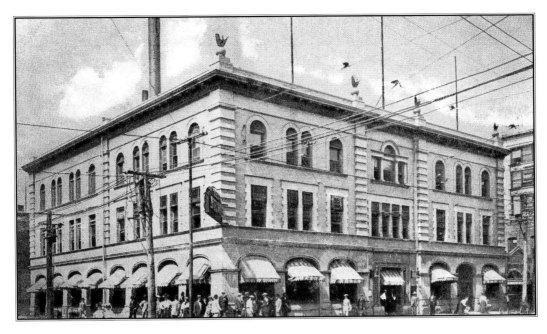

eight hundred Klansmen marched silently through the darkened streets of downtown Dallas behind an American flag and a flaming cross. Going up against the organization was not a simple matter, and the popularity of the *Dallas Morning News* suffered from their principled stand.

In 1923, the *Galveston News* was sold to the Moody family of that city, allowing George Dealey to focus all of his efforts on the Dallas paper. In 1926, he bought out Colonel Belo's remaining heirs and retained the name A. H. Belo Company. In 1940, property for expansion was acquired on the Main Street side of the block, but it was not enough. Despite a fondness for their location of over four decades, the *Dallas Morning News* elected to build a new home at Houston and Young streets, just across from Union Station. In October 1946, construction began, and the building was completed in March 1949. Two years after the new building was occupied, the old 1900 home of the *Dallas Morning News* was purchased by Texas Bank & Trust Co. and then demolished to make way for a seven-story parking garage and drive-through bank.

Carnegie Library

—Commerce and Harwood Streets—

•

During the waning years of the nineteenth century, the leading citizens of Dallas coveted a library worthy of the city's ambitious spirit. Small libraries had been maintained in various locations until 1901 when Dallas became the third Texas recipient of Andrew Carnegie's largesse. A millionaire industrialist, Carnegie spent a large chunk from his considerable fortune to build community libraries across the United States. Carnegie's attention was apparently caught by the similarity in names between his adopted hometown in Pittsburgh, Pennsylvania, and Pittsburg, Texas, so his first gift in Texas went to the tiny city of Pittsburg. Next to receive a Carnegie library was Ft. Worth, and Dallas followed soon afterward.

Carnegie's $50,000 gift came with strings attached. The city had to furnish the land for the structure, and pledge $4,000 annually for maintenance. The city responded with a corner site fronting two hundred feet on Commerce Street and extending one hundred feet back to Jackson. In January

1901, the cornerstone was laid. Rev. W. M. Anderson of the First Presbyterian Church delivered an invocation, and Rev. George W. Truett of the First Baptist Church gave a benediction. Ben E. Cabell, former sheriff and current mayor, offered an address, as did several others.

The library, designed by Ft. Worth architects Sanguinet & Staats, was two stories with a basement, and was constructed of gray Roman brick and Bedford limestone. Ionic columns flanked the portico. On October 29, 1901, the Carnegie Library opened with ten thousand books, an invocation from Bishop Garrett of St. Matthew's Episcopal, and speeches from politicians and library organizers. Two thousand people attended out of a population of forty-three thousand. The construction had only exceeded Carnegie's gift by ninety-seven dollars.

The grand new structure was ideal in 1901, but the rapidly expanding city soon began to outgrow the facility. By 1951, when Dallas celebrated the fiftieth anniversary of the Carnegie Library, criticism had mounted over the crowded conditions

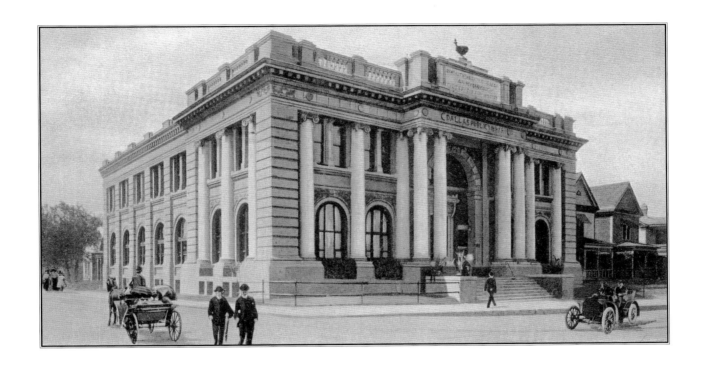

inside. Two hundred thousand volumes bulged from shelves designed for a fraction of that number. Plans for a new library were snarled by acrimony over proper sites. In late 1953, the issue was finally settled by a controversial decision to demol-ish the Carnegie library and rebuild on the site. The library moved into temporary quarters on the second floor of Union Station while construction proceeded. In the final days of December 1953, the old Carnegie Library was razed.

Cathedral of the Sacred Heart

—Ross and Pearl Streets—

•

To step out of the bright sunshine on Ross Avenue and into the hushed, dark confines of the Cathedral Santuario de Guadalupe is to take a trip back in time. Begun in 1898 as the Cathedral of the Sacred Heart, the church was erected on Ross Avenue at a time when it was known as "Dallas's Silk Stocking Row." Magnificent houses lined the street for blocks, and extended well to the east of downtown.

Dallas Catholics had met for several years at a smaller church on Bryan and Harwood, but a growing city and a growing congregation demanded a grand new cathedral. The new edifice was built under the leadership of Bishop Dunne of the northern diocese of Texas and congregation member James Moroney. Mr. Moroney, who was an Irish immigrant, built a prosperous hardware business in Dallas and served in many civic capacities.

N. J. Clayton, a noted Galveston architect, was engaged to design the Victorian-era, Gothic cathedral. It was planned in the form of a Greek cross with a short nave and a long transept. The building was constructed of red stone with a red tile roof, and was planned to include soaring spires on the corners facing Ross Avenue. A 224-foot bell tower was supposed to grace the southwestern portion of the building. Budgetary realities forced the cancellation of the proposed spires, but the project forged ahead with cornerstone placement in June 1898.

Construction continued over the next four years, and in the fall of 1902, the dedication took place. The completed cathedral was replete with massively vaulted ceilings and over one hundred magnificent stained-glass windows. It was reputed to be the largest church in the south. As the years progressed, the Sacred Heart Cathedral suffered the ravages of time and reduced membership due to the growth of suburban congregations. In 1977, the name of the Cathedral was changed to Cathedral Santuario de Guadalupe.

Maintenance and restoration efforts were ongoing over the next few decades, and in 2005, the original spires, envisioned so long ago by N. J. Clayton, were finally added to the structure. ArchiTexas, an architectural firm, designed the soaring, copper-clad additions to the magnificent cathedral.

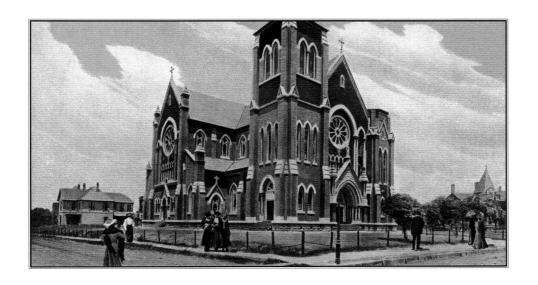

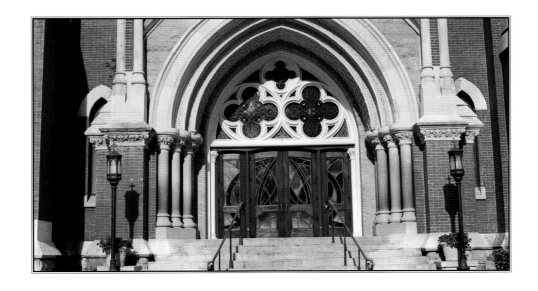

Texas School Book Depository

—411 Elm Street—

•

This building, which is so intimately associated with the Kennedy assassination, is widely known by a name that it bore for only a few years. The Texas School Book Depository did not lease the building for a book warehouse until 1963, the year of the assassination.

In 1898, the Southern Rock Island Plow Company first erected a five-story brick warehouse on the site at the northwest corner of Elm and Houston Streets for their plows, buggies, and wagons. It was occupied in 1899, but a lightning-induced fire destroyed the building two years later. It was immediately rebuilt as a seven-story facility and then occupied in January 1902. A dance was held in the building to celebrate its rebirth.

In 1937, D. Harold Byrd, a Dallas oilman, aviator, and Civil Air Patrol co-founder, bought the building. Byrd had invested in an air-conditioning manufacturing concern operating under the name of Carraway-Byrd Corporation, and he planned to use the building as a production and distribution facility. Thomas Carraway was a pioneer in the field of evaporative air-conditioning, and with Byrd's backing, the company's future looked promising. The air-conditioning units were distributed by Perfection-Aire Corp., and in 1938, the building took that name. The company soon ended up in receivership, and in 1940, the building was leased to Sexton Wholesale Foods.

For over two decades, Sexton used the building as a distribution facility. In 1953, Sexton allowed area Ford dealers to erect a thirty-three-foot tall and sixty-two-foot wide neon sign advertising the Ford name in eighteen-foot flashing letters. Mayor R. L. Thornton tripped a switch in the Adolphus Hotel that lighted the sign on the fiftieth anniversary of the Ford Motor Company. Years later, this sign became the framework for the massive Hertz Rent-A-Car sign that was mounted on the building at the time of the Kennedy assassination. In 1961, Sexton erected another building and then vacated their old facility, which was soon remodeled for the expansion of the Texas School Book Depository located just up the street.

On November 22, 1963, Lee Harvey Oswald, a depository worker, was alleged to have slain President John F. Kennedy

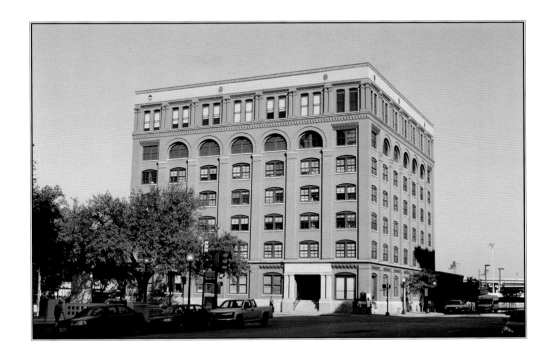

by firing a rifle from a sixth-floor window in the building's southeast corner. The building continued to house the Texas School Book Depository until 1970 and then fell vacant. In the years following the assassination, there were fears that the historic building would be purchased and used to exploit the tragedy. In 1977, Dallas County bought the building to prevent such a possibility. After years of searching for the proper

way to memorialize the events surrounding the president's death, the building became home to the Sixth Floor Museum. The nonprofit institution preserves the building with tasteful exhibits occupying parts of three floors including the infamous sixth floor with its sniper's perch. The rest of the building is occupied by Dallas County personnel.

City National Bank

—Main and Murphy Streets—

•

One of the city's lost treasures is the 1903 City National Bank building at the intersection of 1201 Main and Murphy. City National Bank had already spent thirty years in a modest building at Commerce and Market before planning their new home on Main Street. The design by Sanguinet & Statts suggested a Corinthian temple with massive, white stone columns framing the Main Street portico. In 1917, when the building was doubled in size, the architects maintained and enhanced the classical design. A carved pediment surmounted the center cluster of columns, crowned by lion's heads symbolizing strength and security. Each of the column capitals was carved with an American eagle. Heavy, bronze-bound mahogany doors led into the bank.

The barrel-vaulted main lobby was supported by polished stone columns, and ten teller cages ran along the edges of the lobby. The cage railings were of Italian marble inlaid with Venetian glass mosaics topped by bronze grillwork. The banking lobby floors were of mosaic marble. The chrome steel vault was at the rear of the main lobby. The second floor where the safety deposit vault and director's room were located was reached by a wrought iron and marble staircase.

City National Bank had prospered under the leadership of E. O. Tenison, who started as a thirteen-year-old messenger boy. In 1914, Tenison left to head the Dallas Federal Reserve Bank. In 1923, he founded Tenison National Bank, and donated to the city a large park bearing his name. In 1929, City National Bank merged with the American Exchange National Bank, forming the largest bank in the Southwest with $85 million in deposits. Both banks dated back to the 1870s. R. H. Stewart was chairman of City National Bank, while Nathan Adams was the up-and-coming president of American Exchange, and these two men were destined to shape Dallas banking for years to come as leaders of the new First National Bank. The employees of City National Bank soon vacated their location on Main Street for the newer, larger premises of American Exchange National Bank.

For the next decade, the old City National building sat vacant. In 1940, when Reserve Loan Life Insurance moved to Dallas

from Indiana, they leased the structure for three years. In 1943, Reserve Loan Life exercised their option and bought the building from First National Bank for $325,000. The company operated from this location until they erected a new structure in 1949. A few years later, Clint Murchison, a millionaire oil-man, an entrepreneur, and the father of the future owner of the Dallas Cowboys, chose the old City National Bank building as the headquarters for several of his companies, including Southern Union Gas. Murchison eventually left downtown, and then the building was again vacant.

Eventually, the beautiful but aged building fell victim to progress. In the 1960s, it was demolished to make way for One Main Place.

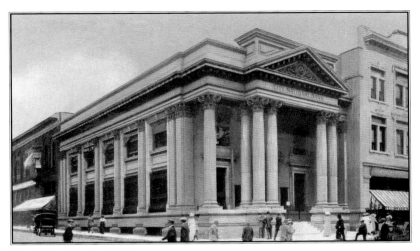

City National Bank, c. 1910.

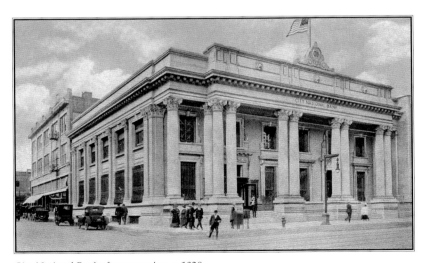

City National Bank after expansion, c. 1920.

Elks Club

—1808 Main Street—

•

During the early years of the twentieth century, the Benevolent and Protective Order of Elks was a hugely popular fraternal order functioning as a community service organization and meeting place for local men.

The Dallas Lodge was extremely successful. In June 1900, the Elks hosted a street fair that drew thousands of people. Prominent archways and a massive tent were erected to accommodate the large crowds, who were entertained by magicians, acrobats, and an Egyptian snake-eater by the name of Esau. This man of dubious talents was renowned for his ability to bite the heads off of fearsome snakes before totally devouring them, and during the Elks fair, Esau supposedly dispatched more than two hundred reptiles in this manner.

Beginning in 1902, the Dallas Elks Lodge erected a substantial clubhouse on Main Street just to the east of the Post Office. In March 1902, the cornerstone was laid, and in January 1903, construction was completed. Architect H. A.

Overbeck designed a Corinthian-style building with massive stone pillars and a pediment gracing the upper floors of the Main Street facade. The classical structure featured two stories above ground plus a basement. A bowling alley and café occupied much of the basement space. The upper floors contained card and billiard rooms, dressing rooms, a dining room, and a large lodge room adorned with the Elks Head symbol of the organization.

In July 1908, the National Elks reunion came to Dallas. A massive, lighted welcoming arch was erected spanning the intersection of Main and Akard Streets. A court of honor was held beneath the arch, which remained standing for years. In 1910, the arch became notorious when a black man was seized from the county courthouse by howling vigilantes and lynched beside the Elks arch. The cumbersome structure soon became a nuisance for the growing city. In 1911, it was moved with some difficulty to Fair Park.

In 1912, the Dallas Elks Lodge sold its 1903 structure to busi-

nessman G. H. Schoellkopf and then, two years later, moved to a new location adjacent to City Park. H. A. Overbeck, a prominent Elk, was again called upon to design the new structure utilizing a Spanish motif. The old clubhouse was eventually occupied by the State Bank and Trust Company. In 1925, the bank completed extensive remodeling on the structure, completely altering the facade. After the bank failed and vacated the premises, the building became home to the Dallas USO during the World War II years. After the war, the Empire State Bank remodeled the structure once again and then occupied it for nearly two decades before merging with National Bank of Commerce. The aged structure eventually was demolished for the expansion of the Mercantile National Bank complex.

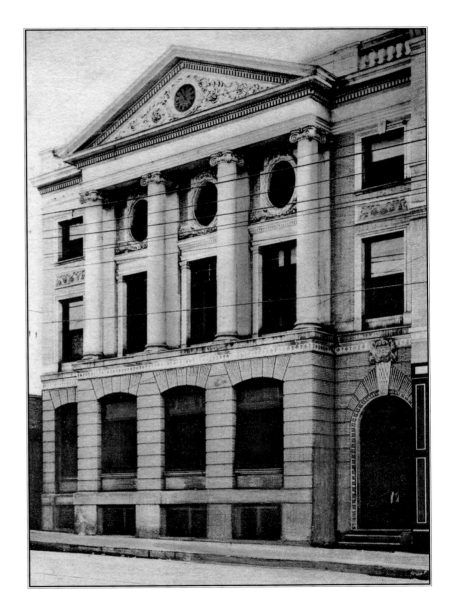

Wilson Building

—Main, Ervay, and Elm Streets—

•

The Cave Saloon was a wooden shanty that stood at the corner of Main and Ervay Streets. It had been built at the eastern edge of town at a time when most structures still surrounded the courthouse square.

As Dallas grew to the east, the property became more viable, and it was soon purchased by a man named Dick Flanagan. Flanagan loved boxing, and his saloon became a magnet for amateur prizefighters hoping to pick up some extra cash. A ring was erected on the lot behind the saloon, open to all comers. The action was fast, furious, and often violent. Even the famous John L. Sullivan fought there. The saloon walls were covered with photographs of famous fighters.

After Flanagan died, the saloon was sold, and then it slowly deteriorated. On a cold January morning in 1902, a group of workmen with axes and hammers entered the saloon, and within a few hours, they had demolished the unsightly old structure. They cleared the lot for a planned five-story building to be erected by J. B. Wilson, a wealthy cattleman and financier. The ornate building was designed by Ft. Worth architects Sanguinet & Staats in Second Empire style. The plans were soon expanded to eight stories, with the building facing Ervay Street and having smaller frontages and entrances on Main and Elm. The Titche-Goettinger department store was to occupy the

first two floors and basement, so the ground floor consisted of plate glass display windows extending completely around the building. A line of thirty-ton iron columns supported the upper structure of buff brick, terra-cotta, and Bedford stone. The facade gracefully curved from Ervay Street into the Main and Elm Street sides of the building. Two light courts down to the third level divided the structure into three wings. The light courts were faced with white, enameled brick in order to reflect more light into the building. Wilson left his mark on the building by placing his personal initials on light switches, door hardware, elevators, and exterior details. With Titche-Goettinger occupying the lower floors, the upper floors were leased to doctors and dentists. In 1923, the completion of the Medical Arts Building drew many of these professionals away, only to be replaced by lawyers and bookkeepers.

As Titche-Goettinger flourished, Wilson was forced to expand the building for them. He considered additional floors but decided instead to erect a twelve-story annex on the west side of the structure facing Elm Street. This narrow addition was sufficient for Titche-Goettinger's needs until 1929 when they occupied their own building nearby. With the department store gone, the Wilson building was remodeled to become a general office building. At a cost of $100,000, new elevators were installed, and an arcade was built to extend

through the building from Main to Elm. The interior was finished in black marble.

Soon after the departure of Titche-Goettinger, the twelve-story annex was occupied by the W. A. Green department store. In 1896, the Green family had moved to Dallas and set up shop in a one-story building on Elm Street. As the company grew, they moved several times into ever-larger quarters until the old Titche-Goettinger space was occupied. This became home to the store for the next thirty-one years.

As the 1960s dawned, a combination of suburban growth and the store's tall, narrow configuration made staying in the Elm Street location unfeasible. Hurried downtown shoppers with newer options in the suburbs were no longer willing to wait on the old building's four elevators traversing twelve floors. In 1961, W. A. Green consolidated to an Oak Cliff location.

The vacant twelve-story annex was immediately leased by McCrory Corp. for the expansion of their H. L. Green variety store, which was already housed in the two lower floors of the main building next door. H. L. Green occupied parts of the building for three decades.

The Wilson Building languished for many years as downtown Dallas struggled to attract tenants and shoppers. The historic structure soon faced the same fate as other aging relics of the past. Then, in 1997, Columbus Realty Trust took a chance on the old building and developed it into 140 apartments with ground-floor retail. Over one hundred years after its construction, the beautiful Wilson Building is still thriving.

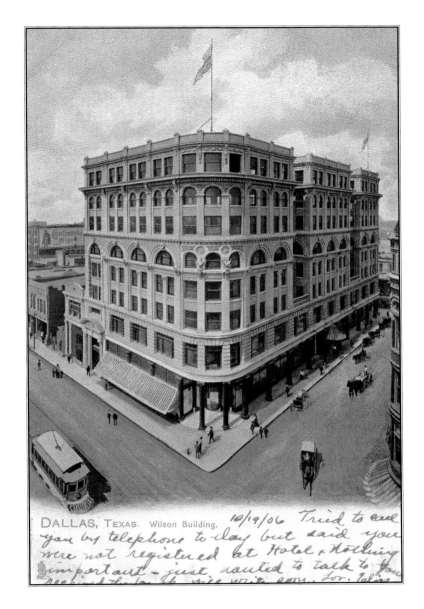

DALLAS, TEXAS. Wilson Building.

Metropolitan Business College

—Commerce Street at St. Paul Street—

•

In the earliest years of the twentieth century, the rapid rise of Dallas was largely fueled by explosive growth in the cotton and insurance industries, local wholesale houses, and banking institutions. These companies required growing numbers of stenographers, bookkeepers, and bank clerks. As population patterns changed and rural dwellers flocked to the cities, business colleges sprang up to impart badly needed skills to these former farm workers.

In 1887, the Metropolitan Business College of Dallas was founded. By the turn of the century, more than six hundred students were enrolled. In 1904, under the leadership of President A. Ragland, a new three-story home for the college was planned. The $20,000 building of cream-colored brick was located on the northwest corner of Commerce Street and St. Paul, directly across from the old First Methodist Church. Business courses were adapted to the needs of local industries. In 1908, a course on cotton grading was added. As typewriters replaced handwritten correspondence, the school churned out legions of typists. In addition to teaching business skills, the school offered a free employment service to help graduates find desirable jobs.

In 1937, Metropolitan Business College celebrated its fiftieth anniversary, having provided thousands of graduates to the Dallas business community. One famous alumnus was R. L. Thornton, chairman of Mercantile National Bank, whose background was typical of many students. Thornton had come to Dallas from Bristol, Texas, around the turn of the century, following a hardscrabble boyhood spent picking cotton and clearing stumps. Thornton was rough and uneducated, but he was also shrewd, driven, and had a head for figures. After preparing for life in the business world at Metropolitan, Thornton went on to become a millionaire banker and a beloved Mayor known as "Mr. Dallas." Milton Brown, the man succeeding Thornton as president of Mercantile National Bank, was also a graduate of Metropolitan Business College. Over the years, more than twenty-five hundred students graduated.

A. Ragland, the school's owner and president, retired in

1947, and then sold out to Rutherford School of Business. The Commerce Street building was soon vacated in favor of Rutherford's existing location, and in 1953, the old structure was demolished. Ironically, the site was soon occupied by an addition to R. L. Thornton's Mercantile National Bank.

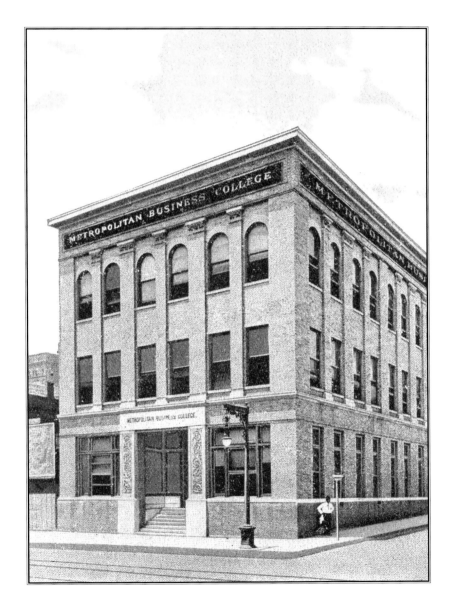

During the early 1900s, as Dallas grew in size and refinement, the city saw its first motion picture houses established. In 1905, one of the earliest was the old Majestic Theater, erected on the northeast corner of Commerce and St. Paul. Vaudeville still ruled the world of entertainment, and the Interstate Theater Circuit busied itself creating a chain of these theaters across the south central and southwestern United States.

The Dallas Majestic had seats for twelve hundred patrons, with 450 on the lower floor and 750 in the deep balcony. Vaudeville acts were presented on the proscenium stage, and silent, color motion pictures were shown to the accompaniment of a full orchestra. The handsome building of buff brick and green terra-cotta aimed for an Oriental effect. An ornate interior featured mosaic floors, marble wainscoting, and brightly painted walls. A cluster of flags was displayed above the center of the stage, including Old Glory, the Confederate Stars and Bars, the Texas State flag, and a flag that flew above Ft. Sumpter. A cloak room and smoking room were provided, as well as an attended "retiring" room for ladies. Among the uniformed staff was a valet, who looked after arriving carriages.

On the evening of October 31, 1905, the new theater opened. Each guest received a souvenir program of red silk. The program presented a bill of fare that included an acrobatic troupe, a singer known as "the Australian songbird," a violinist, mimes, a dog and pony show, and more. The Majestic was a huge success, but as the years progressed, it was outgrown. By 1917, Interstate Theaters, led by Karl Hoblitzelle, was planning a new and larger venue. The grand new theater was built on Elm between St. Paul and Harwood, costing upwards of $500,000. One concern over the new location was the Texas & Pacific railroad line that ran behind the site on Pacific Avenue. The noise, smoke, and dust created by the trains was a nuisance. It was hoped that the line could be moved, but before plans were completed, the existing Majestic Theater was destroyed in a catastrophic December 1917 fire. It was just the latest in a series of theater fires that had seriously damaged the Old Mill, the Queen, and the Newport over the previous two years. The Majestic's management quickly leased the old Dallas Opera House at Main and St. Paul and then continued operation while they built their long-anticipated, new home on Elm Street.

In the years just prior to World War I, several new theaters arrived in quick succession, including the Washington, the Queen, the

Hippodrome, the Old Mill, and the Crystal. Vaudeville was still popular, but silent motion pictures were quickly gaining in popularity, creating a need for more exhibition venues. These new theaters would usher in the era of grand movie palaces. On Thanksgiving Day in 1912, the Washington premiered. Located at 1615 Elm on the north side of the street near Stone, the theater's eye-popping facade featured intaglios, classical figurines, and gaudy lighting. The Washington became a popular destination, but faded as newer and larger movie houses emerged. In 1927, the theater closed, and then in 1932, it was demolished. Thanksgiving Tower occupies the site today.

The Queen Theater's opening followed the Washington's by two months. Located on the northeast corner of Elm and Akard, the 900-seat Queen welcomed its first patrons at the end of January 1913. The theater's ornate interior was specifically dedicated to famous queens and to the female form in general, with life-sized sculptures of Cleopatra, Queen Dido of Carthage, Queen Isabella of Spain, and others. The face of the mezzanine level was decorated with ten, life-sized, female figures covered by the sheerest of drapes. A massive pipe organ was played by a noted London keyboardist. The Queen Theater operated continuously until 1948 when it was remodeled. It then reopened as the Leo. In 1953, the building was demolished and replaced by the Dallas Federal Savings building.

The Hippodrome Theater followed the Queen by just over a month. Opening March 1, 1913, the Hippodrome rivaled the Majestic in size, seating twelve hundred between the ground floor and lobby. Located farther west than most theaters, the Hippodrome was built at the intersection of 1209 Elm and Murphy. Designed by Lang & Witchell, the theater's dark brick facade was set off by twin towers capped with glazed green tiles. The appearance was much simpler than that of the Washington Theater, but an Egyptian motif throughout the building gave it a unique character. The foyer was decorated with representations of ruins along the Nile River. The fire curtain featured a painting of a Roman chariot race, and over the proscenium arch was an allegorical painting portraying Dallas as the commercial center of the Southwest. A huge pipe organ was played by Professor Dee from England, alternating with a seven-piece orchestra. An indirect lighting system was utilized to discourage the patrons from "spooning," an old term used to describe physical intimacy. As in most fine theaters of the era, smoking rooms and attended dressing rooms were provided. In future years, the Hippodrome was superseded by the great movie palaces farther east on Elm Street. The old theater resorted to hosting wrestling bouts on its stage for several years. In 1947, the theater was reborn as the Strand Theater. The change extended the building's life for thirteen more years. In 1960, it was demolished in favor of a parking lot. Renaissance Tower occupies the site today.

In June 1913, four months after the opening of the Hippodrome, the 1,400-seat Old Mill Theater debuted. Located at 1527 Elm Street, the building's unique facade of red brick included two "windmill" towers on either flank, housing a pair of huge shuttered ventilating fans. In 1917, these came in handy during a catastrophic fire that nearly destroyed the building. Within a year of its construction, the Old Mill had forsaken Vaudeville for a "pictures only" format. Admission prices ranged from a nickel to a dime. Will Rogers supposedly appeared on the theater's stage early in his career, performing rope tricks. After the February 1917 fire badly damaged the theater, it was quickly restored, and then operated successfully for another seventeen years before being closed and remodeled. In 1935, the Old Mill was completely reworked by LaRoche and Dahl, and then reemerged as the Rialto Theater.

In September 1913, the Crystal Theater, another of the early movie houses, opened. Erected at a cost of $100,000, the building was located on the south side of Elm between Stone and Ervay, adjacent to the Wilson Building. It was one of the few theaters ever erected on that side of the street. The small, three-story theater only seated six hundred, but offered an attractive Japanese theme to its patrons. The lobby featured Japanese frescoes, mirrors, and an enormous Japanese lantern suspended overhead. The projection booth was a replica of a Japanese joss house. The ubiquitous pipe organ was present to accompany performances. Through the years, the Crystal hosted silent films starring Mary Pickford, Charlie Chaplin, Wallace Beery, Theda Bara, and Hoot Gibson. In 1923, D.W. Griffith's *The Birth of a Nation* was shown here. As the small theater became outmoded during the 1920s, it was sold to McCrory Stores of New York for the erection of a dime store, and then in 1928, it was razed. The old McCrory building still occupies the site.

Right: Hippodrome Theater, erected in 1913. Demolished 1960.
Below: Washington Theater, erected in 1912. Demolished 1932.

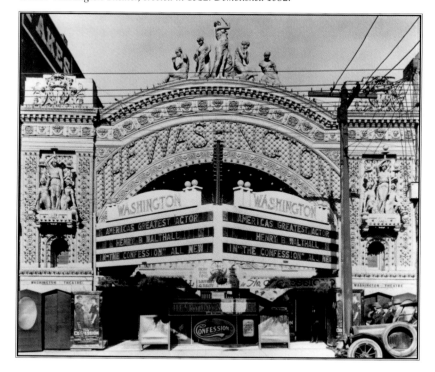

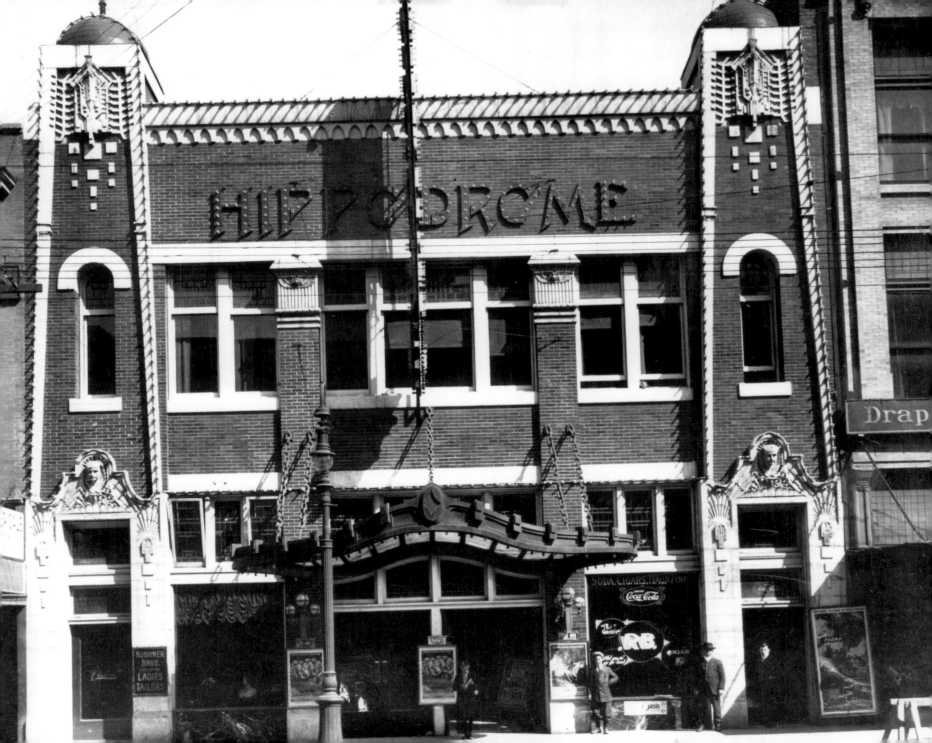

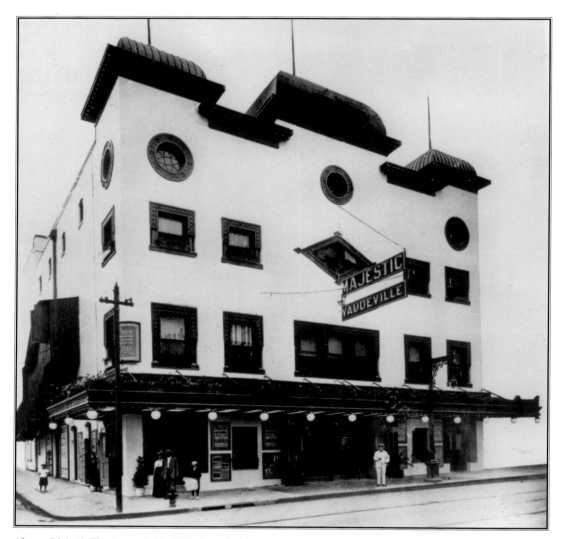

Above: *Majestic Theater, erected in 1905. Burned 1917.*
Right: *Crystal Theater, erected in 1913. Demolished 1928.*

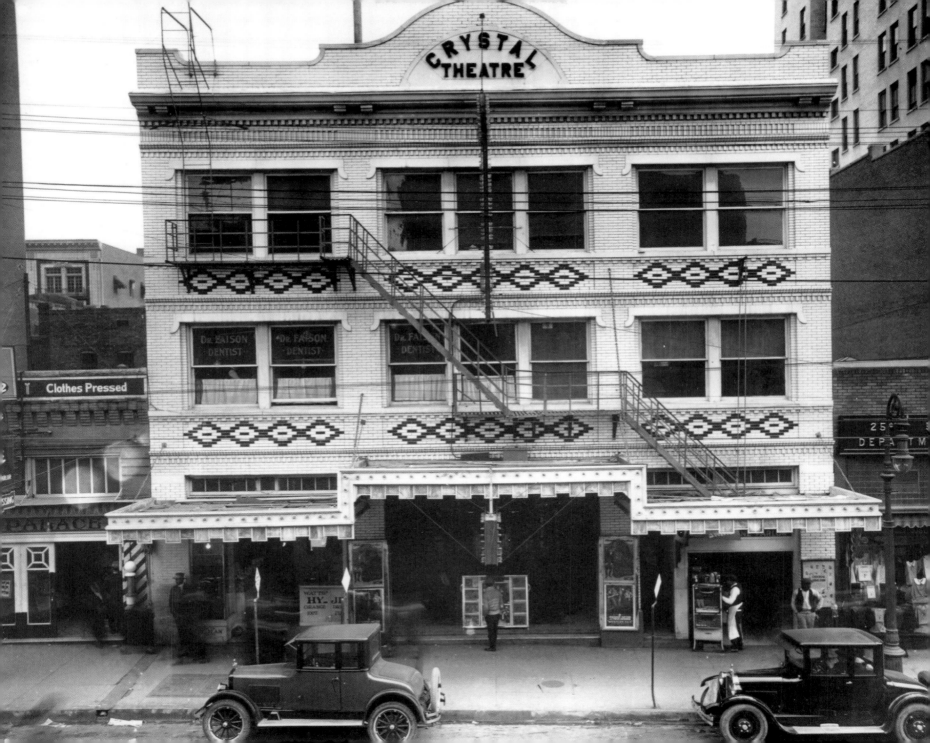

Southland Hotel

Main and Murphy Streets

In 1907, the intersection of Main and Murphy was the premier business location in the city. The new City National Bank was on one corner; Dreyfuss & Son Clothiers was soon to be on another. It was upon the southeast corner of this busy intersection that the Southland Hotel chose to build. The structure stretched from Main to Commerce, facing westward. It was eight stories in height, framed in steel and concrete, and finished in brick and terra-cotta. The lobby was ornately tiled. It was considered so fireproof that the owners did not bother with fire insurance. There were two hundred rooms, half of them with a private bath. The chefs were imported from France and the waiters from Chicago and Detroit.

The hotel had been open for only a few days when it experienced its first major excitement. Alex Pegues, a drunken city detective, walked into the crowded lobby one evening and emptied his pistol into the new ceiling. If it was attention he was seeking, he got it. Mr. Pegues was charged with conduct unbecoming an officer, and then forced to resign.

A few weeks later, the rocky start continued when a runaway carriage crashed outside the hotel. The driver was William H. Gaston Jr., a member of the prominent Gaston family for whom Gaston Avenue would be named. Mr. Gaston Jr. had his wife along as a passenger. Their horse was reputed to be skittish, and when a harness strap broke, the horse bolted. The carriage careened along Commerce Street before crashing against the curb outside the hotel. Both riders were thrown to the pavement, and Mrs. Gaston received a fractured jaw and lacerations to the head. Mr. Gaston received internal injuries. They were carried into the hotel where they were fortunate to be treated by the eminent surgeon, Dr. W. W. Samuell. (Samuell Blvd. was named after him.)

Besides mishaps, the Southland was the setting for thousands of conventions, card games, and get togethers of all types during its sixty-five-year lifespan. During World War II, the Southland was conspicuously convenient for soldiers assigned to the Eighth Service Command, based across the

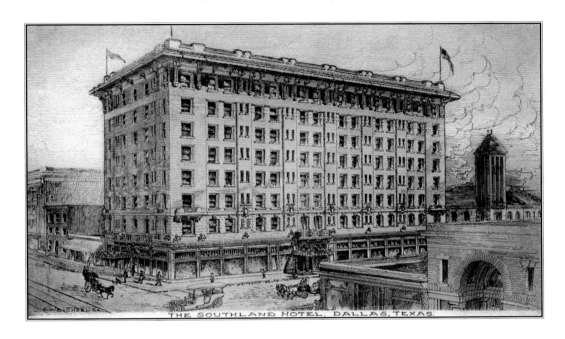

THE SOUTHLAND HOTEL, DALLAS, TEXAS.

street at the Santa Fe complex. The hotel was eventually placed off limits to military personnel due to the high number of prostitutes frequenting the premises and fears of venereal disease outbreaks.

In 1971, the veteran hotel finally fell victim to age and progress. The prime space was more valuable for office tower develop-ment than for renting $8 rooms. The lot was purchased for the construction of the twenty-five-story Main Tower. At the end of April, Ed Bowman, a twenty-eight-year employee of the hotel, turned out the lights and locked the doors for the last time. Shortly afterward, the Southland Hotel and all its memories were demolished.

Dallas High School

—2218 Bryan Street—

In 1900, Dallas's only high school was cramped, noisy, and unsafe. The city's rapid growth forced students to be packed into classrooms and assembly halls designed for fewer children. Bare, thin wooden floors caused footsteps to echo throughout the building. Stairways were steep and narrow. There was not any kind of central ventilation system, which presented significant problems on cold winter days. Classroom windows had to be closed against the frosty outside air, creating stale, germ-ridden conditions inside. Coal-fired classroom heaters released smoke, coal gas, and carbon monoxide, resulting in headaches and drowsiness for the students.

For several years, parents and civic leaders clamored in favor of a new high school, and in 1906, they got their wish. The new school was constructed on the same site as the old—Bryan Street near Pearl. Lang & Witchell designed a large, modern building of three stories plus a basement that would accommodate the city's immediate needs and future growth, at least for a few years. In 1907, work got under way, and in September 1908, construction wrapped up in time for school to start. It was proclaimed the finest high school in the state. Corridors were thirteen feet wide. A large auditorium seated nine hundred students. The basement contained a spacious lunchroom where students could purchase a meal for less than fifteen cents. The top floor housed four laboratories and several lecture halls. Steam heat was conveyed from the basement to the entire building. The building's exterior was finished in light brick and terra-cotta. An ornate vestibule was provided with a nine-foot statue of "Winged Victory."

As the city grew and new high schools were created, the school's name had to change. In 1916, Dallas High School became Bryan Street High School. The school's focus became technical training during the 1920s, so in 1928, the name was changed to Dallas Technical High School. In 1943, the school was finally renamed Crozier Technical High School in honor of a past superintendent.

Through the years, many of the city's most prominent citizens attended the school. It continued in use through the 1980s before being vacated. Today, the stately old building waits on the eastern fringes of downtown—out of place, boarded up, and stained with graffiti.

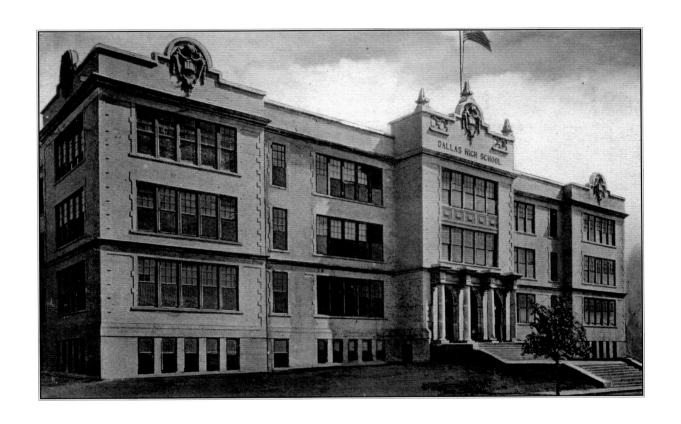

Praetorian Building

—Main and Stone Streets—

•

In Dallas around the turn of the twentieth century, any building of more than five stories was likely to be called a "skyscraper." The six-story Linz Building (1899) and the eight-story Wilson Building (1904) had already been referred to in this fashion. In 1905 when the Praetorians, a fraternal insurance society, announced plans to erect a fifteen-story Main Street building, it was a cause for curiosity and celebration.

It was also a cause for skepticism. Many locals felt that if the Texas wind did not blow the building over, it would remain largely vacant, and they wondered who would want to maintain offices in such a risky structure. In April 1905, groundbreaking took place after architect Clarence W. Bulger had drawn plans for a building with a full basement and fifteen stories above ground. Excavation for the basement and foundation progressed during the summer, but problems with construction financing soon halted the project. Fall rains turned the excavated basement into a lake. In September 1906, the steel to erect the building arrived, and in October 1907, the cornerstone was finally laid during the state fair. National economic uncertainties slowed progress on the building, but in July 1908, the city's tallest skyscraper was finally ready for rooftop visitors. At nearly two hundred feet in height, it was almost twice as tall as the Wilson Building. The attractive exterior was finished in light-colored brick and terra-

cotta, with a fifteen-foot cornice projecting from the building. The national Elks convention was in town, and the awestruck visitors were permitted to ascend to the top of the building via elevator and take in the view. It was said that visibility was good for twenty miles from that height.

Work continued on the interior finish for several months. Green Vermont marble was used for the lobby wainscoting with white Italian marble above. Large pilasters in the lobby were finished in yellow Egyptian marble. In the waning months of 1908, the Praetorians moved into their new home, and in October 1909, four-and-a-half years after ground was broken, the entire building was pronounced ready for occupancy.

During the 1909 state fair, Frank Goodale, an airship pilot, attempted the first aerial flight in Texas history. He lifted off from the fairgrounds and then steered for downtown and the new Praetorian Building at an altitude of three hundred feet. Goodale circled the skyscraper in his dirigible, and returned to his berth. The five-mile trip took fifty-one minutes, partly due to engine problems. It was thought that over one hundred thousand people witnessed the flight.

The Praetorian Building's reign as Dallas's tallest was short-lived. In 1912, the Southwestern Life Building was completed at a height of

sixteen stories, and in 1918, the American Exchange National Bank Building was built at an equally lofty height. In 1922, the twenty-nine-story Magnolia Building was completed, taking the crown for tallest skyscraper and holding the record for two decades.

By 1959, the old Praetorian Building had served for fifty years. Praetorian Life had been reorganized as a mutual life insurance company and had over $78 million of insurance in force. More space was needed. The original building's steel frame was enveloped in a larger structure of the same height, achieving twice the square footage. Architect Grayson Gill, responding to the sensibilities of the day, draped the building in porcelain steel panels of chromium yellow and white with black granite trim at the corners. During reconstruction, the original cornerstone from 1907 was opened, revealing a sealed copper box holding a cigar, a souvenir shaving mug, a 1907 newspaper, a pair of ladies' gloves, and Praetorian lodge books. In the summer of 1961, the remodeled building opened.

In 1984, a 500-pound chunk of the black granite trim fell away from the building, slamming into Stone Place Mall below. Several pieces of the material had apparently been improperly anchored during the 1959 remodeling. Fortunately, no one was hurt. The building's yellow and white color scheme disappeared in the late '80s when a graphite gray coating was applied to the porcelain steel façade.

In 1987, an eighty-year chapter in the building's history finally came to a close when the Praetorian Mutual Life Insurance Company abandoned their downtown home and moved to the suburb of Las Colinas. The old building struggled with dwindling occupancy, and finally closed in 1993. Today, as the Praetorian approaches its hundredth anniversary, it awaits conversion to downtown housing or some other useful purpose that will extend its life into a second century.

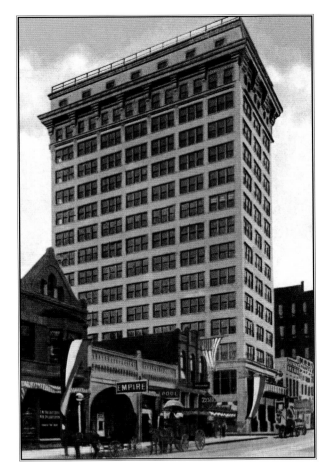

Sanger Bros. Building

—Main, Lamar, Elm, and Austin Streets—

•

Today, the city block defined by Main, Lamar, Elm, and Austin Streets houses the sprawling complex of the Dallas County Community College District's El Centro campus. A century ago, this same block housed another sprawling complex, destined to become famous as the Sanger Bros. department store.

The Sanger brothers immigrated to Texas from Bavaria in the years prior to the Civil War. In 1857, the first Sanger operation in Texas opened when Isaac Sanger established a store in McKinney, which, at that time, was larger than Dallas. His brother, Lehman, soon joined him. Other stores followed in Weatherford and Decatur over the next few years. The Sangers closed their stores when the war began and fought for the Confederacy during the next few years. Upon their return, Lehman opened a store in Millican—at that time, the northern terminus of the railroad. Isaac and Philip Sanger soon joined him. They began the process of northward expansion along the railway route in the years ahead, and opened stores in eight cities. Samuel

Sanger stayed to run the Waco store. In 1872, their youngest brother, Alexander Sanger, joined the firm.

In 1872, the railroad tracks had not quite reached Dallas, so Philip and Alexander Sanger came ahead by buggy and rented a small store on the courthouse square. At the time of their arrival in Dallas, the town had only a few establishments clustered around the courthouse. Fifteen hundred people inhabited the small village on the Trinity River. Mail arrived weekly by stagecoach. After a few months, the brothers bought a small lot on the south side of Elm Street between Lamar and Austin, and erected a one-story frame building on it. Three years later, this was replaced by a two-story brick building. In 1880, they were able to purchase the lot and building to the east of their store, at the corner of Elm and Lamar. The following year, an opportunity to secure an opening on Main Street was realized when Sanger Brothers bought the mid-block property to the rear of their original store, between the Trust Building at Main and Austin and the small businesses near the Main-Lamar

corner. They promptly erected a two-story building on this fifty-foot-wide site. In 1884, the entire Elm Street frontage fell into their hands with the purchase of three small buildings near Elm and Austin. Philip Sanger subsequently erected a six-story wholesale building there at the southeast corner of Elm and Austin.

In 1901, the twenty-year-old structure on Main Street was torn down for a new, six-story Sanger Bros. store. The lot configuration only allowed a fifty-foot storefront, so the building had to be tall and narrow. During the construction of the new building, Philip Sanger died unexpectedly at sixty-one years of age. In December 1902, his brother, Alexander, opened the new store to the public. It contained thirty-five thousand square feet within the six aboveground floors and the basement. The building was constructed of steel, brick, and terra-cotta. This was a full-fledged department store featuring silverware, china, cut glass, confectioneries, toys, and clothing for men, women, and children. It also featured a soda fountain and reading rooms. Elevators were hydraulic, powered by rooftop gravity tanks holding thousands of gallons of water. In those days, there were frequent building fires, and the Sanger Building featured the latest technology in fire safety. In the event of a fire, the older portions of the store were automatically partitioned from the newer, fireproof section by automatic shutters. Wrought iron fire shutters also closed automatically over all windows and doors while an automatic gong warned of fire. Another unique building feature involved prism glass embedded in the sidewalks, which provided natural illumination of those portions of the basement extending under the sidewalk.

The valuable corner of Main and Lamar had been owned for many years by Mr. Gouffe, one of the original French La Reunion settlers. He built his "French-style" two-story home on the corner and operated a popular restaurant on the ground floor. The home was later torn down in order to build several two-story, brick office buildings on the site. In 1903, Sanger Bros. acquired the buildings, and in 1907, they acquired the ground under the buildings, which gave them control of the entire block except for the Main-Austin corner where the Trust Building was located.

Having secured the crucial Main-Lamar corner, Alex Sanger engaged Lang & Witchell to design an eight-story structure that would adjoin his existing Main Street store. The east wall of the older store was removed in order to fuse the two

buildings together. In the spring of 1909, work got under way and was completed by the fall. The following year, the old Sanger buildings immediately to the north at the Elm-Lamar corner were razed in order to erect an exact replica of the new building just completed at Main and Lamar. When it opened in early 1911, the unified store presented a gleaming facade of white brick, terra-cotta, and glass that stretched for two hundred feet along Lamar Street and for one hundred feet along Main and Elm.

The Sanger brothers continued their tradition of innovation when they installed the South's first escalator system in their new store. The invention had been introduced only eleven years before at the 1900 Paris Exposition. Outside of the Northeast, only Chicago and St. Louis could boast of the new convenience.

The store continued its rapid growth, and in 1919, Sanger Bros. purchased the eight-story Trust Building at the southwest corner of the Sanger block. The Western Union Telegraph Co. had just vacated several floors of the building for new space in the Masonic Building on Pearl and Main Street. Sanger Bros. now owned the entire city block. In 1923, they began a complete remodeling to unite their three buildings. All executive and service offices were moved into the Trust Building, and

the remaining three quarters of floor space, including the old wholesale building, was dedicated to retail sales. Traffic was so brisk that the company was forced to erect the first high-rise parking facility in the city, on the northwest corner of Elm and Austin. The five-story garage was designed by J. A. Pitzinger. It could accommodate three hundred automobiles, eliminating the need to provide courtesy cars from two remote lots owned by the store. A filling station and a wash rack within the $100,000 garage provided important amenities for Sanger customers while they shopped.

Alex Sanger lived long enough to see these triumphs, but in the fall of 1925, he died. After his death, Clarence Linz, who was related to the family by marriage, attempted to fill the void, but inefficient management and too much family involvement sowed the seeds of financial problems. Despite $30 million in annual sales, the company struggled to produce a profit, and foundered. A year later, controlling interest in the company was sold to a St. Louis investment banking firm. The Sanger interests realized $14 million from the sale. Chester Jones, a Kansas City department store president, bought a large interest in the stores, and initially planned to assume the presidency of Sanger Bros. Instead, he sent Edward P. Simmons, one of

his executives, to run the struggling operation. In order to celebrate the reorganization, a seven-day sale took place on August 30, 1926. Four hundred temporary salespeople were added in the Dallas store alone. On the sale's opening day, an estimated one hundred thousand people swamped the store, setting a one-day Texas retail sales record.

Jones had made a sound decision in sending E. P. Simmons to Dallas. Simmons energized the operation, making needed changes and immersing himself in community activities. The Depression brought the company to its knees again, but it was strong enough to survive behind Simmons's leadership. As part of the Dallas store's diamond jubilee celebration, Simmons directed that a series of Texas history murals be painted throughout the ground floor of the store. In 1941, another change in appearance occurred when the projecting cornice was removed from the Lang & Witchell portion of the complex in a modernization scheme. Three years later, two vertical 126-foot-tall signs with eighteen-foot-high letters spelling out the Sanger name were installed at the Main-Lamar and Elm-Lamar corners of the building,. These huge signs were common in that era, and the ones on the Sanger store were the largest in downtown Dallas.

In 1951, E. P. Simmons died suddenly, creating a tremendous loss for both the company and the city. In an ironic twist, leading merchants Herbert Marcus, Sol Dreyfuss, and Arthur L. Kramer of A. Harris & Co. all died within months of Simmons. The sudden leadership void created by Simmons's death was the catalyst for the board and stockholders of Sanger Bros. to sell out to Federated Department Stores, operators of Bloomingdale's in New York and Foley's in Houston, among others. In 1957, the downtown store received a facelift in time for the centennial anniversary of the company's founding.

In 1961, Sanger's took a quantum leap forward with the acquisition of A. Harris & Co., which was based in the Kirby Building. The new company was called Sanger-Harris, and included the downtown, Highland Park, Preston Center, and Big Town locations of Sanger Bros., as well as the downtown and Oak Cliff locations of A. Harris & Co. Plans were immediately made for a huge, new downtown store occupying the entire block inside Pacific, Akard, Field, and Federal Streets. The six-level, 463,000-square-foot structure was designed by Thomas E. Stanley, who provided architectural continuity between the store and the nearby First National Bank Building that he was designing. Crafted in white Grecian marble with slender col-

umns supporting soaring arches, the storefront featured contemporary murals of imported glass mosaic tile. The colorful murals covered the entire facade above the display windows, and became a trademark of all future Sanger-Harris stores. One of the innovative engineering features in the new store was the "air curtain" door system. When the store opened each morning, the entry doors were retracted into the ceiling, and a curtain of air was forced from blowers above the door, sealing the interior from heat, cold, dirt, and insects throughout the day. The building lacked furnaces for heat, and relied on heat from lighting and shoppers to keep the store warm. In August 1965, the new building opened to the public.

The old abandoned Sanger complex on Lamar was revitalized when the newly created Dallas County Community College District (DCCCD) chose the site for a downtown campus. In 1966, the portion of the complex facing Lamar was remodeled and occupied, but during the mid-1970s, the other two buildings became the focus of the most contentious preservation fight ever witnessed in Dallas. The western half of the old Sanger block contained the two nineteenth century buildings that Sanger Bros. had owned, the 1884 wholesale building and the 1892 Trust Building. Both were prime examples of late Victorian, Romanesque architecture in Pecos red sandstone.

The structures were timeworn and promised to be expensive to repair and adapt for other uses, but both were basically sound. After consulting engineers evaluated the situation, the DCCCD decided to demolish both historic structures on the basis of cost and practicality. They soon had a fight on their hands. The battle between the junior college district and local preservationists lasted for two years and then went all the way to Austin where the Attorney General pleaded for the preservation of the buildings. In the end, the courts held for the DCCCD, and in 1977, both structures were destroyed.

After their 1965 move, Sanger-Harris continued to prosper over the next couple of decades, especially in the suburbs. In the 1970s and 1980s, the downtown store began to experience the same woes as other downtown retailers. In 1987, Federated Department Stores merged the Sanger-Harris stores into their Foley's chain, and two years later, Foley's closed their downtown store. In the early 1990s, Dallas Area Rapid Transit purchased the abandoned department store and converted it into a headquarters building. The Sanger-Harris trademark facade of mosaic tile was covered over with stucco during the renovation. Windows were also cut into the facade. Today, the only remnant of Sanger-Harris is the store logo carved into Thomas Stanley's graceful white marble columns from 1965.

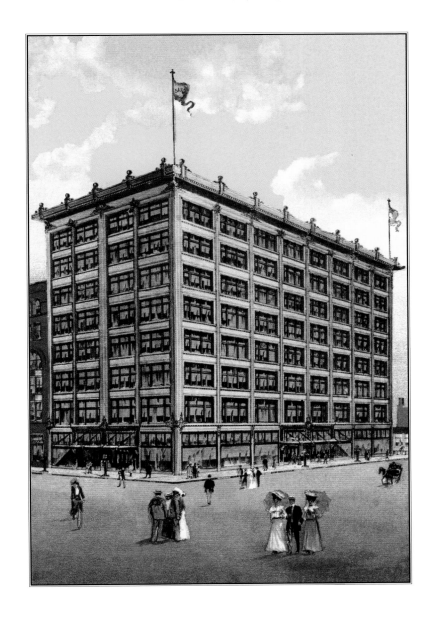

Butler Bros.

—Ervay, Young, and Marilla Streets—

The hulking, eight-story building standing diagonally across Ervay Street from City Hall was once home to one of the country's biggest wholesale firms. In Boston in 1877, Butler Brothers was founded as a small, dry goods wholesaler. The decision to promote their merchandise in a catalog rather than through traveling salesmen was fortuitous, and over the next few years, the company expanded to Chicago, New York, St. Louis, Baltimore, and Minneapolis. The concept was described as a "wholesale department store" where a country merchant could order virtually all of the merchandise needed in his store. The company catalogue boasted over thirty thousand items. By the time Butler Bros. decided to expand to Dallas, national sales had reached $80 million. Their St. Louis staff had previously handled sales to the Southwest, but growth in the region dictated a Texas location. Dallas was a natural choice. Each branch functioned like an early version of a regional merchandise mart. Sample rooms were maintained for the display of catalog items, allowing merchants to travel to market four times a year and select merchandise for their store. Between visits, all merchandise was ordered through the company catalog.

In 1906, the Dallas branch was opened after a four-story building was leased from the Schoellkopf saddlery firm. The building was located at Commerce and Lamar, and contained forty-two thousand square feet of space. Business was good in Dallas, and by June of 1910, it was necessary to build a larger facility. A lot was secured at Ervay, Young, and Marilla Streets, and then a St. Louis construction firm was chosen to design and build the facility. An eight-story building of reddish brick with a twelve-foot basement was designed, fronting 326 feet on Ervay and 165 feet on Young. The massive building contained 475,000 square feet of floor space, and over four miles of aisles. A rail siding adjoined the efficient building, and eighty-five rail cars were required to deliver the stock prior to opening in the spring of 1911.

By 1916, the Dallas branch was so successful that an annex was required. A matching eight-story addition was joined to the corner of the original building at a right angle, creating a huge, L-shaped structure. The addition fronted 340 feet on Marilla Street and added two hundred thousand square feet to the facility. In 1917, the annex was completed.

Later, the company entered the retail merchandising business when they launched Ben Franklin Stores, a franchised variety chain supplied by Butler Bros. As national demographics changed and rural merchants began to disappear, the Butler Bros. catalog concept became less viable. In 1951, the company sold their historic building to a Dallas realtor and then downsized into two hundred thousand

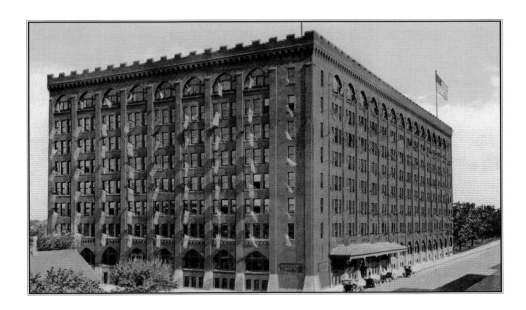

square feet of the old facility. A few years later, Butler Bros. sold their retail stores. The remainder of the building was modernized and converted for multi-tenant market use. Reopened in 1953 as the Merchandise Mart, the building at 500 S. Ervay was the forerunner to the massive Dallas Market Center on Stemmons Freeway. The building was configured into individual showrooms with large plate-glass windows for the display of housewares, gift items, appliances, furniture, and apparel.

Charles Sammons of Reserve Life Insurance soon took over ownership of the building, waging a spirited battle to retain tenants against encroachments from Trammell Crow's new Dallas Market Center. Sammons lost the battle against the larger, newer, and specialized facility that was free from downtown congestion. In the 1970s, the structure was converted to general office use and covered with a light, concrete-stucco finish. With its proximity to the new city hall, the building was a natural and reasonably priced location for various city departments and private tenants.

In 1994, Sammons Enterprises donated the building to the city. The city was not quite sure what to do with such a large building and considered moving the Dallas Police Department out of the old Municipal Building and into 500 S. Ervay. In the end, the plan was rejected, and the building continued to house a small number of tenants, awaiting better days. In 2006, plans were under way to convert the facility to downtown housing.

Katy Building

—Commerce and Market Streets—

•

In the days before auto and air travel largely superseded rail passenger travel, railroads were a tremendously powerful presence in many American cities. In 1893, the Missouri, Kansas, and Texas Railway Company (M. K. & T.) organized and established its first Texas offices in Denison. In 1895, M. K. & T. management realized that Dallas was becoming the nexus of North Texas commerce, and they moved their offices to Dallas. Space was taken in the Gaston Building until 1898 when the Linz Building was erected. The M. K. & T., or "Katy" (from the last two letters of the railroad name), occupied two full floors in the new building and maintained city ticket offices on the ground floor. As the company expanded, it began to outgrow the available space in the Linz Building and began searching for a larger headquarters.

In 1911, Colonel John N. Simpson announced the construction of a speculative, seven-story building at the corner of Commerce and Market. The M. K. & T. agreed to take five floors in the proposed building. The architect chosen was H. A. Overbeck, who had also collaborated on the design of the Linz Building. Overbeck designed a reinforced concrete structure that was finished with reddish-black face brick and elaborate terra-cotta ornamentation. Soon after the plans were announced, M. K. & T. management decided to buy the building from Colonel Simpson, and then complete it under their auspices.

In the fall of 1911, construction got under way, and in September 1912, it was completed. The railroad had invested $400,000 in the finished building. It was said to be the most elaborate and expensive railroad headquarters south of St. Louis. Railway officials later admitted that they would never have designed such a fine structure for their own use. The lobby featured a white-tiled floor inlaid with the Katy monogram. Lobby walls, pilasters, and ceiling beams were finished in Georgia marble. Coffered ceilings with dentil molding added to the lobby's elegant appearance. At the rear of the lobby, a marble stairway with a cast-iron balustrade led to the second floor.

In the early 1930s, the building was remodeled once, and for several decades, continued to house the general offices of the Katy Railroad. By the 1970s, the railroad's presence in the building had dwindled to two floors. In 1977, the railroad decided to undertake a $1.2 million, ten-month renovation of their landmark home. Thomas E. Woodward & Associates was the architectural firm responsible for the respectful adaptive reuse of the old headquarters. The exterior details and building lobby, including the original monogrammed floor, were carefully preserved. They adapted most of the building to multiple-tenant configuration. Mechanical systems were completely updated. Today, the Katy Building is well suited to the many small law firms and other companies that it houses. In 1989, the Katy Railroad was absorbed into the Missouri Pacific, or "MoPac" line.

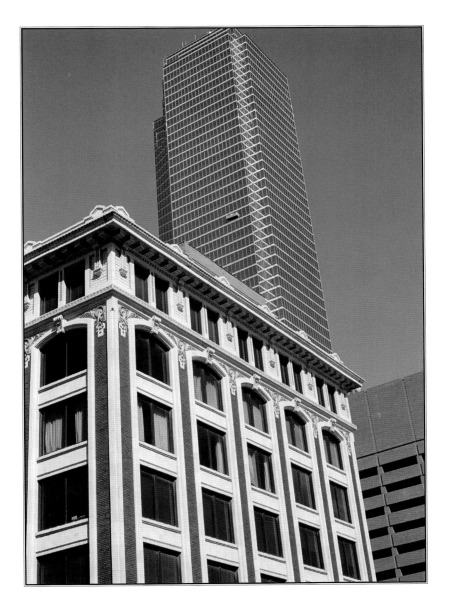

Southwestern Life Building

—Main and Akard Streets—

●

For most of the twentieth century, Dallas was the titan of the Southwestern insurance industry. Many home-grown companies grew to regional or national prominence, not least of which was Southwestern Life Insurance. Organized in 1903, the company counted Sam Cochran, Alex Sanger, Edward Titche, E. O. Tenison, and J. B. Wilson among its founders.

The company grew rapidly, and plans were laid in 1910 for a new headquarters building of sixteen stories and a basement on the southeast corner of Main and Akard. In the largest real estate transaction in Dallas history, $300,000 was paid for the prime corner property. Otto Lang was retained as architect, and in early 1911, excavations began.

Lang designed a steel-framed building with a semi-glazed terra-cotta base extending to the fourth floor, and reddish-brown brick from the fourth through the fifteenth floors. A richly ornamented terra-cotta finish was used on the top two floors, surmounted by a heavy cornice. The ground floor was reserved for retail shops and featured display windows on Main and Akard Streets. The elevator lobby was finished in sienna marble with polychromatic inlays and a green antique marble base and cap. The lobby was floored with mosaic tiles. The vaulted ceiling was highly ornamented, and the elevator enclosures were finished in bronze and closed off with wire glass. All floor corridors were wainscoted in Georgia marble. In late 1912, the new building opened.

Southwestern Life operated from this location for the next five decades. In 1946, Grayson Gill designed a four-story addition adjoining the east side of the building, providing retail space, a cafeteria, and an assembly room. By 1960, the company had over seven hundred employees, and over $3 billion of insurance in force. It was occupying almost ninety thousand square feet in the Main Street building, and it needed more. A site was purchased on Ross Avenue at Akard, and then a new, low-rise, white marble and glass structure was erected that gave the growing company over three hundred thou-

sand square feet. The grounds were lavishly landscaped with trees, walkways, pools, and cascading waterfalls. In 1964, the company occupied the structure and remained there for two decades before moving to the new Lincoln Plaza Building in the 1980s.

In 1965, Bill Clements, an oil man and future governor, purchased the old Main Street building. It soldiered on for a few years, but in December 1971, the few tenants remaining were given notice to vacate. By the fall of 1972, the historic building was just a memory. The vacant space was used as a parking lot for several years before being turned into Pegasus Plaza in the early '90s.

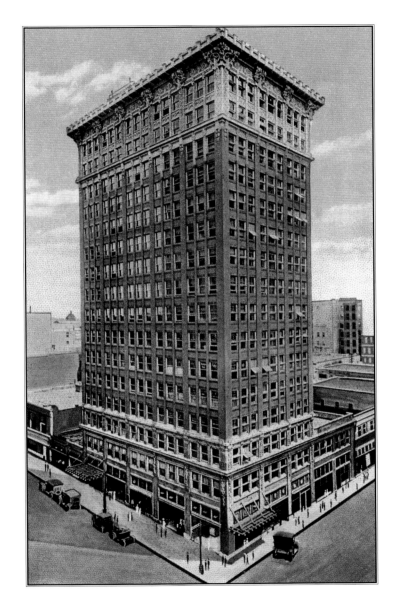

First Church of Christ, Scientist

—Cadiz and Browder Streets—

●

Mary Baker Eddy founded the "Christian Science" denomination in New England after the Civil War, and it drew both converts and critics through its advocacy of metaphysical healing. In the early 1890s, the controversial, new practice of Christian Science arrived in Dallas when John J. Plunkett, a church lecturer from New York, moved to Dallas. Christian Science churches were also novel due to their reliance on "readers," who read to the congregation from official church tracts, rather than relying on ordained ministers to deliver prepared sermons. One of the earliest local adherents to the new movement was Sam P. Cochran, a prominent Dallas businessman and Masonic leader. His wife became the first reader in the Dallas church.

After a few years, the Dallas congregation erected a small church on South Ervay Street, on the site where Butler Bros. stood a few years later. In 1889, the church was completed. Growth in the congregation coupled with the arrival of the Butler Bros. wholesale firm presented an opportunity for the church to sell its building and construct a larger facility. Under Cochran's leadership, a site was chosen at the intersection of Cadiz and Browder Streets. The architectural firm of Hubbell & Greene was selected to design the structure. An attempt was made to remain faithful to the Christian Science "mother church" in Boston. The attractive, neoclassical facade of buff brick and stone faced Browder Street. It featured Ionic columns and a prominent metal dome. An eighteen-foot-wide foyer led into a sanctuary seating nine hundred worshippers, although at the time of construction, the church could count only 172 members. The sanctuary was equipped with a Hook and Hastings organ and beautifully decorated with stained glass. A basement provided space for Sunday school rooms. In August 1910, the cornerstone was laid, and in January 1912, the first service was held.

The church served the congregation for decades, but through the years, the surrounding area deteriorated, and the congregation dwindled. By the 1990s, the building was in dire shape. Despite efforts to shore up the aging structure, it had suffered terribly from moisture, vandalism, and decay. The roof was partially collapsed and had been suspended to prevent further destruction. In 1999, developer Herschel Weisfeld noticed the building and instantly fell in love with it. Despite the formidable nature of the renovation challenges, Weisfeld was determined to save the beautiful structure, and he forged ahead. Beginning in February 2000, every inch of the grand building was put in order before it reopened as a performing arts center and multiuse rental facility. Weisfeld named the center in honor of his parents.

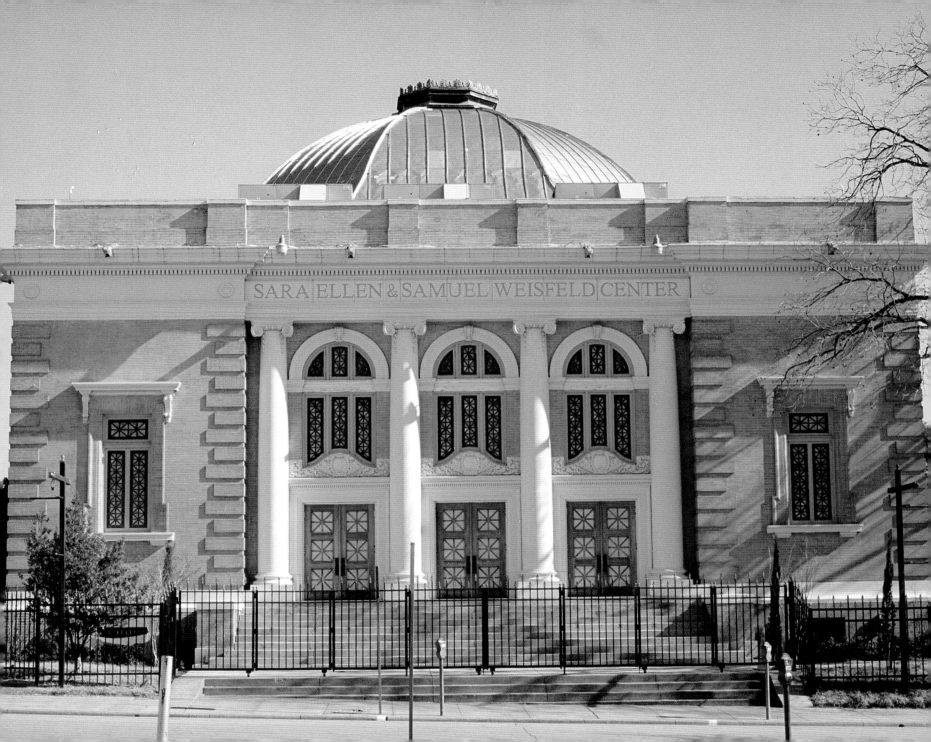

SARA ELLEN & SAMUEL WEISFELD CENTER

Fidelity Building

—Main and Poydras Streets—

•

In 1912, the Commonwealth National Bank erected a twelve-story building close on the heels of the new South-western Life Building. The $600,000 building stood at the southeast corner of Main and Poydras, adjacent to Griffin St. On January 2, 1913, the bank opened for business in its new quarters.

The first visitors found a lobby wainscoted in white marble with red marble baseboards. A white marble stairway with green marble inlays led to the mezzanine floor where the safety deposit vault and directors' room were located. The bank occupied the entire ground floor and featured brass teller cages, marble fittings, electric fans, and radiators common to that era.

The bank later became the Security National Bank and then was absorbed by Southwest National Bank. In 1925, Fidelity Union Insurance bought the building and established offices there. For the remainder of its existence, the structure was known as the Fidelity Building. During the 1930s, Noah

Roark, an attorney known for his fiery rhetoric and quick temper, was one of the building tenants. In 1933, Roark shot and killed the building manager and wounded his secretary in a rent dispute. During World War II, the entire building was occupied by various governmental agencies.

During the late forties, the building was modernized and air-conditioned, and plans were made to convert it into an apparel mart. That never materialized, and in 1951, the International Fidelity Insurance Company took over the building.

The historic old building survived until 1969 when it was demolished by explosives to make way for a planned Two Main Place project that was never built. The site is now a parking lot.

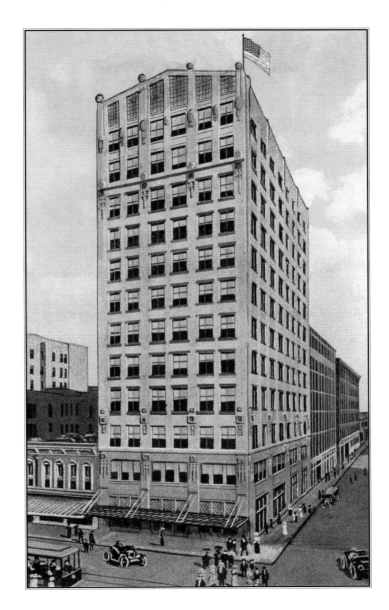

Adolphus Hotel

—Commerce and Akard Streets—

•

The Adolphus, grande dame of Dallas hotels, was the creation of Adolphus Busch, a German immigrant and St. Louis beer baron. Busch already owned the Oriental Hotel, an 1892 structure on the southeast corner of Commerce and Akard. By 1910, Dallas had outgrown its 1888 City Hall on the northwest side of the intersection, and the city wanted both a new municipal building and a fine hotel to represent their growth. City leaders approached Busch about creating a luxury hotel on the site of the existing City Hall. Busch agreed, and then announced plans for a million-dollar hotel at Commerce and Akard.

In late 1910, demolition and construction got started. Barnett, Haynes, & Barnett of St. Louis was chosen to design the opulent building. A baroque masterpiece was created, unlike anything standing in relatively unsophisticated Dallas. The original plan was to call the hotel the New Oriental, but it eventually became the Adolphus, named in honor of the owner.

The proposed building was to be twenty stories in the Louis XIV style of red velvet brick and gray Bedford stone. Red granite would clad the first floor. The upper portion of the building was ornamented with a decorative cornice. It was surmounted by an attic and a French mansard roof of variegated slate. The southeast corner of the roof featured a turret with a minaret for the American flag. Large bronze figures from Roman mythology that signified night and morning were placed above the fifteenth-story pediment. The lobby was to be paneled in Circassian walnut and gold. A large dining and dance hall known as the "Palm Garden" graced the top floor of the hotel. It featured a domed ceiling, incredible views of the city through huge windows, and a mezzanine for the orchestra. No expense was spared in creating the new structure. Over $1.5 million was eventually spent, with an opening projected for September 1911.

It took a little longer than planned. In December 1911, the cornerstone was laid, and in October 1912, the building opened to the public. The Adolphus was an immediate success, and by 1916, additional rooms were needed. Construction was undertaken on a twelve-story, U-shaped annex to the west of the original hotel. The architecture by Lang & Witchell was an acceptable match with the original tower, and it gave the enlarged hotel over five hundred rooms. A fifteen-foot passageway connected the annex

to the rear of the main hotel that was fifty feet away. This western annex to the hotel was known for many years as the "Junior Adolphus." It featured a rooftop open-air restaurant known as "Bambooland" because it was decorated with bamboo walls and oriental furnishings. On New Year's Day 1918, the grand opening took place. During the early 1920s, a massive, rotating searchlight was placed atop the hotel for promotional purposes.

By 1924, another expansion was needed. Alfred C. Bossom, an English architect fresh from his work on the Magnolia Building, was called upon to design the twenty-two-story, million-dollar structure to the left rear of the original tower. Once again, an attempt was made to harmonize with the existing architecture. The same dark red brick and Bedford stone exterior materials were used. This addition became known as Adolphus III, and it added 325 rooms to the hotel, making it the largest in the state at 825 rooms. Small buildings between the original tower and the Adolphus Junior were razed, allowing for the construction of a three-story main lobby, entered from Commerce Street and extending back to the Adolphus III, which unified all portions of the hotel. A grand arcade entrance was built on Main Street connecting the lobby all the way through from the main hotel entrance on Commerce. In April 1926 when the grand opening was held, thousands of Dallas residents crowded the hotel lobby areas. Adolphus Busch Jr. traveled from St. Louis, and a fireworks demonstration was staged on the roof of the Adolphus III.

In 1936, the city of Dallas engaged in a building and refurbishing spree for the Texas Centennial Exposition, and the Adolphus was no exception. A half-million dollar improvement program was initiated, and a new nightclub called the "Century Room" was built. The walls were made of translucent glass. Indirect lighting was utilized, and a blue mirrored disc was suspended above the dance floor. Terraced seating for 550 diners surrounded the dance floor. In June 1936, when President Roosevelt attended the Centennial festivities, he and Mrs. Roosevelt stayed at the Adolphus. The president was the guest of honor at a luncheon in the Century Room. During the big band era, Glenn Miller, Benny Goodman, and Jimmy Dorsey played there. Dorothy Franey Langkop, a two-time Olympic gold medal speed skater, performed from 1943 to 1957, one of the venue's longest-running acts. The skaters performed on a twenty-foot by twenty-four-foot ice sheet. This famous room hosted hundreds of memorable events through the years, and continued in operation for decades.

In 1949, Leo F. Corrigan, a Dallas real estate mogul, purchased the Dallas Hotel Company, the Adolphus' parent company. In 1950, Corrigan planned for an immediate expansion and modernization of the old hotel. Approximately $2.5 million was invested in air-conditioning upgrades, elevator replacements, remodeling, and

refurnishing. A modern, twenty-four-story tower was designed by Wyatt C. Hedrick above the Main Street entrance to the property, connecting through to the rest of the facility. The new tower was not architecturally compatible with the older buildings, but it was not visible from the Commerce Street face of the hotel. The expansion added 520 rooms, making the 1,370-room final product one of the largest in the country. Sixteen-foot-high neon letters topped the new tower, spelling out the Adolphus brand for miles to the east and west.

By 1980, the hotel was in need of a major facelift and was closed for remodeling. Approximately $60 million was spent on a major renovation of interior and exterior spaces. The main tower was carefully restored, and the later additions to the original tower were unified with false fronts and a stucco finish, giving the huge structure a more cohesive appearance. An original and enduring feature of the hotel, the French Room, was completely restored. The ceiling of the baroque dining room was painted with cherubs, clouds, and beer hops, in honor of the hotel's founder. In 1981, the restored hotel opened to rave reviews. Today, it continues to be an essential part of downtown Dallas. Through the years, the Adolphus has hosted countless famous celebrities. Queen Elizabeth and Prince Philip, Presidents Carter, Reagan, George H.W. Bush, and numerous other luminaries have stayed under her roof.

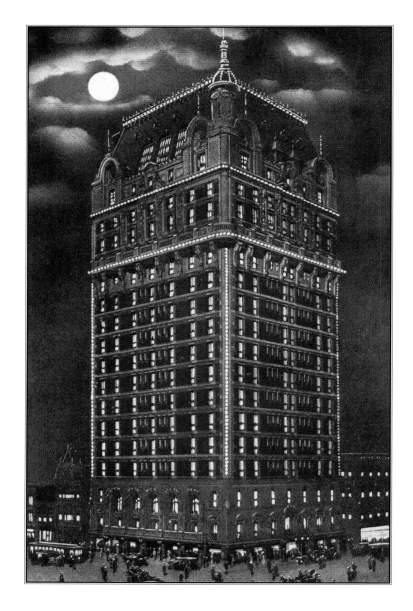

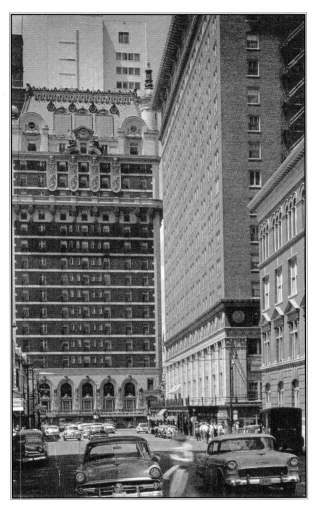

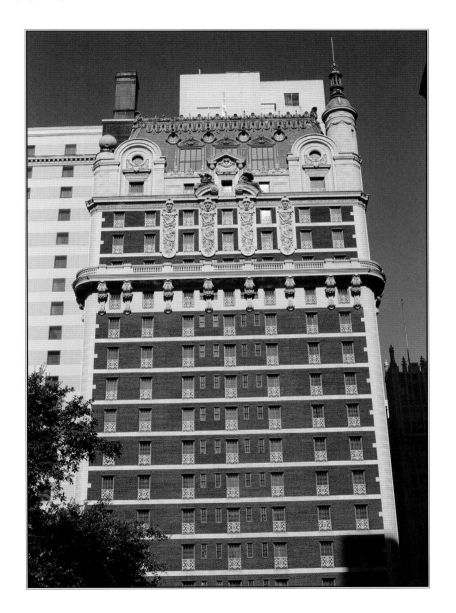

Above: *Mid-1950s view of Akard Street showing the Adolphus Hotel (left), the Baker Hotel (center) and the Telephone Building (right). The Telephone Building was razed in 1961.*

Right: *The Adolphus Hotel today.*

Kirby Building

—Main and Akard Streets.—

•

Shortly before finishing work on the nearby Adolphus Hotel, the Busch interests began work on a companion office building to be known as the Busch building. The Southern Hotel, a structure built in 1889, was razed to make way for the new building. The new building was planned to be sixteen stories, and was designed to get its heat and electrical power via an underground passageway from the Adolphus. Work crews were transferred from the hotel site to begin the construction, and in August 1912, work got under way.

The design chosen by the Barnett firm was "continental Gothic," and the materials used were terra-cotta granite panels with a pink granite base, elaborate interior furnishings, and marble flooring and wainscoting.

By April, 1913, an underground utility tunnel between the Adolphus and the Busch building had been cut from solid rock and walled with cement. A crew of twenty-five men worked for two weeks with picks, shovels, and dynamite to complete the task, and when it was finished, the tunnel was tall enough to walk through.

The A. Harris & Co. department store became the anchor ten-ant, leasing the basement and first five floors of the building. Adolphus Busch did not live to see the November opening of the new building. The seventy-one-year-old died in Germany on October 10, 1913. Flags were lowered to half-mast on the Adolphus and Oriental Hotels, and their offices were closed and draped in black.

The finished product was seventeen stories plus a basement, and was an immediate success. A. Harris & Co. operated from this location for over five decades. In 1918, the Busch interests turned a quick profit when the million-dollar building was sold to the Great Southern Life Co. of Houston for $1.6 million. Great Southern Life contemplated relocating their headquarters to Dallas, but eventually settled for moving only certain parts of their operation. Less than two years later, the Kirby Investment Co. of Houston bought the building for $2.2 million, and in 1922, the name was changed to the Kirby Building.

By 1962, when A. Harris & Co. merged with Sanger Bros., the building was old and dated. The classic features that gave the building its character were offset by certain problems related to its 1912 construction. Women's restrooms were on every

fourth floor, and other building codes had changed. In 1965, A. Harris & Co. moved out, leaving a great deal of vacant space. In 1970, the building was remodeled and modernized. The ground floor was recessed, and the interiors were brightened. Steps were taken to bring the building up to code. An unfortunate "tree" mural was painted around the U-shaped, rear sky well. Fortunately, the building was largely preserved, and minimal changes were made to the exterior, lobby, and interior floors.

The Kirby struggled for two more decades to hold its own against the newer downtown towers being erected. In 1983, Craig Hall, a real estate developer, indulged a love affair with the building that led him to buy it, but unfortunately it was at the top of an overheated market. He attempted to market the property, but by 1992, the occupancy was at 11 percent. He was forced to shutter the largely vacant building, but he remained determined to save it. The slow emergence of a downtown housing trend gave him an opportunity. Hall and his wife pioneered the in-town housing concept in Dallas when they completely renovated, modernized, and converted the property to urban residences. Once again, the beautiful lobby and interiors were largely preserved. A rooftop pool was added. An upscale restaurant leased most of the ground floor. As the twenty-first century dawned, the Kirby building approached her ninetieth birthday with renewed life.

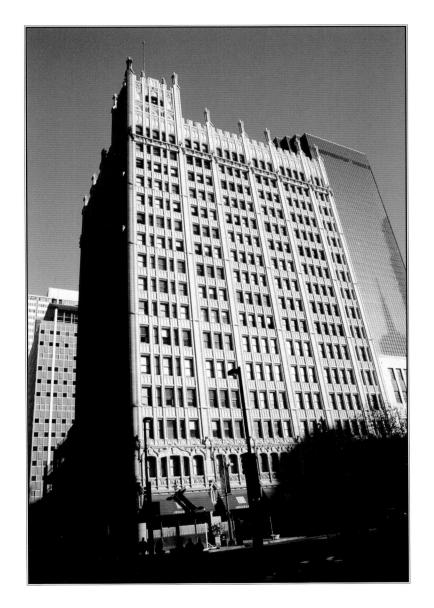

A. Harris & Company/Kirby Building

—Main and Akard Streets—

•

Like the Sanger brothers, the founder of A. Harris & Co. was a German immigrant. In the 1850s, Adolph Harris left his native Prussia as a boy and found his way to San Antonio. During the Civil War, he served for the Confederacy in a company of Texas volunteers. Afterwards, he learned the dry goods business in Houston before moving on to Dallas in 1887. In 1892, Harris formed a dry goods partnership with two other merchants, and then he bought them out. He moved his store to the busy corner of Elm and Murphy, northwest of the City National Bank.

By 1912, Harris desperately needed financial expertise. He brought Arthur Kramer, an attorney and Harris's son-in-law, into the business. The timing was propitious. Later that year, during his annual New York buying trip, the sixty-nine-year-old Harris succumbed to a heart attack. Kramer immediately became president of the bankrupt company, while Harris's son, Leon, became Vice President. Kramer immersed himself in reorganizing the business, paying off creditors, and forging ahead with growth plans, while young Harris focused on merchandising.

In November 1913, when the new Busch Building was completed, A. Harris & Co. was its first tenant, occupying five floors. Thousands attended the grand opening of the elegant new store, which featured an interior finish of white marble, bronze, mahogany, and beveled mirrors. The firm's crest was prominently woven throughout the carpeting. Like other fine department stores of that era, A. Harris & Co. provided ladies lounges where dressing tables, couches, stationery, and writing instruments were available. An elegant third-floor French salon displayed evening wear and millinery. A concierge desk dispensed city and store information to visitors. Other shoppers took advantage of an on-site post office, ticket office, telephone/telegraph office, and luggage checking station.

The new store was a sensation, and A. Harris & Co. never looked back. The store prospered in this location for nearly fifty years until 1961 when Sanger Bros. acquired it. In 1925, Lang & Witchell designed a $75,000 six-story annex on the

rear of the store, providing much-needed floor space and an Elm Street entrance. Five years later, an additional annex was erected on Main Street, adjoining the Kirby (formerly Busch) Building on the east. Also designed by Lang & Witchell, this five-story, $100,000 structure provided only twenty-five feet of additional frontage for the growing store. A. Harris & Co initially leased the ground floor to Philipson's, a ladies-wear merchant, but by 1935, the space was taken over for the A. Harris & Co. men's shop. That same year, Leon Harris passed away on his forty-ninth birthday. In a bizarre coincidence, Harris died of a heart attack during a New York buying trip, just like his father.

During the post–World War II years, the store continued to prosper and expand around its nucleus at Main, Elm, and Akard. Then in 1950, while on a vacation in California, Arthur Kramer died of a heart attack. He had led the store for nearly forty years. The leadership of the store was quickly passed to Arthur L. Kramer Jr., his twenty-eight-year-old son. Arthur Jr. was young but well-educated, and he had already served in the Army Air Force during the war. He had also apprenticed in the store for four years. In 1954 while under his presidency, the store opened its first suburban location.

The 1961 acquisition of A. Harris & Co. by Sanger Bros. marked the end of an era. Within a few years, the combined Sanger-Harris vacated both their historic Lamar Street store and the former A. Harris & Co. corner at Main, Akard, and Elm. In August 1965, when they moved to the glitzy new Pacific Street location, decades of memories began to fade.

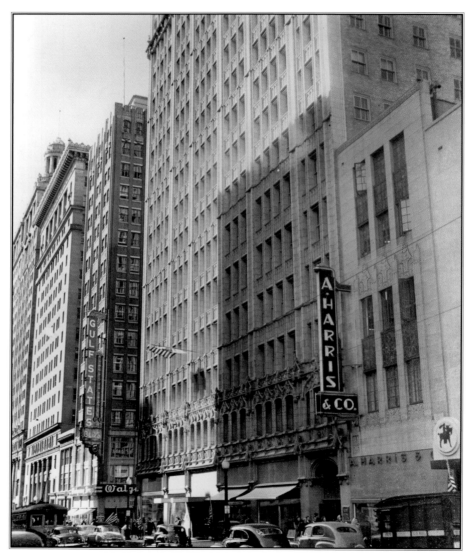

A. Harris & Co., Main Street, c. 1950.

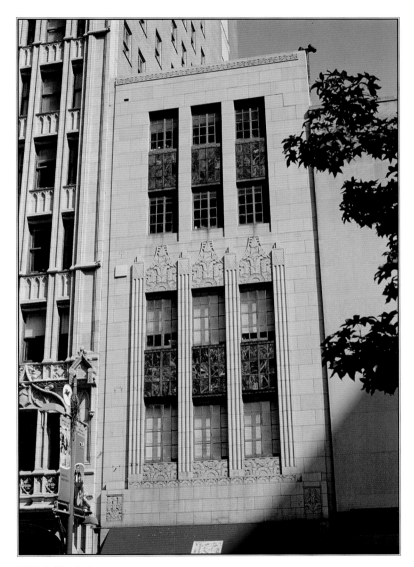

1930 A. Harris Annex.

Scottish Rite Cathedral

—500 S. Harwood Street—

•

Standing on the southeastern edge of downtown Dallas near the First Presbyterian Church is a neoclassical gem about to celebrate the one hundredth anniversary of its construction. On March 21, 1907, the Masonic order of Dallas laid the cornerstone for their Scottish Rite Cathedral. Into the cornerstone went a variety of ceremonial objects, some customary and some unusual. They deposited various Masonic documents and mementos, a copy of the *Stonecutters' Journal*, a March 21 copy of the *Dallas Morning News*, a thirty-third degree Masonic gold ring, various silver and foreign coins, a railway pass, a dollar bill, an indelible pencil, photos, letters, a Russian newspaper, a measuring tape, bottles of wine, and a corkscrew.

The planned building was the third-largest Masonic facility in the United States.

Herbert M. Greene designed a grand, beaux-arts temple fronting 144 feet along its prominent Harwood Street location. The structure had two stories and a basement and featured a Corinthian facade with a magnificent portico fronted by six massive stone columns.

The exterior was faced with taupe brick and buff-colored Stamford limestone. A flight of stone steps, fifty-eight feet in width, led up to the large portico. The six, Corinthian-styled limestone columns supporting the portico roof were over thirty feet tall and three feet in diameter. They were quarried in Bedford, Indiana, and carefully hand-fluted by master stonecutters, who rejected half of the stones because of imperfections. Richly carved Corinthian capitals topped each column. A double-headed eagle was inlaid in mosaic tiles on the portico floor directly in front of the main entrance doors. A stone balustrade ran along the top of the portico, with a seven-foot, double-headed stone eagle in the center. A terra-cotta cornice ran along the front and both sides of the building.

A visitor passing the triple-entry doors and the vestibule encountered the Statuary Hall, wainscoted in veined white

marble and floored with inlaid white tile. Veined marble pilasters supported a ceiling bordered and paneled with Doric beams and cornices. Directly across Statuary Hall stood the largest banquet facility in the South or Southwest, capable of seating eleven hundred guests. This was the Crystal Banquet Room. Decorated in Louis XVI style, the room featured ornate columns supporting a ceiling of highly ornamental beams and panels twenty feet square. Crystal chandeliers provided "shower" lighting from the corners of each panel. Beautifully polished hardwood floors and one thousand Birchwood chairs lining the walls completed the rich effect. It was the most beautiful room in the building.

The first floor also contained a ladies' parlor, and a library finished in modified Gothic style. The library featured quatrefoil plaster ceiling moldings and eight-foot-high wall panels of cathedral oak. Glass-fronted oak bookcases lined the perimeter, and a reading area with Gothic tables and leather armchairs surrounded the tiled fireplace. The woodwork and plasterwork in this room were outstanding. A secretary's office, billiard room, and social room adjoined the library.

Two flights of marble and bronze stairs lined the sides of the entry hall, joining at a halfway platform and continu-ing as one, ten-foot-wide stairway to the second floor. A marble lobby in Ionic style waited at the top of the stairs. Directly across from the stair landing was the degree room, or auditorium. This room had thirty-foot ceilings and was designed to comfortably seat up to three hundred Masons when degrees were conferred in special ceremonies. The auditorium design was taken from the Temple of Karnak at Thebes. Large columns and beams profusely illustrated with Egyptian themes divided the deep blue ceiling into five panels. The constellations of the zodiac and the planets of the solar system were accurately represented on the ceiling by gold paint or ground glass apertures that opened into the attic above. A system of small lights was placed in the attic so that when the room was plunged into total darkness, the ceiling twinkled like the heavens. It made for quite an effect. The auditorium stage was the largest in Texas, and the $25,000 pipe organ was the largest in America. A shut-tered choir room off the balcony allowed for discreet, vocal accompaniment.

Also located on the second floor were the spacious lodge room and the candidates' lounging room. The lodge room, or green room, featured high-relief, richly ornamented plaster ceiling molds, and magnificent birch woodwork.

The green color theme was used for the curtains, rugs, and leather-trimmed furniture. Raised platforms seated the lodge officers. Across the lobby, the candidates' lounging room, or blue room, was finished with mahogany woodwork and wall panels of Spanish leather. Curtains, rugs, and furniture were deep blue in color.

The basement housed a large kitchen, a grill room, and a double bowling alley as well as facilities for checking up to twelve hundred hats and coats. The finished cost of the magnificent facility was $250,000 for the building and another $100,000 in equipment and furnishings. In April 1913, the building was ready for use.

Today, the well-maintained Cathedral still receives regular use for Masonic activities, and the magnificent Crystal Ballroom is available for wedding receptions and other functions.

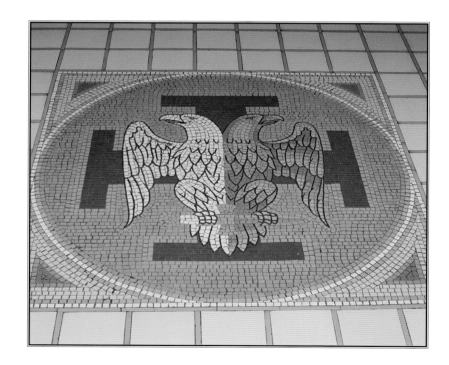

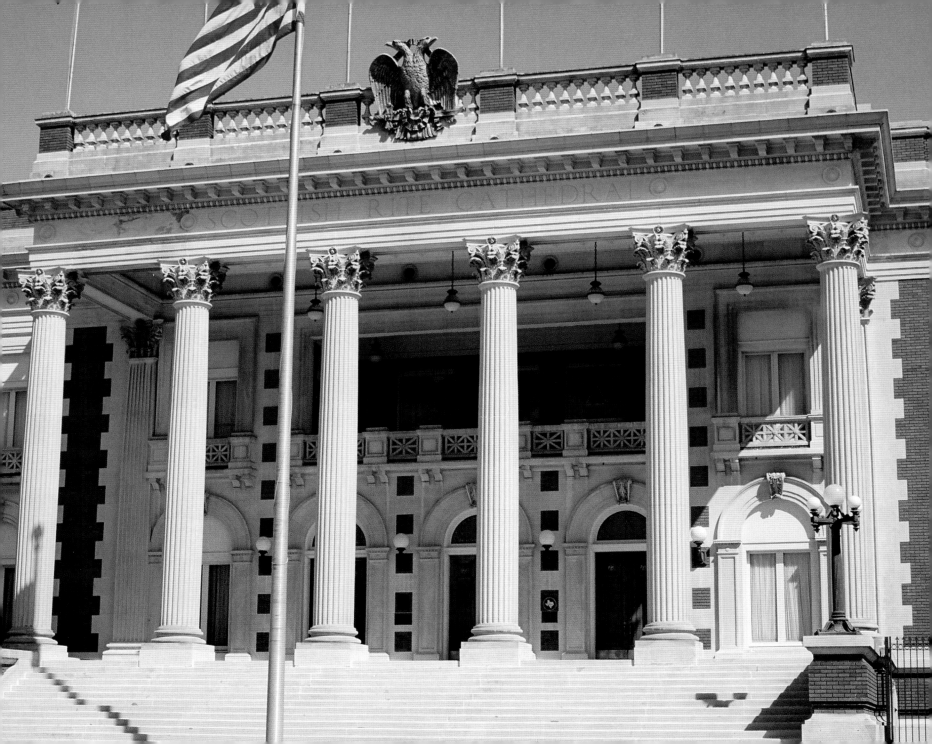

First Presbyterian Church

—Harwood and Wood Streets—

•

In February 2006, the congregation of First Presbyterian Church celebrated their 150-year anniversary. Founded in 1856, the church began with only eleven members and lacked a formal place of worship, meeting in private homes and various businesses. In 1873, the congregation was able to erect a small frame church at Elm and Ervay, but the structure was soon outgrown. In 1880, a second church was built at the northeast corner of Main and Harwood. There, the congregation erected the first brick church in Dallas, which would serve for the next seventeen years before being remodeled into a much grander structure. A three-story Victorian red brick structure with Romanesque elements was designed. It featured a triple-arched entrance, turreted corner, a prominent bell tower and steeple, and beautiful stained-glass windows. It was one of the most imposing structures in the city. The new church was the vision of A. P. Smith, their longtime pastor, but he never lived to see it. In 1895, A. P. Smith passed away after leading the congregation for twenty-two years. Dr. William M. Anderson quickly succeeded him and then continued planning for the new church. In May 1897, construction began with the new building being occupied the following November. Several prominent citizens were in the congregation, including bankers E. O. Tenison and R. H. Stewart, realtor Charles Bolanz, and many others.

In 1901, Dr. Anderson left Dallas for a Nashville church, but then in 1910, he returned to the pastorate of First Presbyterian. By this time, plans were well under way for a new church building on Harwood and Wood streets, several blocks south of the present structure. Architect C. D. Hill was commissioned to design the building, which was expected to cost around $135,000. Hill created a beautiful neoclassical temple of Bedford, Indiana, limestone and terra-cotta, with an imposing central dome covered in green glazed tile. Twin Corinthian entrances faced Harwood and Wood streets with wide steps leading up to grand porticos featuring massive limestone columns. Each of the eight columns was twenty-four feet high and nearly three feet in diameter. They weighed over sixteen tons and required their own flatcar for shipment. A huge derrick handled the installation.

In the early months of 1911, work got under way, with completion expected one year later. Unexpected problems with deliveries of materials delayed the opening until February 1913, but the new church was undoubtedly magnificent. The beautifully decorated, fan-shaped sanctuary was capable of seating twelve hundred between the main floor and balconies, and capacity could be expanded to more than fifteen hundred. The sanctuary was also graced by a large pipe organ. The basement contained a banquet

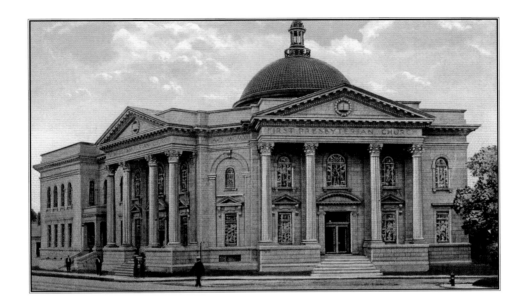

room and large kitchen. The previous church home on Main and Harwood had been purchased by Sam Cochran, who intended to erect a small office building on the site. The historic structure survived until 1918 when it was razed.

In 1916, Dr. Anderson began experiencing problems with paralysis, so his son, William Jr., was called to First Presbyterian from another Dallas church to assume the junior pastorate. Upon his father's death in 1924, the younger Anderson assumed the senior pastorate of the church. In 1927, a four-story Sunday school building was added to adjoin the church. In 1935, William Jr. succumbed to a heart attack at only forty-six years of age. He had been an extremely

popular minister and civic leader, so the church carefully considered his replacement. At the beginning of 1936, Dr. Frank C. Brown was called from a church in West Virginia. He led First Presbyterian through the mid-century mark. Dr. Brown delivered the invocation at President Roosevelt's unveiling of the Robert E. Lee Memorial in Lee Park.

Since that time, First Presbyterian Church has continued to grow and expand its ministries in downtown Dallas. The church has taken a lead position in programs for the poor and homeless with its Stewpot ministry for street people.

Sumpter Building

—1604 Main Street—

•

Across from the old Praetorian Building on Main Street is a derelict office building with a prime location and limestone facade that hints at a more dignified past. The rusting window frames and grimy stonework do not do justice to the structure's rich history.

In 1880, Guy Sumpter, a young Tennessean, immigrated to Texas. Only twenty-six years of age, Sumpter knew that Dallas was a place where fortunes could be made. He entered the banking and real estate businesses and quickly prospered. By the turn of the century, Sumpter was a wealthy man. He began to scale back his business activities. Toward the close of 1911, Sumpter announced that he would spend part of his fortune on the erection of a new office building on the south side of Main Street, just east of Stone.

The Sumpter Building was eight stories tall with a full basement, and it utilized the latest fireproof concrete construction methods. C. D. Hill was chosen to design the structure, which utilized buff face brick and ivory terra-cotta. The entrance featured a copper marquise overhead, and the lobby was decorated in Italian marble. Each floor featured a fireproof vault for tenant use. In January 1913, the new building was completed.

In 1920, Sumpter sold the building to Central State Bank. Two years later, the bank took occupancy of the basement and ground floor. It was only four years later that the bank, now known as Central National Bank, was acquired by the North Texas National Bank. The bank space in the Sumpter Building was soon vacated.

In 1935, Great National Life Insurance purchased the building as a corporate headquarters and commissioned Mark Lemmon and Grayson Gill to remodel the structure. Approximately $250,000 was spent in modernizing and updating the building, including the removal of the large vaults on each floor. The facade was sheathed in limestone, and the interior was completely remodeled.

In 1952, E. M. Kahn opened their swank new uptown store in six thousand square feet of the basement, ground floor, and mezzanine of the building. In 1968, this location replaced the

old E. M. Kahn store when the original was razed to make way for the Main Place development.

Great National Life operated from their Main Street location for nearly three decades before relocating to Harry Hines Boulevard in 1963. The old Sumpter Building lapsed into long-term vacancy with only street-level retail space being utilized by E. M. Kahn and Zale's Jewelers. Today, the forlorn property's location is in the eye of a great deal of redevelopment activity, which suggests that a possible rescue may be on the horizon.

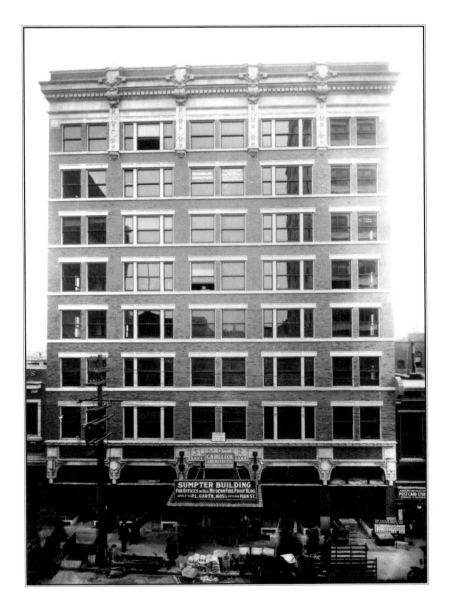

Municipal Building

—Main, Commerce, and Harwood Streets—

•

By 1910, fast-growing Dallas was in need of a larger City Hall. The previous structure at Commerce, Sycamore, and Akard had been completed in 1889 and was no longer sufficient for a city of ninety thousand people. When Adolphus Busch of St. Louis agreed to build his namesake luxury hotel on the site, it gave the city an opportunity to sell the property to him and build elsewhere. A site was chosen at Main, Commerce, and Harwood, where the city's Central Fire Station was located. This building was also outdated and in need of replacement. The fire station was moved six blocks to the east, and the old site was cleared for the new municipal building. The city moved its offices into temporary quarters while construction on the Adolphus Hotel and the new City Hall proceeded.

Mayor W. M. Holland and the city commissioners selected architect C. D. Hill to design the structure, specifying a building along "plain, dignified, and classic lines." He responded with a neoclassical gem. In the waning months of 1912, construction got under way.

The Beaux-Arts building was four stories with a basement and a sub-basement. The design was described by the architect as "Roman Corinthian with a strong feeling of modified French Renaissance." To the layman, it suggested a temple for municipal government. A line of Corinthian columns along the Harwood Street facade supported an entablature of Bedford stone and a mansard roof of green slate and copper. The primary stone work was done in Texas gray granite. All ornamentation, including the column capitals, was done in semi-glazed terra-cotta or Bedford stone. The ground floor featured large arched windows. Heavy bronze entrance doors from Main, Commerce, and Harwood led into marble vestibules with ornamental ceilings. A twenty-foot-wide stairway led from the first to the second floor with a large landing midway. Two elevators were also furnished.

The $500,000 building housed all city departments, including the police, who had a pistol range in the basement. Restrooms were provided beneath the sidewalk on the Main Street side with access to the public from outside the building. An audi-

torium with seating for twelve hundred occupied the third and fourth floors on the south side. An unusual feature of the building was that Dictaphone listening devices had been installed in certain rooms. These devices were plastered over so that accused criminals could not see them. Suspects were placed in these rooms and then encouraged to talk freely.

Construction proceeded throughout 1913 and early 1914. Once the granite had been mounted on the steel framework of the building, it had to be thoroughly scrubbed due to the accumulated soot picked up on the rail journey from the quarries. During the prolonged construction period, office arrangements apparently became stressful for city personnel housed in temporary quarters. In January 1914, a citizen by the name of Stanberry visited the temporary city hall where an argument ensued with Streets Commissioner S. B. Scott. The two came to blows in a corridor and had to be separated by Mayor Holland. While the two men were being held apart, citizen Stanberry made a derogatory remark about Commissioner Scott, causing Water & Sewer Commissioner R. R. Nelms to land a left-right combination on Mr. Stanberry's jaw and nose, bringing blood. In October 1914, the grand new City Hall finally opened on the first day of the State Fair of Texas.

For several decades, the building efficiently housed Dallas city government. Starting in 1917, the top floor was used as the city jail, which was known as "High Five." The police, still housed in the basement, amused themselves by shooting rats in the vermin-infested jail and basement with .22-caliber rifles loaded with mustard shot.

In anticipation of the 1936 Texas Centennial Exposition celebrations, a series of ten murals was commissioned for the second floor lobby of the building. Beginning in 1934, artists Jerry Bywaters and Alexandre Hogue executed the murals with funding from the Depression-era WPA. Bywaters eventually became director of the Dallas Museum of Fine Arts, and Hogue was head of the art department at Tulsa University. The murals began with the city's founding in 1841 and traced the historical development of Dallas up through the first automated traffic signals and radio-equipped police cars.

By the 1950s, the 1914 structure was outmoded and overcrowded, so a nondescript, architecturally incompatible annex was constructed on the east side of the building. This became known as the "new City Hall" when it opened in 1956, and the old building was completely gutted and remodeled. Interior walls, floors, and ceilings were removed, as were the Depression-era murals on the second floor. About the

only interior feature retained was the inlaid mahogany wall paneling from the Council chambers. The police department acquired greater space in the old building, as did city courts. The fourth and fifth floors were completely devoted to jail quarters. Floor five, or "High Five," was a maximum security facility. These old City Hall cells were later used to house Lee Harvey Oswald and Jack Ruby after the Kennedy assassination. Ruby's nationally televised shooting of Oswald took place in the basement garage beneath the building.

After the 1978 opening of still another city hall, the 1914 structure continued to be used for various municipal functions, as it is today. The exterior is much like it was when originally built, but aside from the vestibules, there is not much to see of C. D. Hill's original interior.

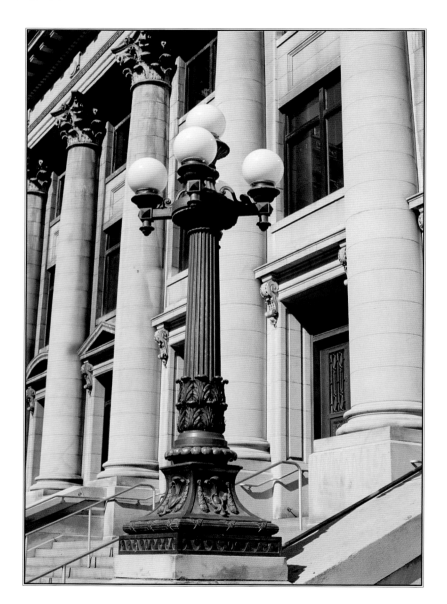

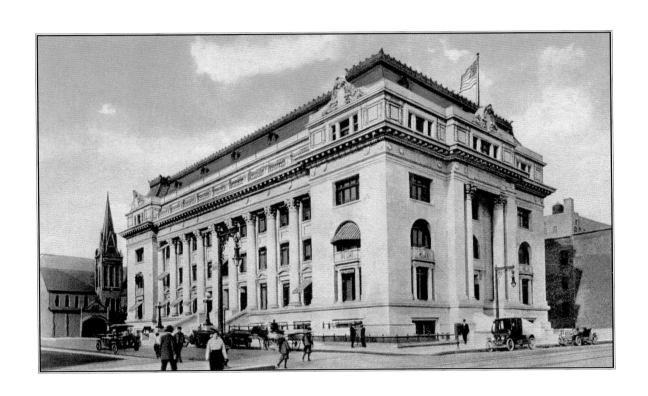

Neiman Marcus Company

—Main, Ervay, and Commerce Streets—

•

In 1907, Herbert Marcus, his sister Carrie, and her husband, Al Neiman, opened the first Neiman Marcus store at the corner of Elm and Murphy. In the following decades, the company became a retailing legend.

From the outset, Neiman Marcus aimed for excellence and exclusivity. Their stock, fixtures, and service were top drawer. In 1913, after six years in the Elm St. location, a catastrophic fire destroyed the store and all of its stock. The loss was largely insured, so plans were made for a larger building at a new location. After only sixteen months, the new store opened at the corner of Main and Ervay. The modern building boasted four stories plus a basement and was constructed of red tapestry brick with terra-cotta trim.

The environment just outside the store was decidedly not modern. One day during the construction of the new building, a major traffic problem arose at the corner of Main and Ervay. The wheel of a horse-drawn laundry wagon had become wedged in the switch of the electric streetcar system. Numerous attempts to lift the wagon were unsuccessful. Fire

and dynamite were both foolishly suggested. Finally, someone brought a crowbar from the Neiman Marcus building and pried the wheel loose.

By 1927, the company was ready to expand through to Commerce Street. A matching, four-story addition was added on the south side of the existing building. George Dahl drew the plans for the Herbert M. Greene firm, and his design for the facade called for a terra-cotta finish, replacing the original red brick and terra-cotta scheme. Thousands attended the opening of the new store, and no sooner was the grand opening concluded than further expansion was announced.

In 1928, a three-story annex on the west side of the Commerce face of the building was built to house a beauty salon and other store facilities. In 1939, the rectangular form of the building was reestablished when Neiman Marcus bought the buildings to the west of the store on Main Street. As soon as World War II was over, Neiman Marcus was on the move again, planning further expansion. During the 1946 Christmas season, a blaze threatened the enlarged store, but progress continued.

Herbert Marcus remained active in the business. After losing his eyesight around the time of the 1946 fire, he used other people's vision to compensate for his own. In 1950, he announced that additional stories would be added to the store and that in 1951, further westward expansion would double their floor space. Unfortunately, Marcus died before work got under way. Four sons were already involved in the business—Stanley, Edward, Lawrence, and Herbert Jr. With so many of Marcus's sons working in the store, employee communications sometimes became a little complicated when referring to one of the brothers as "Mr. Marcus." As a result, employees adopted the habit of referring to the brothers as "Mr. Stanley," "Mr. Edward," "Mr. Lawrence," and "Mr. Herbert." For the rest of his long life, Stanley Marcus would be affectionately known to the city as "Mr. Stanley." After the death of Herbert Marcus, Stanley assumed the store's leadership and proceeded with expansion plans. In 1951 and 1952, two stories were added on top of the existing building plus fifty-foot-wide, six-story additions on the west side of the building. In October 1953, a four-day celebration capped the $4.5 million expansion of the downtown store. Carrie Marcus Neiman passed away before the project was finished.

Stanley Marcus had a flair for promotion. Each autumn, he created annual expositions to sell fall fashions in a state that rarely knew a fall season. Later on, he would pioneer the Neiman Marcus Fortnights, spotlighting the products of a different country each year during a two-week extravaganza. After decades of success, the Marcus family eventually sold out, and the stores became part of the Federated chain. By 1990, Neiman Marcus found that it was the only remaining downtown department store. Today, it still thrives at the Main and Ervay location.

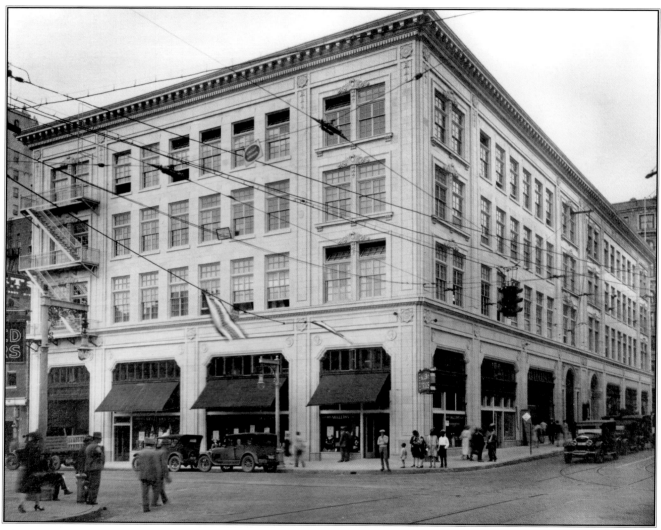

Above: *Neiman Marcus store, 1929. Note Skillern's Drug location on ground floor.*

Right: *Wartime photo of patriarch Herbert Marcus surrounded by sons Edward, Lawrence, Herbert Jr., and Stanley (right).*

Higginbotham-Bailey-Logan Company

—Jackson and Lamar Streets—

•

The rambling, spacious Founder's Square office building seen by today's downtown visitor was actually built as a wholesale dry goods operation prior to World War I. Formed in 1914, the Higginbotham-Bailey-Logan Company originated from the purchase of the Harris-Lipsitz Company, an earlier wholesale operation. W. L. Logan had been a partner in the Harris-Lipsitz Company, and with the purchase, he became a partner in the new company along with Rufus W. Higginbotham and A. H. Bailey.

Rufus W. Higginbotham was born in 1858 in Mississippi. He arrived in Texas at twenty-one years of age and went to work for a central Texas lumber company. He later opened the Higginbotham Brothers store in Dublin, Texas, before moving to Dallas in 1914.

A. H. Bailey was born in 1875 in Tennessee. Bailey worked for a clothing manufacturer in Knoxville before moving to Texas in 1913. The following year, he met Rufus Higginbotham. The two men forged a partnership and then made their way into the Dallas business world.

The new company soon erected a seven-story building at Jackson and Lamar streets. Designed by Lang & Witchell, the Renaissance Revival structure was clad in brown brick and terra-cotta. At the end of the following year, a $200,000 addition on the east side of the building was announced. In 1917, it was completed, adding ten thousand square feet of space to the building.

The company soon found it necessary to plan for further expansion. In 1918, they purchased the fifteen thousand–square-foot vacant lot at the southwest corner of Jackson and Poydras. The company's expressed intention was to eventually occupy the entire block. In 1923, this second matching expansion finally occurred and gave the operation three hundred and twenty thousand square feet of floor space under one roof. Higginbotham-Bailey-Logan now employed over one thousand workers operating hundreds of machines. The company had become a major producer of ladies' apparel as well as a wholesale distributor of dry goods.

In 1931, R. W. Higginbotham died at his Swiss Avenue home.

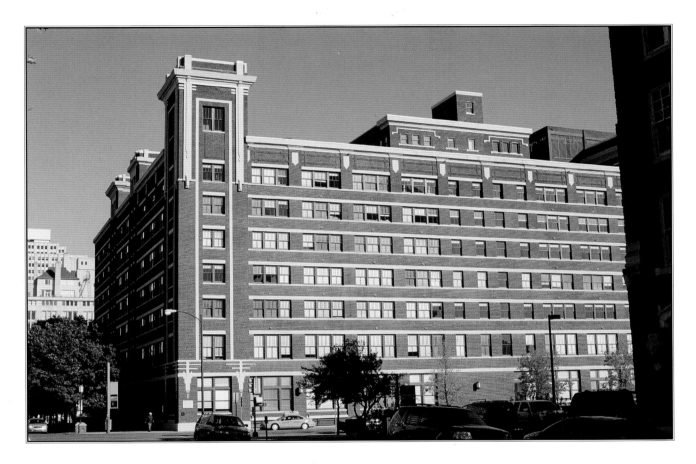

In 1938, W. L. Logan passed away at his retirement home in Mount Vernon, New York. In 1945, Logan's interest was sold, and the business name was changed to Higginbotham-Bailey Company. After A. H. Bailey died in a Dallas hospital in 1955, the company continued to operate under the leadership of R. W. Higginbotham's son, John, until his death in 1966. In 1983, the sixty-nine-year-old company was dissolved, and their landmark home, renamed Founder's Square, was redeveloped as office space.

Criminal Courts Building

—Main and Houston Streets—

•

I n 1913, the Dallas County Jail stood on the site of the future Union Station. The old jail was antiquated and overcrowded, so plans were made for a new jail facility. At the same time, the Union Station railroad consortium needed the jail land for their new terminal. They paid the county $150,000 for the property. The county was given fifteen months to erect a new facility.

County commissioners briefly considered placing the new jail on the courthouse square or even atop the courthouse but fortunately thought better of these ideas. A site was chosen at Main and Houston, directly across Main from the courthouse. H. A. Overbeck was chosen to design the new building. He was paid $20,000 for his services.

Overbeck designed a Renaissance Revival "skyscraper jail" that would pass for an office building from the outside. Dressed in red brick, gray terra-cotta, and granite, the eight-story, U-shaped building featured a handsome and highly detailed facade and looked nothing like a jail. Prison bars were placed inside the windows so as to be inconspicuous

from the street. Two criminal courts were placed on either side of the ornate second floor lobby.

The new jail did not feature a hangman's gallows. In those days before the electric chair, the hangman's scaffold was a prominent fixture at the old jail, and it received one last use before the facility was abandoned. Just before Christmas 1913, Ed Long was executed for the slaying of a night watchman at the Texas & Pacific Railroad yards near Fair Park. Special Officer Henry Bennett had observed some thieves breaking into boxcars, and when he attempted to arrest them, he was shot dead. Ed Long admitted his participation in the burglary, but denied any guilt in Officer Bennett's murder. He proclaimed his innocence to the very end. When led from his cell, Long went to an open window, addressed the crowd below, sang a hymn, and recited Psalms 23 from the Bible. Then, he was led down to the gallows and hung.

At $585,000, the new jail was pronounced one of the most humane in the country by a Boston social welfare expert. Each cell had a washstand, and bathtubs and showers were

plentiful. The building was heated in winter and ventilated in summer by a "washed air" system that filtered and cooled incoming air. Jail guards were stripped of their six-shooters and clubs, using the "water cure" on unruly prisoners. This was administered by blasting the recalcitrant inmate with a fire hose hooked up to the city water main. In addition to women prisoners being isolated from the men, black prisoners were segregated from white prisoners in a separate wing.

In May 1915, the new county jail and criminal courts opened, and it received prisoners transferred from the old jail. The facility was considered escape proof. One month after opening, two sixteen-year-old boys arrested for petty thievery made a rope out of blankets, lowered themselves seventy-five feet from the sixth floor, and made a clean getaway. In later years, the jail held "Pretty Boy" Floyd and Clyde Barrow. In 1964, the trial of Jack Ruby, killer of Lee Harvey Oswald, was held in the east wing of the building.

Today, the historic building houses county offices and courts.

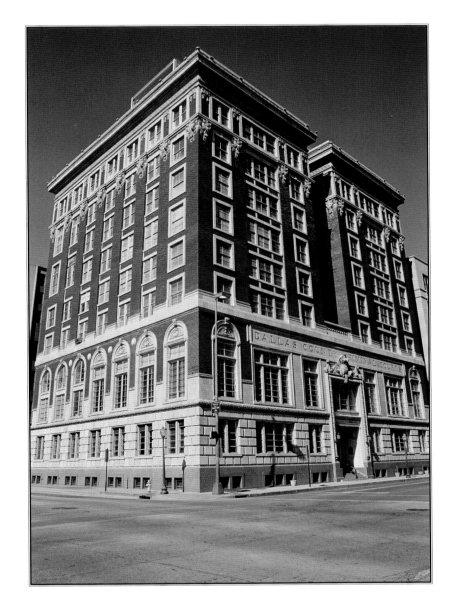

Chamber of Commerce Building

—1101 Commerce Street—

•

Dallas business leaders always had a way of putting aside their differences for the greater goal of city growth. Various booster clubs sprang up long before the turn of the century, and in 1908, four of the largest agreed to disband and form a consolidated Chamber of Commerce. The new organization was initially housed on the second floor of the Cotton Belt Railroad Terminal at Commerce and Lamar, but within a few years, the Dallas Chamber was looking for a more spacious home. A committee of business leaders, including Alex Sanger, Hugo Schoellkopf, Edward Titche, and A. M. Matson of Butler Bros., selected Lang & Witchell in a six-way competition to design a ten-story headquarters building. Most of the space would be rented to tenants with one floor reserved for chamber use. A $450,000 building at Commerce and Poydras was envisioned to be built on land owned by Mr. Sanger. Discussions continued for several years without construction actually beginning.

The proposed building became unnecessary when the Southland Life Insurance Company agreed to buy and enlarge a two-story structure at Commerce and Browder. The foundation had been built to support additional floors, so Lang & Witchell designed an eight-story addition atop the existing structure. With the foundation already in place, construction proceeded rapidly, and in 1918, the building was completed. The Chamber occupied the entire second floor.

The organization's rapid growth continued, and departments were soon scattered throughout several buildings. When the Federal Reserve Bank vacated their five-story building at 1101 Commerce, the Chamber quickly raised funds from its membership to purchase it. Starting in April 1922, they occupied three floors of the structure. This remained the home of the Dallas Chamber for nearly forty years. For generations of Dallas residents, their large vertical sign on the corner of the building became a familiar landmark.

By 1960, the Dallas Chamber was the largest in the United States with nine thousand voting members. All of the space in the Commerce Street building was being utilized in addition to rented space next door. Building or buying a larger

structure was an expensive proposition, so the Chamber elected to sell their historic old home and rent space in a downtown office building. A new location was soon secured in the Fidelity Union Tower where the Chamber remained for many years. In 1962, the old building on Commerce succumbed to the wrecking ball. Over the next few decades, the Dallas Chamber of Commerce was housed in several different downtown buildings.

For nearly a century, the Dallas Chamber of Commerce has been instrumental in promoting the city and attracting business to the Dallas area. The presidency of the organization reads like a who's who of Dallas business leaders: E. R. Brown of Magnolia Petroleum, Arthur Kramer of A. Harris & Co., R. L. Thornton of Mercantile National Bank, L. B. Denning of Lone Star Gas, John. W. Carpenter of Southland Life, and Ben Wooten of First National Bank. Before 1960, they had all served as president. In 1987, the name of the organization was changed to the Greater Dallas Chamber to reflect the broader geographical area being served.

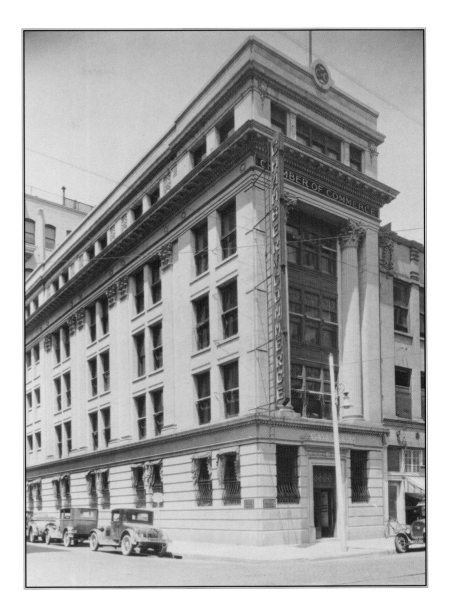

Union Station

—400 S. Houston St.—

•

In the early morning hours of October 10, 1916, the Cotton Belt 101 train pulled in to Union Station in Dallas, inaugurating service to the gleaming new facility. A cooperative venture of eight major railroads, Union Station consolidated five other terminals that were previously used. One of the first-day passengers to disembark was Miss Edith Storey, the "famous moving picture actress," arriving on the M. K. & T. Texas Special. A large crowd had gathered, anticipating her arrival. Miss Storey dutifully proclaimed her honor at inaugurating service into the station. George B. Dealey of the *Dallas Morning News* served as master of ceremonies at the official grand opening a few days later.

Chicago architect Jarvis Hunt had earlier designed the beautiful Union Terminal in Kansas City, and many of the same design elements were utilized here. Hunt used enameled brick, Doric columns, and palladium windows to create his Beaux-Arts masterpiece. A vaulted waiting room with huge chandeliers graced the second floor, reached by a grand staircase capable of accommodating four hundred persons at once. The interior featured a newsstand, drug store and soda fountain, barber shop, florist shop, and dining rooms. Cost for the new terminal was $1.5 million.

Through the years, the stairs were a source of constant discontent. Passengers had to ascend thirty-six steps to the second floor waiting room and then descend forty steps to their train. In 1949, an overhaul was completed that vastly improved the situation. Escalators to the second floor waiting area were installed, and a tunnel was dug under the tracks from the first floor to a parking lot on the west side of the complex. Inclines led off the tunnel to the train platforms. However, none of these improvements could change America's travel habits or rescue the sagging fortunes of rail passenger service. By 1952, no one ventured to the second floor anymore, and the costly escalators were turned off. Ten years later, the terminal was only handling one thousand passengers daily. Buses, airplanes, and cars were the means by which America traveled.

Fortunately, the beautiful building survived until it was integrated in the 1977 master project that included the Hyatt Regency Hotel, Reunion Tower, and Reunion Arena. Union Station was tied in to the tunnel system connecting these facilities, and for a time, it prospered with new restaurants in the upstairs Grand Lobby. Today, it is used as a party and meeting facility, Amtrak depot, and Dallas Area Rapid Transit station.

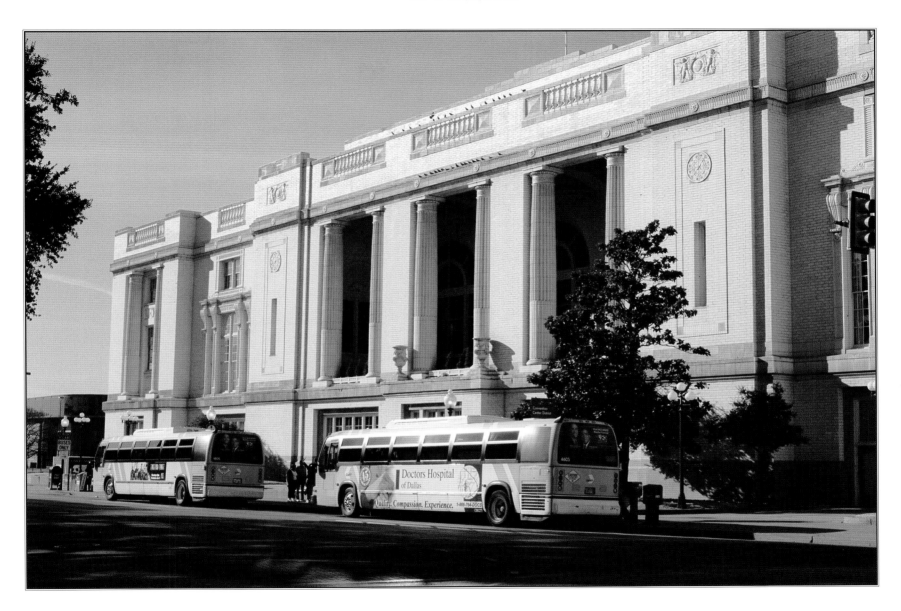

Interurban Building

—Jackson and Browder Streets—

•

In the early decades of the twentieth century, the Interurban system was one of the most popular modes of transportation between Dallas and other cities in North Texas. The Interurban system provided electrically driven trains designed for short-haul passenger service to Ft. Worth, Waco, Denton, Wichita Falls, and other cities. These trains could travel as fast as sixty miles per hour with a reasonable amount of comfort. In 1915, plans were made for a large new Interurban terminal at Jackson and Browder streets.

When the eight-story station opened in 1916, it allowed passengers to commute to and from Dallas, or to change trains for longer journeys. The main passenger entrance was on Jackson Street, with the tracks terminating on the south side of the station. The parking area accommodated twenty-four Interurbans at one time. A large waiting room occupied almost the entire ground floor, which was surfaced with terrazzo tile and marble.

On the floors above, several companies involved with electric power and public transit were housed. Dallas Electric Light and Power (later Dallas Power & Light [DP&L]) occupied one floor. Texas Power & Light (TP&L), responsible for providing electricity in regional cities, occupied another floor. The Dallas Transit System, operator of city street cars, was on another.

By the 1930s, the speed, efficiency, and independence granted by the automobile had made the Interurban an anachronism. As the number of riders dwindled, a new use for the Interurban station was found by converting it to a bus terminal. Initially, several bus lines utilized the terminal, but by 1944, Continental Trailways had exclusive use of the facility. In 1964, the company bought the building, renaming it the Continental Building. DP&L and TP&L had long ago moved out, and in 1966, the Dallas Transit System did the same. The old Interurban station was remodeled, and parking facilities were constructed on two sides of the building. The remodeling removed all traces of the historic 1916 construction, and the building was reduced to a featureless but functional transit terminal. Continental Trailways continued to use the facility until 1987, after which the building fell vacant and began a steady process of decay.

Fortunately, the building was rediscovered in 2000 by developers who first planned to renovate the structure for high-tech office space. In 2001, an economic slowdown delayed the project, but in 2005, it was completed as the beautifully restored Interurban Building (IB) Lofts, complete with a much-needed downtown grocery store.

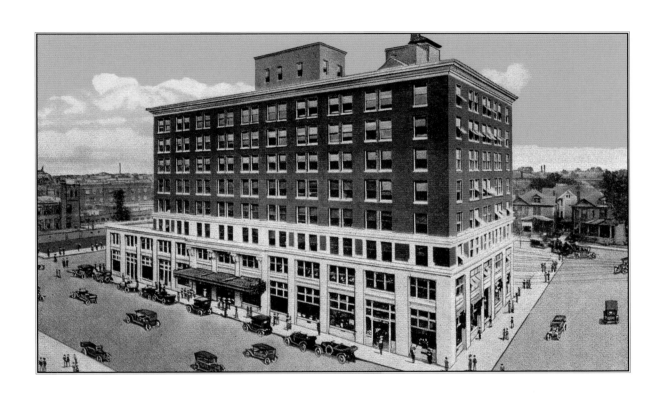

City Temple Presbyterian Church

—1600 Patterson Street—

•

In 1915, the Central Presbyterian Church was one of the oldest churches in the city. The congregation could trace its roots back to 1850 and a sermon preached in John Neely Bryan's cabin. By the early part of the twentieth century, the congregation was housed in a two-story red brick building at Commerce and Harwood.

The growing church needed more space and began planning their "City Temple" at Akard, Patterson, and Bullington streets. This eventually became the accepted name of the church. Architect C. D. Hill designed the three-story Gothic church, which featured a bell tower on the northwest corner and a massive arched entrance along Patterson Street. A glazed terra-cotta finish was utilized. The basement housed a gymnasium, pool, showers, nursery, clubrooms, and a bowling alley. The foyer and the horseshoe-shaped sanctuary, as well as all staff offices, were on the ground floor. The next floor contained the upper galleries for the sanctuary, plus parlors, a dining room, a kitchen, and more clubrooms. A rooftop garden graced the top of the building. In November 1915,

the cornerstone was laid, and in 1917, the $250,000 building reached completion. City Temple continued for many years as a vital part of downtown life.

Over the years, many church members opted for closer, suburban churches, and the City Temple was forced to become a suburban church as well. In 1961, when the church bought land near Northwest Highway and voted to move several miles north, the beautiful building was sold to a parking lot operator. The 1917 structure was soon demolished and asphalted over. The legacy of City Temple lives on at Northpark Presbyterian Church.

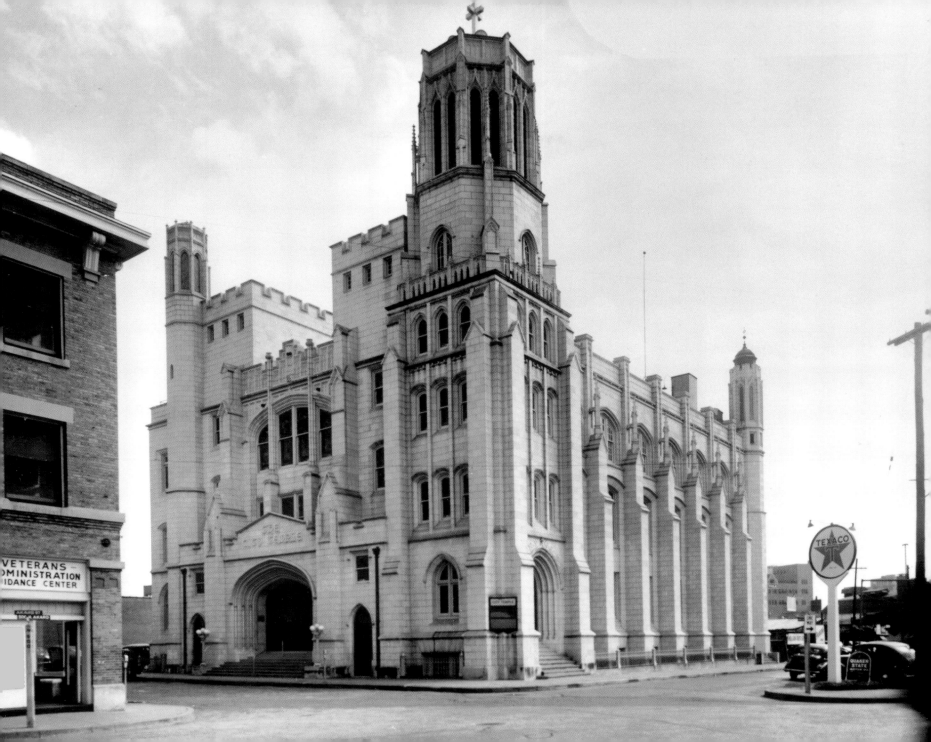

Dallas Trust and Savings Bank

1301 Main Street

Organized in 1903, the Dallas Trust and Savings Bank was the oldest state chartered banking institution in the city. It began as the Trust Company of Dallas, and then in 1907 the institution became the Dallas Trust & Savings Bank. Continued growth and success dictated a larger home, so in 1916, a new facility was begun. Designed by Hubbell & Greene, the stately three story structure featured a facade of ivory enamel polychromic terra cotta framed with Corinthian pilasters and crowned by a decorative cornice and balustrade. The structure adjoined the Cockrell Building and was projected at $100,000.

Upon completion in July 1917, the bank occupied the ground floor while its affiliated title and mortgage companies occupied the second and third floors, respectively. The bank continued to prosper throughout the 1920s. In 1930, the bank merged into the younger Dallas National Bank. Dallas Trust and Savings abandoned its ground floor facilities at 1301 Main and moved into Dallas National s larger building down Main Street to the east. The combined banks had assets of over $13 million.

In the meantime, Dallas Title & Guaranty moved from the second floor of the old building into a portion of the space relinquished by the departed bank. Guardian Savings (1928), another occupant of the building, took the remainder of the first floor. Former Dallas mayor Joe E. Lawther was the president of the savings institution. Dallas Title & Guaranty remained in the facility for decades.

In 1964, the historic old building at 1301 Main was razed to make way for the new enlarged home of Dallas Title & Guaranty Company. A four story structure of pre cast quartz concrete panels took its place, and it still occupies the site today.

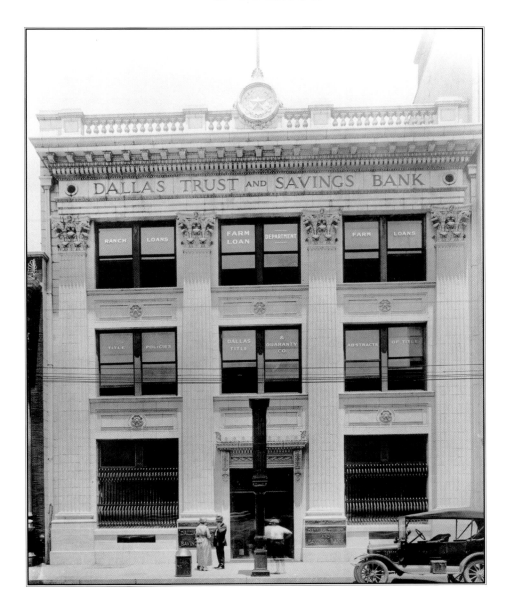

Southland Life Building

—1416 Commerce Street—

•

Established in 1908, the Southland Life Insurance Company was organized to provide regional insurance services to customers within a 350-mile radius of Dallas. This included much of Texas, Louisiana, Arkansas, and Oklahoma. Five million inhabitants were estimated to live within that area, and companies like Southland Life and Southwestern Life wanted to keep insurance premiums in the state rather than see them go to northeastern financial centers like New York.

Within a few years, the Sam Houston Life Insurance Company was merged into Southland Life, with James Stephenson becoming president of the combined companies. Former Dallas police commissioner Harry Seay was made vice president. The San Antonio Life Insurance Company was acquired shortly afterward, giving Southland Life Insurance over $25 million of insurance in force. Harry Seay subsequently bought the interest of James Stephenson and became head of the company.

The rapidly growing enterprise now needed a larger home. At the southwest corner of Commerce and Browder, just east of the Oriental Hotel, was a two-story building occupied by the Chamber of Commerce since 1912. The foundations had been designed to support additional floors, so Southland Life elected to buy the building and add eight stories to the existing structure.

Lang & Witchell designed the addition, and construction proceeded rapidly since the foundations and basement were already in place. Southland Life planned to occupy the seventh and eighth floors, while the Chamber of Commerce rented the second floor, and the newly formed City Club took the top two floors plus a rooftop garden. The F. W. Woolworth offices and the National Bank Examiners occupied another floor. Burroughs Adding Machine Company was another tenant. A barber shop and Turkish baths were planned for the basement. Total cost for the land, original building, and eight-story addition was around $600,000. In June 1917, work began, and the following spring, it was completed.

The building's exterior was finished in reddish-brown brick and terra-cotta. The interior featured pearl gray marble and mahogany woodwork. In August 1918, the prestigious City Club opened on the top two floors with lounging areas, a large dining facility, a dance floor, and a roof garden for summer dining.

In 1930, Southland Life bought the building directly behind them, the eleven-story Insurance Building at Jackson and Browder. It was subsequently joined to the Southland Life Building as an annex. In the weeks leading up to the 1936 Texas Centennial Exposition, the Southland Life Building housed much of the administrative apparatus required for planning the extravaganza. Managing Director

Walter Cline and his assistant, former hotel man Otto Herold, made decisions on land purchases, architects, contractors, and budgets from this location.

On a late December morning in 1937, Joe Breedlove of Sulphur Springs, Texas, walked past the Southland Life Building. He was in town to buy tickets to the Cotton Bowl game between the University of Colorado and Rice Institute on New Year's Day. As Breedlove passed, a human body hurtled toward him from above, slamming him to the sidewalk. Frank Thompson, a window washer, fell from the sixth floor and struck a guy wire on the way down. Both men were rushed to Parkland Hospital for emergency treatment. Amazingly, twenty-five-year-old Breedlove survived the incident with only a wrenched shoulder and severe bruising. Mr. Thompson was not so lucky. He suffered a crushed skull, fractures to an arm and leg, and a severed artery in his neck from his collision with the guy wire. Despite timely first aid treatment from a policeman witnessing the fall, Thompson died from his injuries within days.

In 1938, Southland Life merged into the Gulf States Life Insurance Company. The Gulf States operation vacated its space at Main and Akard and moved into the Southland Life Building. The enlarged operation continued to function from this location until 1959 when the sensational new Southland Center was completed. Southland Life had already sold their old building to Corrigan Properties back in 1947 in order to capitalize on the enormous equity held in the property. After Southland Life vacated its Commerce Street location, the building was renamed the 1416 Commerce Building and then leased for general office purposes. In 1966, the United Service Organization leased space in the building, remaining for several years.

In 1980 when Southwestern Bell Telephone began planning the erection of Bell Plaza, the fate of the old Southland Life Building was sealed, and it was razed.

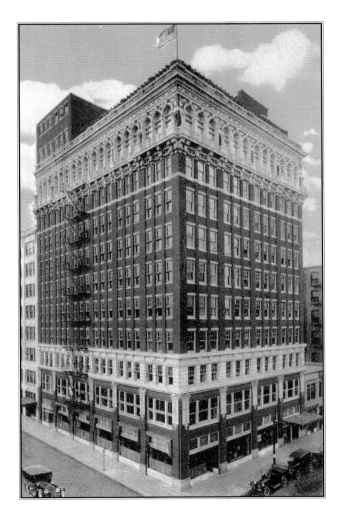

American Exchange National Bank/First National Bank

—1401 Main Street—

•

The roots of the American Exchange National Bank can be traced back to 1875 when the original Exchange Bank was formed. The bank later received a national charter and then changed the name to National Exchange Bank. In 1905, the bank absorbed the American National Bank, and the combined institutions became American Exchange National Bank. The consolidated bank moved into a new facility at Main and Poydras. The rapid growth of the Dallas area was mirrored by the growth of American Exchange National Bank, and when a larger home became necessary after a few years, American Exchange contracted with Lang & Witchell to design a sixteen-story building with a basement at 1401 Main Street. The site had been occupied by the old Imperial Hotel until a catastrophic 1914 fire. Alfred C. Bossom, a New York architect, was consulted on the project. In the spring of 1917, work on the $1.25 million structure got under way, and in September 1918, it was completed. The bank occupied the first two floors and basement.

On the appointed moving day, a small army of officers armed with sawed-off shotguns supervised the transfer of $40 million in assets to the new building. The sparkling structure was faced with Bedford limestone above a base of Llano red granite, the same material used in the state capitol. A prominent terra-cotta cornice projected from the upper facade. The elevator lobby was floored and wainscoted with pink Tennessee marble, which was also used for the upper floors. The banking lobby itself was finished with a newly discovered material, white San Saba marble, showing veins of pink and gray. This beautiful stone was also used for all pillars, customer tables, and railings in the bank. All bank woodwork was done with black walnut. The ceiling was handcrafted in pink and white plaster and contained nine large skylights for illumination. An early form of refrigerated cooling was installed in the modern building.

Just six years after it opened, the bank's new home was the scene of a horrific tragedy. One morning, Paul O'Day, an attorney employed by a firm on the sixteenth floor, was waiting for an elevator when a man entered the lobby with a shotgun. The man approached O'Day, leveled the shotgun at him, and fired three times into his body. The loads of buckshot killed him instantly. W. L. Crawford, the assailant, was involved in an inheritance fight with his stepmother, who was represented by Mr. O'Day.

In 1926, Republic National Bank erected their new building just across Exchange Place to the west of American Exchange National Bank. The two banks waged a six-decade war for supremacy in

the city, starting from these original locations only yards apart. Armored cars routinely used the narrow Exchange Place alley between the buildings to service the banks, so it became known as "Money Alley."

In 1929, a six-story annex on the north side of the building connected the lobby all the way through from Main Street to Elm Street. Bank offices were expanded into the upper floors of the new annex. It was just prior to the opening of the annex that the merger of American Exchange National Bank and City National Bank was announced, creating the largest financial institution in the city. Since the merged banks were the oldest in town, the new bank was to be known as "First National Bank in Dallas." Combined assets were more than $100 million.

Nathan Adams was named president of the powerful new bank. Adams had been with American Exchange National Bank or its predecessor since 1889, starting as a clerk. In 1887, he had arrived in Dallas, an eighteen-year-old kid with less than $10 left in his pocket from the $75 he had borrowed for the trip. Adams came to Texas for a promised job in the auditor's office of the Texas & Pacific Railway. He secured a small room at the St. George Hotel and then plowed into his work. Adams left the railroad after a year-and-a-half to become a utility clerk with the National Exchange Bank, earning $75 per month. Over the years, Adams worked his way up through the ranks, impressing his superiors with his work ethic and financial acumen. As head bookkeeper, assistant cashier, cashier, and vice president, he contributed

steadily to the growth of the bank. In 1924, he became president of American Exchange National Bank, and in 1929, he became president of First National Bank. His name became synonymous with the great institution over the next thirty years. In 1936, Adams, along with R. L. Thornton and Fred F. Florence, was instrumental in bringing the Texas Centennial Exposition to Dallas, an event that helped to firmly cement Dallas in the nation's consciousness. The three banking titans competed ferociously for deposits and loans but were able to put aside their differences long enough to serve the interests of the city. Other Texas cities, including Houston and San Antonio, had stronger historical heritages, but Dallas had Thornton, Adams, and Florence. They secured the important Centennial Exposition for the city of Dallas.

During the 1930s, Adams was also a pioneer in loaning exploration and production money to the burgeoning Texas oil industry. Their symbiotic relationship helped to propel Texas into the front rank of oil producers, and the flood of black crude helped to make First National the biggest banking institution in the Southwest. In April 1939, Adams celebrated his fiftieth anniversary at the bank with a three-day series of events culminating in packed banquets at the Adolphus and Baker Hotels. The modest Adams was an inveterate cigar smoker and, in later years, became a horseman and scratch golfer. He advised others to "work more and gossip less," and he worked tirelessly to raise funds for the Scottish Rite Hospital for crippled children. Nathan Adams was elevated to the chairmanship of First National Bank at the end of World

War II, succeeded as president by Edgar L. Flippen, a realtor and insurance magnate. Adams spent sixty-five years with the bank before retiring from active service in 1954. He lived to be ninety-five years of age and then passed away in 1966.

In 1918 when the original bank was built, a three-story annex had been erected on the east side of the bank but never occupied. In 1951, the bank added three stories to the annex, and occupied four floors of the six-story structure, which rested between the main bank building and the Gulf States Building. The addition gave the bank 116,000 square feet of floor space. A 190-foot-long "telesign" with thirty-inch flashing letters was also installed that year, wrapping around the busy corner of Main and Akard and instantaneously flashing news and sports information to downtown pedestrians and motorists. In July 1952, hundreds stood near the corner and cheered as the sign announced the first-ballot nomination of war hero Dwight Eisenhower for the presidency. In 1950, First National had gotten a new president of its own, Ben Wooten, who had been hired away from Republic National Bank.

In 1952, a seven-story motor bank with a basement was erected across Elm Street to the north, and connected to the main bank by an underground tunnel. In 1953, the main banking lobby was expanded and remodeled using teakwood paneling and new teller stations of English marble. The lobby floors were re-laid in Belgian black and Vermont white marble. In 1954, further changes were required by the absorption of the $100 million Dallas National

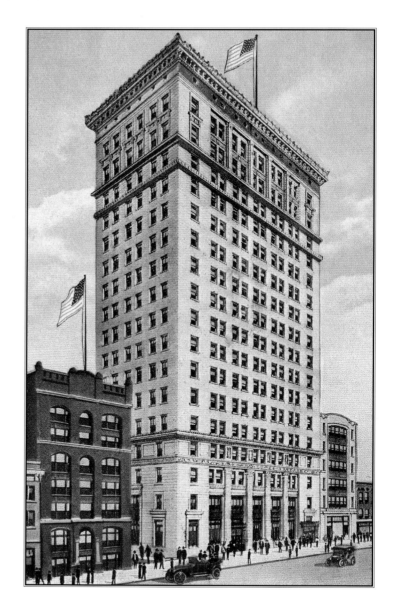

Bank and its employees, creating the largest bank south of Chicago. Also in 1954, after Republic National Bank moved into their new tower, First National Bank leased twenty thousand feet of space in their old building across Money Alley, and another tunnel connected these two buildings. In 1957, the motor bank was doubled in size, but the rapidly growing bank still felt constricted, especially in light of archrival Republic National Bank and their new facility. In 1960, a new era began for First National Bank when Robert H. Stewart III was elected bank president, bumping Ben Wooten into the chairmanship. Stewart's grandfather had once been chairman of First National Bank, and his father had served on the board. By 1961, with assets approaching $1 billion, the bank began planning for a huge new facility across Elm Street, with completion scheduled for late 1964. Arrangements were made for the sale of the old bank to Vaughn Building Corporation, which later signed Metropolitan Federal Savings as an anchor tenant. In 1965, the old building was renamed the Metropolitan Building and then remodeled with metal cladding on the lower floors and an underground mall connecting it to the new bank building. The underground mall became home to the famous Blue Front German Restaurant, a downtown Dallas lunchtime institution since the 1920s. After twenty years in this altered guise, the historic American Exchange National Bank Building was demolished for parking space, leaving an ugly gap between the Davis Building and the Gulf States Building. The only intact stretch of historic skyscrapers in Dallas was gone.

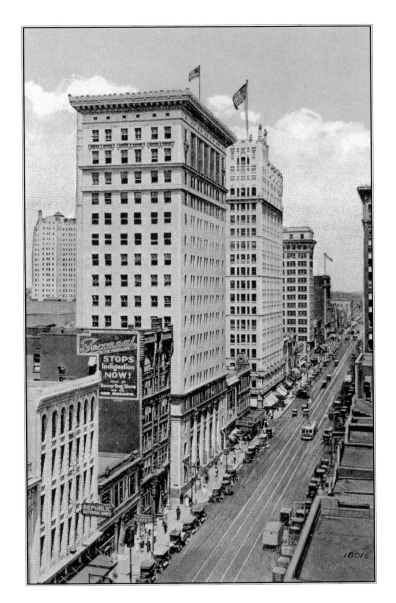

Federal Reserve Bank

—Wood and Akard Streets—

•

When the Federal Reserve banking system was established in 1914, Dallas's choice as the Eleventh District headquarters vaulted the city onto the same financial plane as New York, Boston, Philadelphia, Chicago, and seven other cities that served as regional sites for the new banks. The Eleventh Federal Reserve District included Texas, Oklahoma, and Arkansas. E. O. Tenison, former president of City National Bank, was made the first chairman of the Dallas bank, which opened in November 1914.

After a brief stint in temporary quarters at 1305 Main, the Federal Reserve Bank purchased and occupied the former whole-sale building of Linz Bros. Jewelers at Commerce and Martin. The Federal Reserve Bank of Dallas was the first to choose a permanent home, selecting the firm of Hubbell & Greene to redesign the five-story building for the bank's usage. The exterior was dressed up with terra-cotta ornamentation, and a 250,000-pound vault was installed on the ground floor. The eleven-ton vault door was so precisely engineered that a child

could swing it on its hinges, the fit so exact that a small amount of dirt on the threshold could interfere with the lock bolts. It was said that a sheet of paper placed against the jamb of the vault door would be sheared in half when it closed. On the appointed moving day, $18 million was transported through busy downtown streets in a caged horse-drawn wagon. Eight heavily armed detectives stood guard. In October 1915, the rapidly growing bank moved into their new space but spent only three years at the Commerce Street location before making plans for a larger facility. In 1918, a site was chosen at Wood and Akard streets, directly across Akard from the old Cotton Exchange Building. Several Federal Reserve Bank officials toured cities across the United States to study the architecture of major banks and public buildings. The Treasury Building in Washington was considered as one possible model.

Graham, Anderson, Probst, & White, the Chicago-based architectural firm responsible for the Wrigley Building, was chosen to design the structure. A five-story building with basement

was envisioned, fronting 125 feet on Akard Street. The foundations were designed to allow for three additional stories if needed in the future. Approximately $1 million was budgeted for construction alone, and another $100,000 was allowed for an additional Mosler vault, which would be required. It was anticipated that fixtures and furnishings, plus land cost, would raise the total to $1.5 million. In July 1919, excavation began.

The architects chose the same Bedford limestone that had been used on the recently completed American Exchange National Bank Building (1918). Their aim was to achieve a massive, neoclassical design that suggested stability and permanence. To this end, huge Doric columns, fifteen feet in circumference, graced the entrance, and the number of windows was minimized to preserve architectural lines. In April 1920, the cornerstone was laid, and Reverend William M. Anderson of First Presbyterian Church offered prayer. Into the ceremonial cornerstone box went a history of the bank and copies of current newspapers.

In September 1920, the stonecutters commissioned to execute the allegorical statuary above the entrance loggia arrived. Henry Herring, a New York sculptor, designed the two fourteen-foot female statues symbolizing "Integrity" and "Protec-

tion." A cartouche between the figures featured an American eagle with outstretched wings and the seal of the Eleventh Federal Reserve District. The pediment ornamentation was completed by cornucopias and perched eagles to either side of the statuary and lions' heads below. The chief stonecutter required four months to complete the figures.

The white marble for the interior wainscoting and counter screens was quarried in San Saba, Texas. Banking lobby floors were laid with Tennessee marble. The two-story main lobby was surrounded by a mezzanine floor and supported on columns with white marble bases.

The new building served well for the next two decades, but by 1939, conditions were getting tight in the building. Grayson Gill was asked to design a two-story addition to the top of the building, raising it to seven stories. In January 1941, the work was completed and then celebrated with a formal dinner at the Baker Hotel. By the late 1950s, the facility was once again in need of more space. In 1959–1960, a multimillion dollar expansion was undertaken that added two hundred thousand square feet on the east side of the structure. Grayson Gill was again tapped to design the addition, modernizing and remodeling the original structure at the same time. The new space

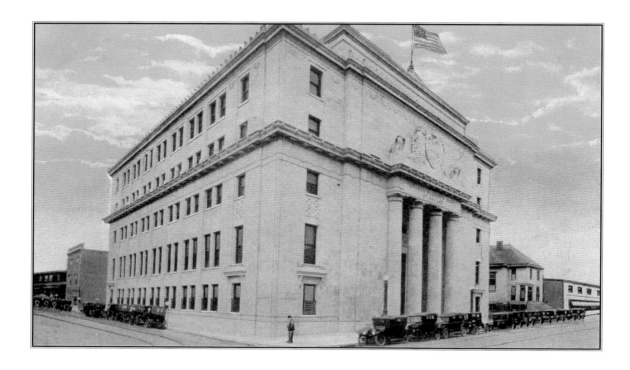

comprised three levels below ground and five stories above. In the end, $7.5 million was spent on the program.

After more than seventy years in the Akard Street location, the Federal Reserve Bank of Dallas built a new facility just north of Woodall Rodgers Freeway, and in 1992, the bank occupied it. The old building was utilized for a short time as a telecommunications center, but in the early 2000s after the telecom industry collapsed, it fell vacant again. As of 2006, an architectural firm occupied the structure.

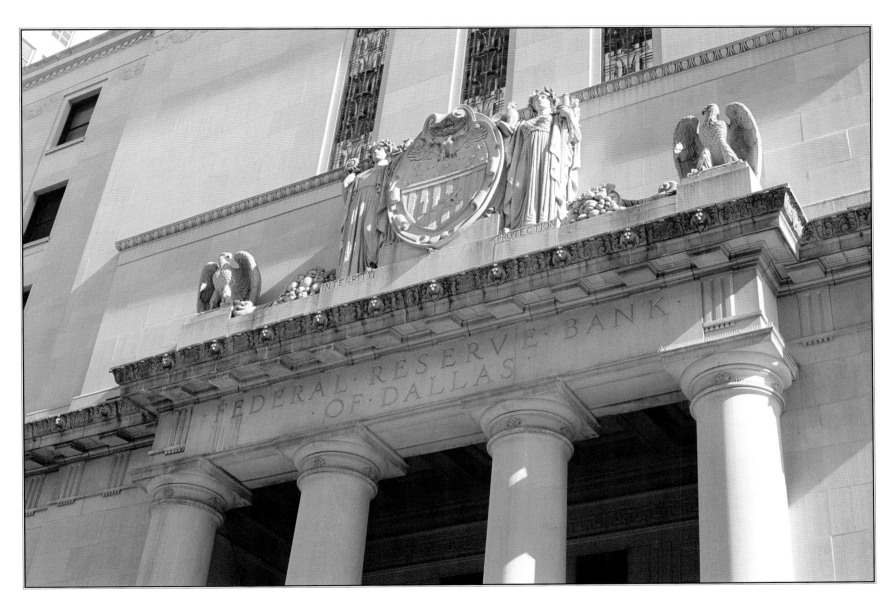

Magnolia Building

—Main and Akard Streets—

•

The Magnolia Petroleum Company had gotten its start in Corsicana, Texas, around the turn of the century, establishing a refinery there. In 1914 when the Corsicana oil field played out, Magnolia moved to Dallas, opening offices in the Great Southern Life (Kirby) Building. In 1919, the company's success led it to erect its own headquarters building. A site was purchased at the northeast corner of Commerce and Akard across from the Adolphus Hotel. Plans were made for a sixteen-story building, but this was quickly changed to twenty-four stories. Alfred C. Bossom, a New York–based, English architect, was chosen to design the building in association with Lang & Witchell of Dallas.

In late 1920, excavation work got under way with a completion goal of eighteen months. The design chosen was a U-shaped tower with east and west wings separated by a light court beginning at the fourth level. This arrangement provided natural light and ventilation to all offices, regardless of location. An arched columned bridge spanned the two wings at the eighteenth level. Above the twenty-fourth level, the structure was stepped back to a balconied multistory pent-

house capped by a hipped green-tiled roof. The penthouses extended the structure to twenty-nine stories. Surmounting the building base above the main entrance was an allegorical sculpture group known as "The Reawakening" with figures representing the commercial and industrial activities of the state. Centered between the figures was a cartouche with the seal of the Magnolia Petroleum Company and the building date. The building was constructed of steel and brick faced with Indiana limestone.

At twenty-nine stories and over four hundred feet tall, the Magnolia Building was the tallest building in Texas and one of the tallest south of New York. A three-story annex was constructed on the eastern side of the building with the expressed purpose of preventing any future neighbor from encroachment on the light and air available to the building.

Despite strenuous safety precautions, the construction was not without mishaps. In June 1921, Arthur Hardcastle and Mason Henson were two ironworkers who were part of a riveting gang working on the twenty-sixth floor. Hardcastle

was wielding the riveting gun, and Henson was the "bucker up," flattening the hot rivets as they were driven through the girder. The vibration of the gun caused Hardcastle's support plank to slip, and as he fell, he grabbed frantically for any handhold. Unfortunately, his hand found Henson and pulled him off his perch. Hardcastle plunged through temporary flooring on the thirteenth floor and then landed on the twelfth floor where he immediately died. Amazingly, Henson's plunge was stopped by a crossbeam at the seventeenth floor, but his fall was not fatal. Though critically injured, he eventually survived the ordeal.

Only two weeks later, a large chunk of concrete fell from the top of the building, glanced off a girder, and then crashed through a plate glass window across the street. Minutes later, a steel rivet fell from the same floor and followed a similar arc, knocking a chunk out of the sidewalk below. Police moved pedestrians out of harm's way until things settled down. In the end, one hundred million pounds of material went into the $4 million structure.

No expense was spared in the building's impressive interior. Tennessee marble wainscoting was used throughout the building. The polished Italian marble elevator lobby was particularly stunning, highlighted by a coffered ceiling decorated in hand-painted plaster of paris rosettes. Beautiful chandeliers completed the effect. The twenty-fourth floor, occupied by Magnolia Oil executives, was notable for its floor-to-ceiling walnut paneling.

In June 1922, the building formally opened with Southwest National Bank occupying the basement, ground floor, and parts of the second floor. The bank's marble and brass interior appointments were in keeping with the building's overall appearance. During the 1922 state fair, thousands of visitors were transported to the top of the tall new building for a view of Dallas.

During the 1930s, the Magnolia Building was a mainstay of local commerce and the Dallas skyline. Throughout the decade, Mercantile National Bank occupied the lower floors while the oil company occupied the top. In 1931, the upper floors were beautifully illuminated with 322 red, white, and green floodlights, and in 1934, the famed "Pegasus" revolving sign was placed atop the building, identifying the Magnolia headquarters. The winged horse eventually became the symbol of Mobil Oil, and the red neon tubing on the huge sign could be seen for miles.

Over the years, the Magnolia Petroleum Company was acquired by Standard Oil of New York, evolving into the

Socony-Vacuum Company and eventually Mobil Oil. The oil company occupied the aging, outmoded building until the 1970s, eventually deeding it to the city of Dallas. The city was not entirely comfortable as the landlord of a fifty-year-old historic building, and there was serious talk that the Magnolia building would be demolished. The red neon outlining the Pegasus sign went dark. Once again, preservationists dug in their heels, and the magnificent building was spared.

By the 1990s, the building was in need of a purpose and extensive repairs, so it was shuttered. Fortunately, Steven Holtze, a Denver developer, discovered the building and, along with architect Guy Thornton, transformed the building into the Magnolia Hotel. In 1999, the $40 million project opened—a wonderful compromise between preservation and utility. The building's exterior was left virtually intact, and the original, ornate elevator lobby was preserved and restored. The gorgeous ceiling, chandeliers, and gleaming elevators are all comfortably nestled within the contemporary hotel. For the Millennium celebration, the "Pegasus" revolving sign was returned atop the building at a cost of $600,000.

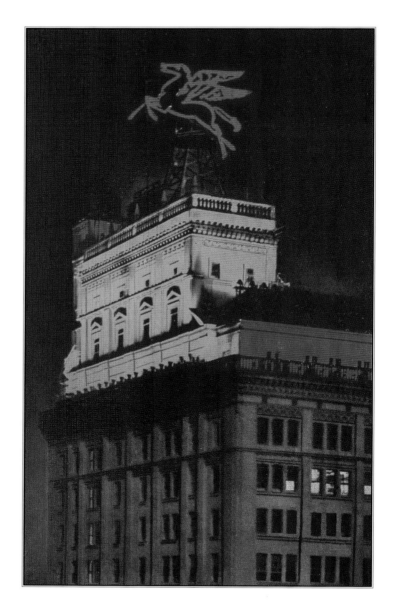

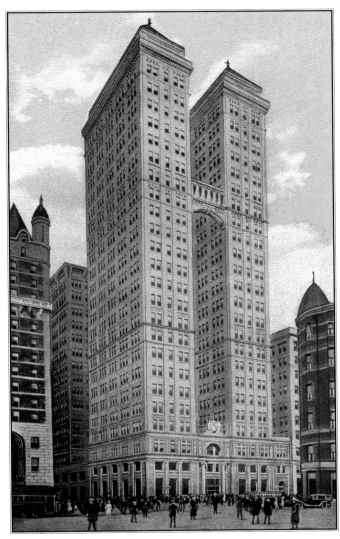

The Magnolia Building after its 1922 completion. The Adolphus Hotel is visible at left with the Oriental Hotel to the far right.

Medical Arts Building

—1717 Pacific—

•

Dr. Edward Cary wanted to create a building that would concentrate medical professionals of all types in one downtown facility. He became the driving force behind the creation of Dallas's Medical Arts Building.

A site was chosen at the intersection of Pacific Avenue, St. Paul, and Live Oak. The Herbert M. Greene architectural firm was chosen, along with St. Louis consulting engineer W. J. Knight, who had worked on the Adolphus and Busch buildings in Dallas. The construction was of reinforced concrete rather than a structural steel framework. In 1922, construction began, and the following year, it was completed.

The final product was a nineteen-story cruciform design of buff-colored brick and white terra-cotta trim. A granite facade reached the second floor. The building quickly filled with physicians and dentists, and by 1926, an addition was needed. A fifteen-story tower was built on the west side above the existing four-story parking garage. Finished in 1928, the expanded building contained two hundred thousand square feet of office space. The ornate lobby was decorated with medically themed murals and adorned with marble columns,

floors, and wainscoting. Cast bronze medallions of famous physicians decorated the elevator doors.

In 1945 and 1950, the building was refurbished twice before being overshadowed by the neighboring Republic National Bank tower. In 1966, the bank took ownership of the medical building when Dr. Cary's son, Ed Cary Jr., got into financial trouble over the planned Cary Plaza project, which later became the Fairmont Hotel. As urban patterns changed and physicians left downtown for the suburbs, the old building struggled to hold tenants, especially younger ones. In 1974, the bank took over operation of the building and initially planned a multimillion-dollar modernization and facelift. Numerous upgrades were needed to conform to current building and fire codes. In those days before downtown housing became fashionable, an older building had to compete with newer office buildings, which could only be accomplished through low lease rates. In 1977, Republic National Bank decided that the Medical Arts investment could not pay for itself. In 1978, despite objections by many preservationists, the historic old building came down. A few years later, it was replaced by an expansion of Republic National Bank.

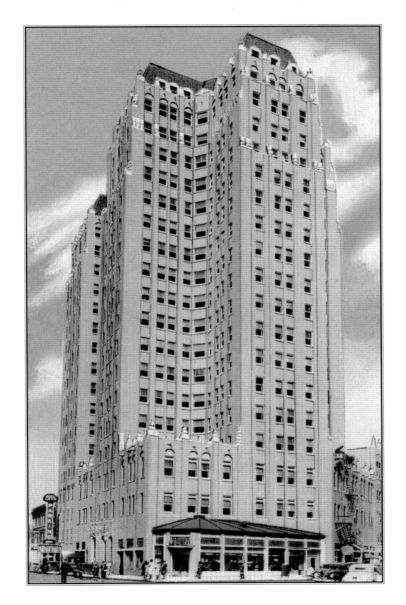

Dallas Athletic Club

—Pacific and Ervay Streets—

The modern office building at 1700 Pacific occupies the former site of one of Dallas's most famous structures, the Dallas Athletic Club (DAC). From 1923 to 1924, the Dallas Athletic Club was under construction at a cost of $2.5 million. Lang & Witchell designed a thirteen-story, Georgian Renaissance structure of red brick and Bedford stone. It contained six bowling alleys, a gymnasium, men's and women's pools, a dining room, and dormitory rooms for one hundred guests. The top five floors were devoted to office space. The building faced St. Paul Street, and a light court beginning at the seventh floor divided the front of the building into two wings. In early 1925, the building opened and became a focal point of Dallas social life.

The Depression years were hard on all private clubs, and the DAC was no exception. Joe E. Lawther, former mayor of Dallas during WWI, then headed up the Liberty State Bank. He worked tirelessly to keep the club afloat. He was also responsible for the development of White Rock Lake in east Dallas. Today, the road that follows the shoreline is named for him.

In 1937, the DAC Building changed names when it became the new home of Mr. Lawther's Liberty State Bank, which was founded in 1920. The bank took the ground floor and basement of the Elm Street side of the building. It featured air-conditioned space, the new air tube communications system, and blue neon ceiling lighting that "served to paint the ceiling sky blue." In 1946, the bank received a national charter and became National City Bank. The DAC Building changed names with it. Eight years later, National City was absorbed into Republic National Bank, already a major stockholder.

From the 1950s, the DAC shifted its focus to golf, eventually building and maintaining a championship golf club in east Dallas. In 1977, the DAC reluctantly sold its downtown headquarters to the McLendon Company. McLendon initially suggested that the classic structure might be converted to luxury apartments, but it was later sold to developer Cadillac Fairview Corporation. In 1981, the building was demolished to make way for First City Bank Center (1982), which is known today as 1700 Pacific.

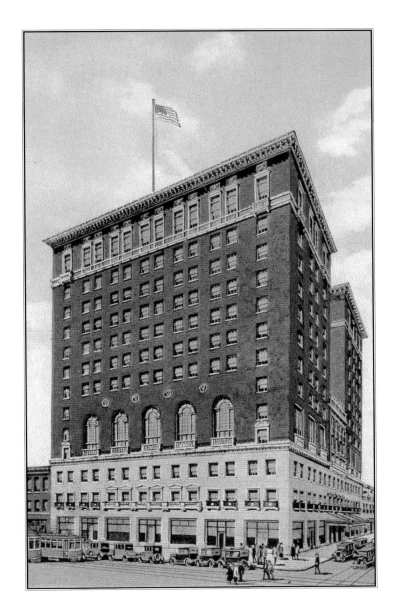

Lone Star Gas Company

—Harwood and Wood Streets—

•

As early as 1873, the city of Dallas used manufactured gas for lighting downtown streets. The gas was carried underground through wooden gas mains. Over the next thirty years, a succession of companies attempted to provide the expensive manufactured gas for the city's needs. With the development of the Texas oil and gas fields in the early 1900s, it became feasible to extract and burn natural gas, but first, it had to be delivered to the marketplace. In 1909, a meeting at the Oriental Hotel created the Lone Star Gas Company, an organization founded to bring the less expensive natural gas to Dallas and Ft. Worth. L. B. Denning, representing the fledgling gas company, met with E. R. Brown, Corsicana oil man and future head of Magnolia Petroleum. Brown's company owned the Petrolia field in Clay County, and Denning successfully negotiated with him for two gas wells. A pipeline was immediately begun from the Petrolia field to Ft. Worth and then on to Dallas. Hundreds of workers, many of them immigrants, were imported from the northeastern United States for the backbreaking manual labor. Working from dawn to dusk with picks, sledgehammers, and shovels, a shallow ditch was carved across the prairie for the sixteen-inch gas line. In April 1910, the 126-mile pipeline reached Dallas. The new fuel was soon flowing through downtown mains.

The small gas company managed in rented space until 1924 when a new four-story building was completed at the corner of Harwood and Wood streets. Lang & Witchell designed the reinforced concrete and brick structure. The $175,000 building featured a facade of reddish-brown brick and terra-cotta and was supported by a foundation that would allow for future additions up to twelve stories. In 1927, the wisdom of that decision was proven when the company's rapid growth called for the addition of two stories to the building. In the midst of construction, the decision was made to add a total of six stories, creating a ten-story headquarters building. Soon, even this was inadequate.

Part of the company's success was the result of tireless pro-

motion of the relatively new resource. During the 1929 state fair, the Automobile Building hosted a massive Lone Star Gas Company exhibit promoting the use of natural gas. An allegorical sculpture featured a twelve-foot-tall 1200-pound worker struggling with a huge gas main beneath a giant map of Texas and a replica of the State Capitol.

In 1930, continued growth in the new utility's customer base led to plans for a companion building to the north of the 1924 structure. The new building at Harwood and Jackson serviced the seventy thousand accounts of the Dallas Gas Company, now a distribution unit of the Lone Star Gas Company system. Like its contemporary, the Dallas Power & Light building, the Dallas Gas building utilized an electrically welded frame. Lang & Witchell were once again called upon for the design. By this time, the art deco movement was in vogue, and the new $800,000 building featured a totally different architectural style. The new structure exhibited the setbacks and artistic flourishes characteristic of the era. A facade of terra-cotta and cream-colored brick extended twelve stories above a base of gray and black granite. A belt of allegorical human figures was featured in the window spandrels above the second floor. The impressive lobby was finished in

black and travertine marble and featured a beamed ceiling painted in brilliant colors. Cream-colored marble pillars were encircled by bronze check-writing platforms. Lobby floors were inlaid with black and white patterned marble. A black marble stairway led to a Spanish-style downstairs lobby with the same beamed and painted ceiling. At the top of the building, an auditorium allowed for gas cooking demonstrations and other educational projects.

In 1950, an additional two-story building joined the Lone Star Gas Company complex. Designed by Mark Lemmon, the $140,000 building occupied the southwest corner of Park and Wood streets, just across from the other structures. The building housed a new exploration department and featured a facade of pink granite and shellstone with limestone trim. It later became a part of the First Presbyterian Church campus.

In 1959, the company observed its fiftieth anniversary. It had grown from only a handful of customers in Dallas and Ft. Worth to more than 834,000 all over Texas and Oklahoma. More space was needed, so in 1966, a seven-story addition was built at 1815 Wood Street to the west of the main buildings. Growth and diversification continued, and by 1975, the company was involved in gas field services, chemical fertil-

izers, synthetic pipe, and thermal energy. A parent company known as Enserch Corporation was set up, and Lone Star Gas Company became an operating unit of Enserch. In 1979, a gleaming, twelve-story glass and white marble tower was erected for Enserch at 1900 Jackson Street.

During the 1990s, Lone Star Gas Company was acquired by Texas Utilities (TXU), the parent company of Dallas Power & Light. Then in 2005, Atmos Energy bought the gas utilities portion of TXU and moved the newly acquired personnel to their headquarters in north Dallas. Having no use for the old Lone Star Gas Company complex, they donated it to the city of Dallas. The city subsequently sold the properties to Forest City Development for redevelopment into downtown housing.

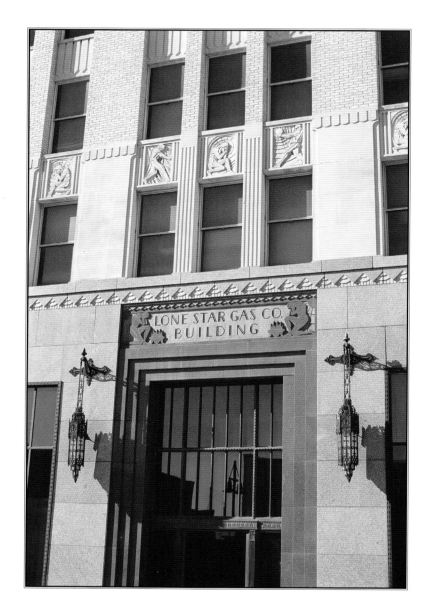

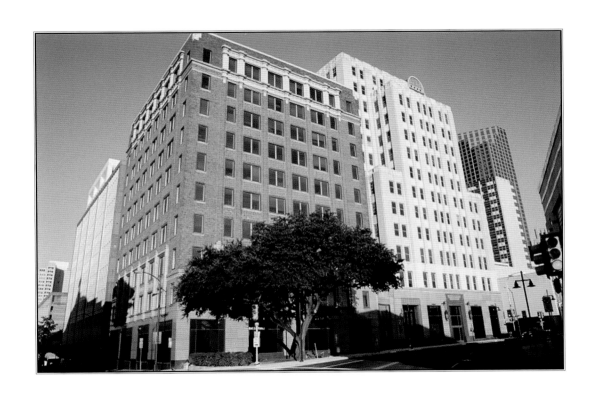

Thomas Building

—1314 Wood Street—

•

Today, few people passing by the boarded-up entrance to the Thomas Building suspect the rich history residing within. Hidden behind the massive AT&T complex, the extraordinarily narrow Thomas Building affords small glimpses of its historic past. The intricate cornice perched eight stories above the street below, the quality of the limestone trim and the bronze metalwork framing the doors hints at the building's credentials from an earlier time.

The Thomas Building was the creation of Mike H. Thomas, a man with the kind of colorful life that is rarely seen today. In 1866, Thomas was born near rural Richardson, Texas. He herded sheep as a youngster. When the family moved to Dallas a few years later, settling near the courthouse, young Thomas sold newspapers and worked as a wrapping clerk for Sanger Bros. He later became the first delivery boy for Western Union in Dallas. As a teenager, Thomas worked as a cowboy on several west Texas ranches, and played minor league baseball.

By the time he turned twenty-one, Thomas had resolved to make his fortune in the cotton business. It became a sizable fortune, which he lost and regained several times. The Panic of 1893, a time of record bankruptcies and soaring unemployment in the United States, wiped out Thomas and his fledgling cotton business. With

$60 in cash and a round-trip railroad ticket in his pocket, Thomas headed for New York to seek a backer and a new start. Having been asked for collateral by one financier, Thomas remarked that he had a wife, two small children, and $265,000 of debt. He earnestly asked the man for a $100,000 line of credit. The amused financier asked Thomas to come home with him for dinner, explaining that he wanted his wife to meet a man with less brains and more nerve than himself. Thomas got the loan. More importantly, he repaid the money within three years and was on the rise again. In 1907, the same New York financier ran into his own financial difficulties and, in turn, came to Mike Thomas for help. A man of legendary generosity, Thomas loaned him several hundred thousand dollars. The man soon died without repaying the loan, prompting Thomas to comment that he had "not expected to see the money again, but he had proven himself to be a friend." On another occasion, Thomas entered a dice game during a transatlantic ocean voyage, winning $44,000. He promptly donated his winnings to the benefit fund for the ship's crew. At one time, Thomas had $5 million in cash deposited locally.

Another of Mike Thomas's famous gambles was the eight-story office building he erected next to the old Cotton Exchange in 1923–1924. Intended for cotton traders, the building was designed

by Anton Korn on a narrow lot, resulting in a frontage of forty-eight feet on Wood Street and a depth more than three times as great. The cream-colored brick and limestone facade featured escutcheons and a fancy cornice decorated with the heads of lions. The purpose-built structure boasted cotton chutes as part of its design.

Thomas wagered the viability of his creation on its proximity to the cotton exchange. He was convinced that any new exchange would be erected near the site of the old one, but events dealt him a cruel blow. In 1926 when the new Cotton Exchange Building was erected, it was on the other side of town. Mike Thomas suddenly had a $500,000 white elephant on his hands. He attempted to market the building for general office purposes, but it proved difficult. By 1932, the building was in receivership and was subsequently sold to the bondholders for just $100,000.

During the 1930s, the building was the scene of several police raids on bookie operations. Gulf Insurance and Reserve Life Insurance spent their early years in the building, and in 1940, the local Boy Scout council moved into the structure, staying for the next twenty-five years. In 1944, one year after Mike Thomas's death, the Thomas Building became part of the Leo F. Corrigan portfolio. By this time, the building was achieving 100 percent occupancy. The Thomas Building weathered the passing years amid increasing deterioration in the area and was eventually shuttered. Today, it is probably a good candidate for conversion to downtown housing, and the historic building awaits a better day.

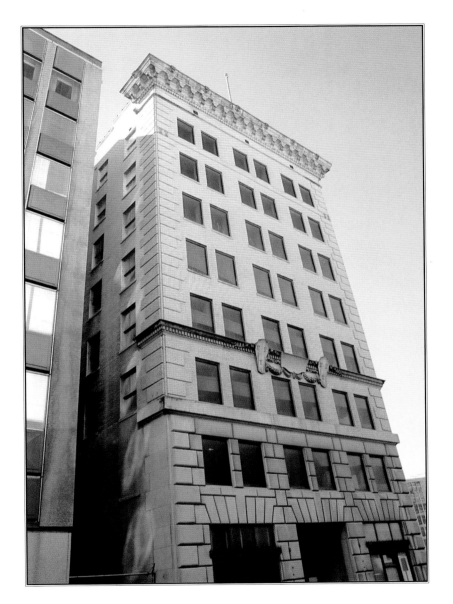

Baker Hotel

—Commerce and Akard Streets—

•

I n the fall of 1924, as soon as the historic Oriental Hotel came down, the equally legendary Baker Hotel started going up in its place. Aiming for a grand opening during the 1925 state fair, construction proceeded at a blistering pace throughout late 1924 and the first months of 1925. At one point, construction crews averaged one floor per week for a period of sixteen consecutive weeks.

Designed for San Antonio hotel magnate T. B. Baker by Preston J. Bradshaw, a St. Louis architect, and John McDonald, the supervising architect, the seventeen-story hotel boasted seven hundred rooms and cost $5.5 million. Much like the Southland Life Building immediately to the east, the Baker featured a red brick facade trimmed in Bedford limestone and terra-cotta. The top of the hotel was finished off with a six-foot overhanging cornice and decorative brackets. Ten retail shops were arrayed around the perimeter of the lobby, which offered entrances on Commerce, Akard, and Jackson streets. The elaborate interior finish included several types and colors of marble and solid walnut woodwork. The lobby-level Georgian dining room featured terrazzo floors and an ornamental plastered ceiling. A grand staircase led to the second floor promenade where the two-story

grand ballroom was the largest in the South, seating 1,750 people. This ballroom became known as the Crystal Ballroom, famous for the Czechoslovakian crystal chandeliers lighting the room. Mezzanine-level banquet rooms included an English room, a French room, a Dutch room, a Spanish room, and a Southern Colonial room. One guest floor was reserved entirely for women and decorated accordingly. Above the guest floors, the glassed-in seventeenth-floor roof garden could accommodate twenty-three hundred diners. A broadcasting studio adjoined the roof garden and was soon occupied by radio station WFAA.

Equipment for the kitchen, coffee shop, cafeteria, engine room, and laundry required forty railroad cars for delivery. Furniture and other accessories required another one hundred railroad cars. Part of the hotel equipment included a chilled-air cooling system.

In October 1925, the Baker Hotel opened to great fanfare. T. B. Baker threw away the keys to the lobby doors, signifying that the hotel would never close, night or day. Dr. William M. Anderson of First Presbyterian Church offered an invocation at the opening of the WFAA studio on the rooftop. Several vocalists

christened the new studios during the premier broadcast. The roof garden was intended for summer dining and dancing, so the design and construction of that area continued through the spring of 1926. Fooshee & Cheek created the garden of a seventeenth century English inn atop the Baker Hotel, with gray, green, and brown flagstones used on the walls and flooring. Low walls of stone topped by weathered cypress railings surrounded the dance floor. Rustic wishing wells with weathered slate roofs broke the walls at intervals, with cages containing live songbirds inserted in place of the well pulley. Overhead, a trellis with trailing vines and twinkling lights suggested a night sky. Brightly colored awnings covered the huge windows. The bandstand was covered with a slate roof and was crowned by a huge peacock with a spread fan and an arched neck. The Peacock Terrace became the Baker Hotel s showplace for many years, creating memories for thousands dining and dancing above the city lights below. During the big band era, Tommy Dorsey and many others occupied the famous Peacock Terrace stage.

Formed in 1934, the Petroleum Club was another occupant of the Baker Hotel roof. In 1935, the elite club, limited to one hundred members, built and occupied a private dining area adjacent to the Peacock Terrace.

In December 1936, the street-level, air-conditioned Mural Room supplanted the Peacock Terrace as the Baker Hotel s summer venue for live shows. It became instantly famous as an intimate spot for big name acts passing through Dallas. Seating 340 patrons, the room was named for French muralist Pierre Bourdelle's bronze, green, and gold murals depicting figures from the Songs of Solomon. An inlaid parquet dance floor was surrounded by tables on a two-level terraced floor arrangement. In the 1950s, Pat Boone made his singing debut in the Mural Room. Tony Bennett, Patti Page, Frankie Laine, and many others performed there before rising talent costs eventually spelled the end for the famed room. In 1956, it was converted to a private club known as the Club Imperial. The murals disappeared during remodeling.

On the morning of June 21, 1946, tragedy struck the Baker Hotel. Just after 11:00 a.m., an enormous explosion ripped the basement, instantly killing seven people and wounding thirty eight. For blocks around, buildings trembled, and plate glass windows tumbled to the sidewalks below. Two blocks away, office workers bounced in their chairs. People and debris were blasted up against the side of the nearby Southland Life Building. Huge chunks of concrete and twisted steel beams were thrown two stories in the air. Thankfully, no fire resulted from the explosion, or the death toll would have soared. A thick cloud of ammonia filled the basement and lobby, hampering escape and recovery. A gaping hole on the east side of the basement showed where the force of the blast had escaped. Dazed survivors were carried

out of the wreckage or hoisted up through manholes. Many of the badly injured received horrific flash burns. Three of these did not recover, increasing the death toll to ten.

All of the dead or injured were either hotel employees or contractors, most of them from the kitchen or laundry areas. No guests were injured, and the hotel continued to operate. Only twenty minutes before the blast, hotel president Fenton Baker had been standing at the basement desk of W. E. Cotton, a purchasing agent. Cotton was dead at his desk after the explosion, crushed by debris. After an investigation, it was determined that the tragedy had occurred from a gas accumulation between the basement and first floor.

In 1949, the Baker family sold their namesake hotel to an investment banking firm. No immediate changes were made in the hotel's operation. In 1953, architect George Dahl was commissioned to update the hotel's public areas. One of his priorities was the old Peacock Terrace. After visiting several similar facilities, notably San Francisco's Top o' the Mark, Dahl converted the Peacock Terrace into a "sky room" by installing huge windows and an illuminated ceiling. The room was renamed the Terrace Room.

In 1971, the hotel was again sold, this time to Bill Clements, a future Texas governor, and his family. A few months after the sale, the hotel was seriously damaged by a fire on the upper two floors. At the time, only half of the hotel's rooms were occupied, but the hotel was still capable of generating cash, especially during the Texas-OU football game.

Beginning in 1972, the old hotel underwent one last restoration, including the Terrace Ballroom and other areas damaged by the fire of the previous year. In 1979, Southwestern Bell purchased the entire block occupied by the Baker Hotel and the old Southland Life Building. In June 1980, after a sale of fixtures, furniture, and memorabilia, the historic old hotel was imploded. Today, AT&T Plaza occupies the site.

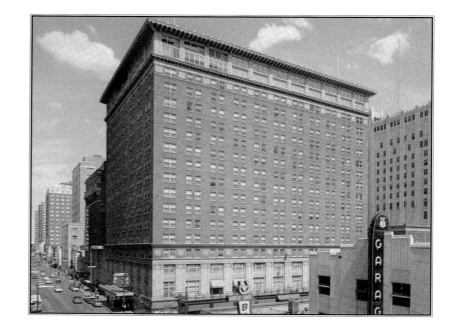

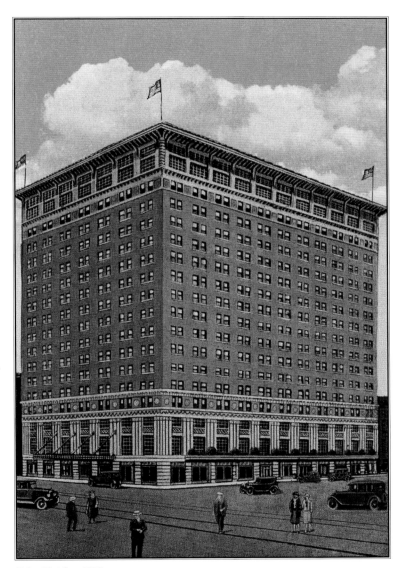

Baker Hotel, c. 1925.

Hilton Hotel

1933 Main Street

During the 1920s, Conrad Hilton started his hotel empire in Cisco, Texas. He bought a handful of medium sized, older hotels around the state, includ ing the Waldorf in Dallas. By 1924, Hilton was eager to build his first high-rise and put his name on it.

A site was chosen at the northwest corner of Main and Har wood, diagonally across from City Hall, on the eastern end of downtown. Hilton commissioned Lang & Witchell to design the structure. They responded with a Sullivanesque, fourteen story structure of reinforced concrete faced with buff brick and terra cotta. The hotel featured the same horseshoe arrangement as the recently completed Magnolia Building. Two soaring towers faced Harwood Street, separated from each other by a light court starting at the second floor. The towers were joined at the tenth floor by an elaborate stonework bridge.

Hilton planned to spend over $1 million on the building, and in the end, spent nearly $1.4 million. On August 6, 1925, the hotel officially opened with the fanfare of a Hollywood premier. The lobby featured a Skillern s Drug store, a barber shop, a beauty parlor, and a tailor shop. These shops were privately owned, leasing space from Hilton, and helped to pay his operating expenses. Each room had a private bath. Hilton marketed the property as a top flight but moderately priced hotel for the average man, coining the term minimax minimum price, maximum service. The hotel s niche was between the opulent luxury of the Adolphus and the faded charm of hotels like the St. George, or Southland.

The Depression years were hard on Hilton, but he managed to hang onto his Dallas namesake. By the late 30s, he had moved to California and broadened his horizons. In 1938, he relinquished his lease on the Dallas Hilton to A. C. Jack White, a former Hilton officer. White changed the name to the White Plaza, a name that would remain on the hotel until 1974. During the 1960s and 1970s, the old hotel declined in popular ity and began to deteriorate badly. All rooms above the fourth floor were closed. After a succession of ownership changes, the hotel had become known as The Plaza Hotel, and in 1985, a restoration began. The building received landmark status, is listed on the National Register of Historic Places, and operated for many years as The Aristocrat Hotel, part of the Holiday Inn chain. The hotel was renovated again in 2006, reopening as the Hotel Indigo.

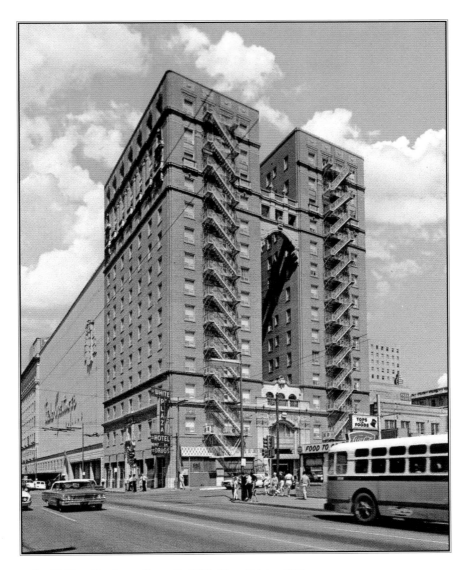

The old Hilton Hotel operating as the White Plaza Hotel, c. 1960.

Cotton Exchange Building

—St. Paul and San Jacinto Streets—

•

In the first decades of the twentieth century, cotton was still an important component of the Dallas economy, and the grading and trading of cotton crops required a suitable exchange facility. In 1911–1912, the first substantial building for this purpose was erected at the corner of Akard and Wood streets across from the future site of the Federal Reserve Bank.

Lang & Witchell designed a seven-story and basement structure of dark red brick and buff terra-cotta, fronting on Akard, but with most of its length along Wood Street. In the summer of 1911, work got under way, and by April 1912, it was completed.

The first floor was primarily used for trading purposes while upper floors contained offices for buyers, brokers, and exporters. There were also freight offices for railroad and steamship lines. Exchange President Shepard W. King, whose palatial Turtle Creek residence became the nucleus of The Mansion restaurant and hotel many years later, presided over the opening ceremonies. Over 250 cotton merchants attended, as did the mayor of Dallas. That evening, a banquet at the Oriental Hotel featured contingents from New York, Chicago, New Orleans, Memphis, and elsewhere.

As the Dallas cotton industry flourished, the 1912 Cotton Exchange building was quickly outgrown. Only one-fifth of the exchange membership was able to be housed in the Akard Street structure. A new site was purchased at St. Paul and San Jacinto streets, on the northeast side of downtown. A much larger structure was foreseen, and competing designs were solicited from Anton Korn, Lang & Witchell, and Thomson & Swaine. The Lang & Witchell design was chosen, in association with Thomson & Swaine. Twenty-two pieces of property were acquired and stitched together at a cost of over $2 million. An enormous area of property around the projected building was purchased in order to preclude future buildings from blocking the available sunlight. Natural north light was crucial for the inspection and grading of cotton, and any tall buildings in close proximity could occlude this important resource. The construction was estimated to cost another $1.75 million.

In January 1926, work on the sixteen-story structure began. The attractive facade utilized cream-colored brick with terra-cotta trim. Construction proceeded rapidly, and at the beginning of September, the building was occupied. Its most prominent feature was the four thousand-square-foot exchange floor with high ceilings, large north windows, and a quotation board that ran the length of the floor.

In the meantime, the former exchange building on Akard was sold, remodeled, and renamed the Construction Building after it was leased to several building industry firms. In 1949, rapidly growing Reserve Life Insurance bought the building and moved over from their Thomas Building headquarters next door. In 1957, the building was modernized and doubled in size. A new exterior of aluminum,

brick, and green porcelain panels was installed. Reserve Life chairman and entrepreneur Charles A. Sammons would become a billionaire from this location on Akard. He also was a leading philanthropist, contributing millions to Baylor Hospital and other charities. In the 1980s, after Reserve Life vacated the building, the derelict structure became a well-known eyesore before being demolished in 2006.

By the 1960s, the 1926 Cotton Exchange Building on St. Paul was also showing its age and needed modernization. The building was still home to 135 members of the cotton exchange, and most of the space was leased. At about the same time that the historic Praetorian Building was being transformed, the Cotton Exchange received a $1.65 million makeover, designed by architect Thomas E. Stanley. During the summer of 1961, the obligatory porcelain panels were installed over the exterior, obscuring the original facade. All mechanical systems were renovated or replaced at the same time. This configuration preserved the old Cotton Exchange building for another couple of decades.

By the late 1980s, the building was timeworn and had become something of an eyesore. There was not yet any downtown housing activity that could justify an adaptive reuse of the decaying structure. In 1994, the winner of a charity contest was allowed to push a detonator button and bring down Dallas's last vestige of the days when cotton was king. As it fell, the building belched out a roiling dust cloud that overtook and engulfed many of the two thousand spectators present. The site was cleaned up and then converted to another downtown parking lot. Some of the bronze memorial tablets from the lobby were rescued and are displayed today in a Turtle Creek office building.

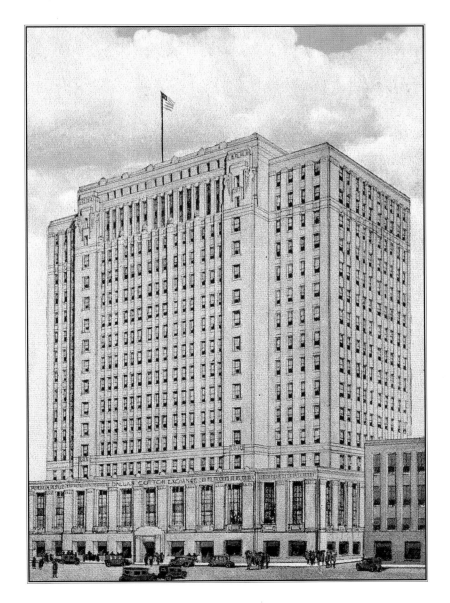

Allen Building

—Commerce and Ervay Streets—

Today, the structure occupying the southeast corner of Commerce and Ervay streets is known as 1700 Commerce Place. It was erected by Colonel Arch Allen, a World War I artillery officer and County Judge. Completed in August 1926, the building was a contemporary of the Santa Fe buildings and the Baker Hotel farther west on Commerce.

Originally planned as a hotel, the structure was later built as an eighteen-story office tower and was known as the Allen Building. Designed by J. N. McCammon and costing $1.3 million, the building was framed in steel and faced with reddish-brown brick and terra-cotta.

It became home to the law offices of Arch Allen after his retirement from the bench. Marvin's Drug occupied a portion of the first floor, and it was hoped to attract doctors and dentists to the upper floors. E. R. Squibb was an early tenant, distributing vaccines and other pharmaceuticals from this location. In 1933, after Judge Allen died in a car accident, his friend, Colonel W. E. Easterwood, bought an interest in the Allen Building Company. Colonel Easterwood was a colorful figure from the early days of aviation in Dallas.

In 1944, the building became known as the Irwin-Keasler Building when two investors bought it for $1.5 million. In 1948, air-condition-ing was added, and the following year, the lobby received a remodeling. In 1950, a new entrance was built.

In 1953, the building's prosaic history took an abrupt turn when it was acquired by the Insurance Company of Texas Group (ICT). ICT provided insurance services to Texas labor union members. It was run by BenJack Cage, a smooth-talking high roller. Upon purchasing the building, Cage proclaimed it an ideal headquarters for his purposes. In years to come, people wondered if his purpose was to sell insurance or commit millions of dollars in fraud. By 1956, the company was insolvent, and Cage had fled to Brazil, a country that conveniently had no extradition treaty with the United States. In August 1957, Cage returned voluntarily to face his accusers and was charged with embezzlement. He was convicted, receiving a ten-year prison sentence before jumping bail and fleeing to Brazil again. Numerous attempts were made to retrieve him from Brazil, where he was engaged in land promotion. Cage claimed to be a farmer in order to evade the customary five-year residency requirement for naturalization. Then, he and his wife turned up with a Brazilian child, claiming it as their own progeny, since the parents of a Brazilian-born child could not be extradited.

In the meantime, the building at 1700 Commerce had been bought and occupied by the National Bankers Life Insurance Company

(NBL). The new signage had barely gone up when it was revealed that Pierce Brooks, National Bankers Life President, had engaged in some convoluted, questionable stock transactions with BenJack Cage. Brooks's financial dealings fell under the scrutiny of state investigators, and he eventually sold his interest in the company, paying $1 million back to stockholders to settle claims against him. The company was reorganized under outside management and prospered throughout the 1960s.

In 1969, controlling interest in the company was bought by Frank Sharp of Houston, a wealthy banker and financier. Within a year, the company was embroiled in the Sharpstown stock fraud scandal. National Bankers Life collapsed when, according to the SEC, its stock was sold at artificially inflated prices in order to create windfall profits for company officers and selected state officials. NBL President John Osorio ended up serving prison time for embezzlement of pension funds.

In the early 1980s, the attractive old building was nicely refurbished. A few years later, Mercantile National Bank moved out of their massive complex surrounding the corner of Commerce and Ervay, and the subsequent deterioration of the abandoned Mercantile buildings made life difficult in this portion of downtown.

Today, 1700 Commerce continues to earn a living as a reasonably priced source of downtown office space. Well past due for a lucky break, the property should benefit enormously from the Forest City redevelopment of the old Mercantile National Bank complex.

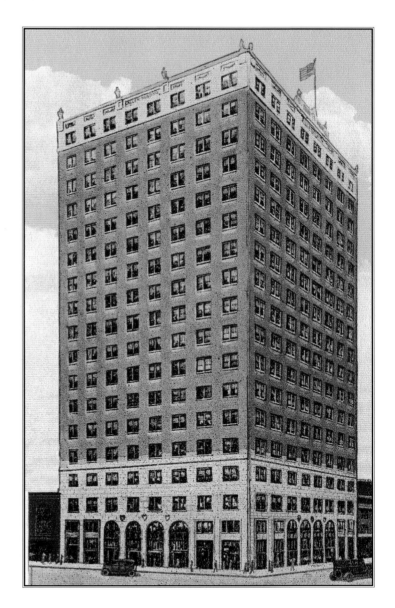

Santa Fe Terminal

—1114 Commerce Street—

•

Since coming to Dallas in 1882, the Santa Fe Railroad had been a major factor in the growth of the area. In 1897, a Santa Fe passenger station was constructed at Commerce and Murphy. In 1916, this station was abandoned when Union Station was opened a few blocks to the west. By the early '20s, the company saw a need for a large freight facility and undertook the construction of a four-unit complex on the site of the old station and parts of several blocks between Commerce and Young streets. The terminal provided warehousing and distribution services for customers of the Santa Fe Railroad.

In September 1923, work started with the razing of the old passenger station and excavations for the new structures. The complex consisted of four separate buildings. First, there was a nineteen-story office building fronting on Commerce with a ten-story rear section for merchandise displays. This unit also featured a convention hall on the fifth floor. Across Jackson Street to the south was the second unit, a ten-story warehouse for general merchandise. The University Club of Dallas placed its clubhouse atop this building. One more block to the south was an eight-story cold storage warehouse, and on Young Street was another eight-story warehouse. All four units were served by an underground railroad that removed congestion and rail beds from the streets above. Five tracks submerged beneath the complex from an entry point on the south side. A special "thermal" locomotive was used to move cars in the switching yard under the complex. Known as the "thermos bottle," it was a quiet, fireless, smokeless engine that operated on steam generated at a stationary filling station.

Whitson and Dale designed a faintly Spanish office building of buff brick with stone trim, capped by an arched copper roof. Four-story arched windows highlighted the Commerce Street facade, along with two setbacks near the top of the building. Huge letters were mounted across the building's crest spelling out the Santa Fe name. The $5 million project required six hundred men and six hundred railcar loads of brick. Eighteen months and two construction fatalities after the groundbreaking, the complex started reaching completion by stages.

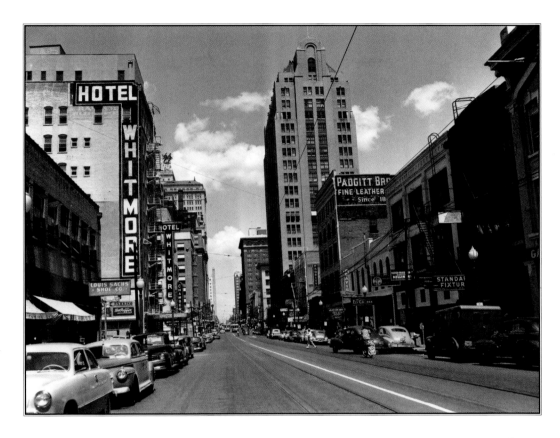

For several years, the Santa Fe Terminal Complex enjoyed a period of intense activity. With the coming of World War II, the Commerce Street office building was taken over by the US Army's Eighth Service Command. This unit of the army provided supply services for a half-million soldiers throughout Texas and the Southwest. Beginning in December 1942, the army spent $100,000 to adapt the facility to its purposes and to remove the massive Santa Fe sign perched three hundred feet above Commerce Street. After the war, the office building remained in federal hands and has housed governmental offices ever since.

University Club of Dallas

—Santa Fe Terminal Complex—

•

In 1919, the University Club was organized under the leadership of George B. Dealey of the *Dallas Morning News*. The club was a gathering place for the power brokers, business leaders, and social elite of the city. Founding members included future mayor Woodall Rodgers, E. M. "Ted" Dealey of the *Dallas Morning News*, and banker and future mayor J. B. Adoue Jr.

The University Club spent several years meeting at the old Oriental Hotel, but it was forced to seek new quarters when the Oriental was demolished to make way for the erection of the Baker Hotel. After a temporary stay at the Adolphus Hotel, a novel concept was hit upon when the club decided to erect a clubhouse on the roof of the ten-story second unit of the Santa Fe Railroad terminal complex. The unit was scheduled for completion in 1926. The club leased the space from Santa Fe to erect a privately owned building. The rooftop club allowed an escape from the stifling heat and afforded the best available views of downtown and Oak Cliff. The club was accessed by an ornamental bridge from the tenth floor of the Santa Fe office building. Fifteen inches of sod were placed on the rooftop to create a lawn in the sky. Flowerbeds and shrubs accented the attractive surroundings. The two-story stucco clubhouse, which was beautifully furnished, included dining halls, parlors, restrooms, and living quarters for members. It was as if an intact clubhouse from a suburban country club had been lifted and placed atop a downtown building. Well-heeled club members could spend an enjoyable evening dining, dancing, and taking in the night views from high atop the Santa Fe warehouse building. In February 1926, the new club opened. It enjoyed several years of success before the Depression hit.

The Depression years were hard on private clubs, and the University Club was no exception. By 1936, the club was $40,000 in debt and its future was in doubt. It was soon decided to sell their rooftop quarters. The property was not idle for long. Maurice Caranas, a dancer, and his wife announced plans to open a new supper club in the space. The new club featured dining, dancing, and floor shows and was known as

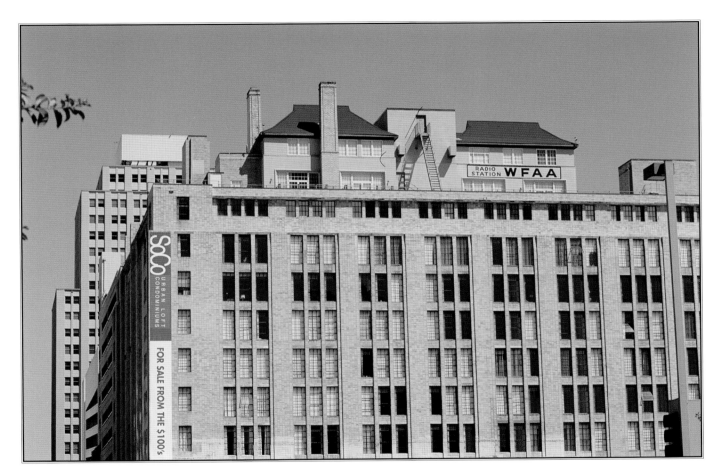

Chez Maurice. The clubhouse was redecorated and given a distinctive red tile roof. Chez Maurice hosted well-known big band acts and, during the late 1930s, was the scene of many memorable evenings.

During the 1940s, radio station WFAA utilized the lofty perch as a broadcast studio. The rooftop structures still wear the radio station banner today.

Republic National Bank Building/Davis Building

—1309 Main Street—

•

The twenty-two story Davis Building at 1309 Main Street began as the new home of the rapidly growing Republic National Bank. Republic National Bank was derived from Guaranty Bank & Trust, which was founded in 1920. That same year, Guaranty Bank & Trust was granted a national charter, and the name was changed to Republic National Bank.

In 1925, construction on the new building began, and at the start of 1926, the bank moved in. Architect C. D. Hill, whose previous credits included Dallas City Hall, First Presbyterian Church, and City Temple Presbyterian, designed a tall, lean, classic revival masterpiece on the site of the old Scollard Building. Corinthian pilasters highlighted the attractive limestone facade. The bank was separated from its next-door archrival, First National Bank, by a narrow service alley known as Exchange Place, or "Money Alley."

The bank occupied the two basement floors, as well as the ground and mezzanine levels, but it was soon bursting at the seams. In 1929, a merger with North Texas National Bank boosted the young bank's assets over $60 million, and more space was needed. In 1931, the original tower was cloned by moving the west wall fifty feet toward Field Street and adding a duplicate facade to the new portion of the building. C. D. Hill had succumbed to a stroke shortly after the original building was occupied, so Coburn & Fowler, his successors, were used to design the enlarged building. The building was only slightly taller than the First National Bank building next door, but a copper-gilded cupola over the 1926 portion of the building gave Republic National Bank clear bragging rights. The cupola was outlined with red neon tubing that could be seen for miles. During the 1931 expansion, tragedy struck when a glass fitter fell ten stories to his death, landing near the Main Street entrance doors.

The year 1931 was a banner year for Dallas building activity despite the Depression. The Republic Bank Annex, the new Dallas Power & Light building, the Tower Petroleum building, the Dallas Gas (Lone Star Gas) building, and the new YMCA building were all completed in one year. The Dallas Power & Light, Tower Petroleum, and Dallas Gas buildings

exemplified the new art deco style. The $6 million in new construction was celebrated in grand style by floodlighting the new structures and staging a rotating radio broadcast from each of the new buildings, featuring speeches and choral presentations.

In many ways, Fred F. Florence, Republic National Bank's president, was the driving force behind the success of the bank. The son of Russian immigrants, Florence moved as a child from New York City to the improbable destination of Rusk, Texas. At the age of sixteen, he began his career sweeping bank floors. In the years leading up to World War I, Florence worked at several small-town banks, patiently learning the trade. In 1917, he entered the aviation corps, leaving as a Second Lieutenant two years later. After being discharged, he became president of a bank in Alto and was also elected mayor. In 1920, Florence moved to Dallas to join Guaranty Bank & Trust as first vice president during its initial year, and in 1929, Florence assumed the presidency of Republic National Bank. He was thirty-seven years old. Over the next three decades, Florence guided the institution from $60 million in deposits to almost $900 million and a position as the nation's sixteenth-largest bank. Along with R. L. Thornton of Mercantile National Bank and Nathan Adams of First National Bank, Florence played a crucial role in bringing the

1936 Texas Centennial Exposition to Dallas, which put the city on the national map. Florence served as president of the exposition, and followed up with the presidency of the Pan American Exposition the following year. By all accounts, the man was a bundle of energy, a tireless marketer, and a financial genius. He was also a philanthropist, a civic leader, and a tremendous asset to the city.

Republic National Bank continued to prosper in this facility for two more decades, vacating the structure in 1954 when the new Republic Bank Center was completed. The building soon had its name changed to the Davis Building. A two-year modernization program followed, and for a time, even First National Bank leased ground floor space in the building. An underground tunnel beneath Exchange Place linked the two structures. First National Bank eventually built its own new tower on Elm Street and then moved out.

In the 1970s and 1980s, the Davis struggled like many older buildings to attract tenants as newer spaces became available. Its future was by no means certain. It could easily have met the same fate as its next door neighbor, the old First National Bank, which was razed in 1985. Fortunately, the Davis was preserved, converted to downtown luxury housing, and opened in 2003.

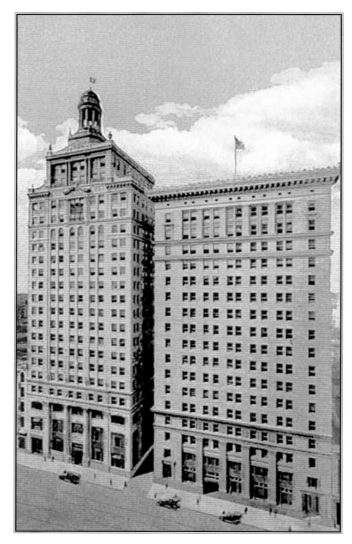

Republic National Bank (left) and First National Bank, c. 1926. The two rivals were separated by "Money Alley."

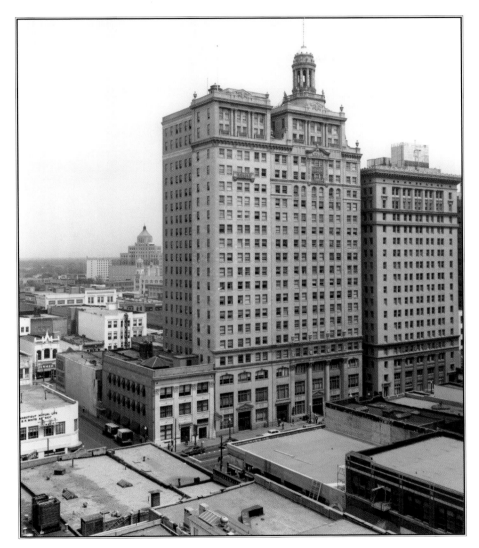

The enlarged Republic National Bank (left) and First National Bank, 1930s.

First Methodist Church

—Ross Avenue and Harwood Street—

•

Methodism in Dallas dates back to the middle of the nineteenth century. By the early years of the twentieth century, the downtown area boasted two large Southern Methodist Episcopal congregations in close enough proximity to compete for members. Trinity Methodist Church at McKinney and Pearl and First Methodist Church at Commerce and Prather each boasted close to one thousand members. In order to form a stronger, unified, downtown church, a plan was devised in 1916 to merge the two congregations. Once this was accomplished, a suitable home for the consolidated churches was needed.

A site was identified at Ross Avenue and Harwood Street where a "cathedral of Southern Methodism" was to be erected. In May 1921, ground was broken for the magnificent English Gothic structure, and in October, the cornerstone was laid. Architect Herbert M. Greene provided the early designs. The former First Methodist Church property on Commerce was sold, and then the building was razed.

The former Trinity Methodist site at McKinney and Pearl became the temporary home of the combined churches while construction proceeded. The process took considerably longer than originally planned, presumably because of the $650,000–$700,000 price tag on the new building. Once the foundation was complete, the project languished until the fall of 1924. When work resumed, R. H. Hunt was the architect, and with a slightly modified set of plans, construction proceeded in earnest.

In the meantime, a third great church was spun off when First Methodist Church agreed to give the proceeds from the sale of their old building to the congregation of the new Highland Park Methodist Church. This congregation was largely made up of Southern Methodist University (SMU) students and residents of the new Highland Park area. The congregation had been meeting for several years as part of First Methodist Church, but this new arrangement allowed Highland Park Methodist Church to use the funds for construction of their own church at Mockingbird Lane and Bishop Boulevard.

In February 1926, the new First Methodist Episcopal Church,

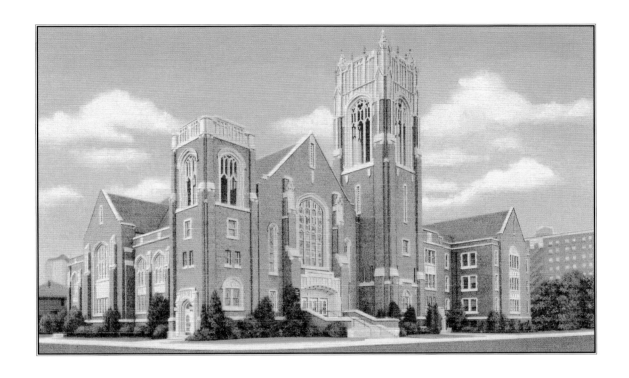

South was completed and occupied. The impressive Gothic exterior was matched by a beautifully finished main sanctuary that seated over two thousand worshippers. A lofty, barrel-vaulted ceiling soared overhead, and huge stained-glass windows illuminated the interior.

In 1939, denominational changes dictated a name change for the downtown congregation when it became simply First Methodist Church of Dallas. Reflecting further denominational movements, this was modified in 1968 to First United Methodist Church.

Dallas National Bank Building

—1530 Main Street—

•

The Dallas National Bank was organized in 1920 and grew so quickly that by 1925, a dedicated building was needed. A site at 1530 Main St., occupied by the thirty-six-year-old Deere Building, was chosen. The old building had been known as the Juanita Building until 1917 when it was purchased by the John Deere estate. Architect C. D. Hill, known for his designs of the new City Hall and the Republic Bank Building, was chosen to design the bank structure. Hill passed away just as plans were being drawn up. His successors—Coburn, Smith, and Evans—completed the task. The lot chosen was narrow and deep—fifty-three feet by ninety feet—so the building design had to be tall and narrow.

A fifteen-story steel and brick structure was erected with a basement and a subbasement. A Gothic Revival facade of Bedford limestone rose above a base of rose granite. Matching terra-cotta was utilized at the top of the structure. A seventeen-foot-wide and thirty-foot-high Gothic archway provided the entrance into the building. The archway was carved with rope moldings and panels. Bronze doors led from the vestibule into the building interior. The bank was floored in gray Tennessee marble and wainscoted with pink marble. Wrought iron Gothic-style light fixtures hung in the elevator and bank lobbies.

The Dallas National Bank occupied the first basement, ground floor, and mezzanine of the building and operated from this location for twenty-seven years before being merged into the First National Bank in 1954. In order to transfer the assets of Dallas National Bank into the newly remodeled First National Bank building just down the street, the heavy bronze doors were removed from their hinges, and the exodus began. An army of police officers wielding sawed-off shotguns and machine guns stood guard as millions of dollars in cash and securities were loaded into armored cars and driven down to Money Alley between First National Bank and Republic National Bank. The ground floor of the vacated bank was left open as an arcade between Main and Commerce, pending arrival of a new tenant. A couple of years later, three twelve-ton vault doors were jack-hammered loose from the

steel-reinforced concrete in the basement, inched across the bank floor on timber tracks, and lifted by crane onto flatbed trucks. The doors were installed in other institutions.

The building was quickly purchased by A. Pollard Simons, millionaire land developer, insurance executive, and entrepreneur. Simons restored the building, renamed it the Simons Building, and moved several of his companies to this location. Bond Clothiers took all of the previous bank space for their downtown location and operated successfully there for many years. In 1974, after Simons died, the building again changed hands, eventually housing Swiss real estate developers, SPG International, who gave the building their name for a time. Like many older structures in the 1980s and 1990s, the narrow old bank building struggled for tenants and then fell vacant. Happily, however, the Dallas National Bank building will find new life in 2006 as the Joule Hotel after developers pour tens of millions of dollars into the historic property.

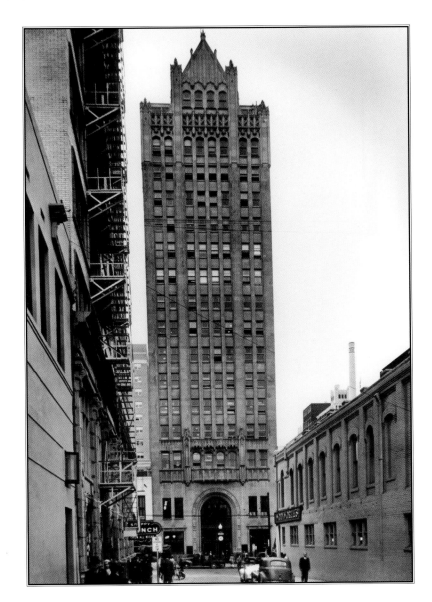

Gulf States Building

—Main and Akard Streets—

•

In 1926, the northwest corner of Main and Akard streets almost became home to a twenty-four-story office tower. Druggist Z. E. Marvin owned the land beneath the three-story Rowan Building (1884) where Mr. Marvin had maintained a drugstore for several years. In late 1925, the property was leased to J. N. McCammon for the construction of a twenty-four-story office building. McCammon planned to erect a three hundred-foot steel building, faced in black brick and trimmed in gold terra-cotta. His model was the American Radiator structure in New York. The interior would be finished with polished marble and feature ornate coffered ceilings. Unfortunately, the project never came to fruition. McCammon was in the midst of the Allen Building's construction, and some observers thought that perhaps both projects were too much.

Instead, Mr. Marvin settled for a more modest project that would continue to house a location of his Marvin Drug Company. The Main and Akard intersection was one of the busiest in the city, so it was an ideal location for a drugstore. Started as a four-story structure, an eventual ten-story tower was erected on the northwest corner of the intersection. Shortly before Christmas 1927, it was completed. The Marvin Drug store occupied most of the ground floor with the upper stories devoted to office space. By headcount, thirty thousand people attended the grand opening.

In 1931, the Gulf States Life Insurance Co. purchased the building for $600,000, and announced that six stories would eventually be added to the structure. Lang & Witchell, architects of the original building, were retained to design the addition. The building was rechristened the Gulf States Life Building.

In 1935, in addition to the heightening of the building, a lobby enlargement and remodeling was undertaken. Italian marble was used to refinish the lobby, along with an ornamental silvered ceiling. A fourth elevator was added, as well

as bronze elevator doors bearing the seal of the insurance company. The company continued its rapid growth and, in 1938, purchased the Southland Life Insurance Company. In an unusual twist, the firm took the Southland Life name and moved into Southland Life's headquarters. The Main Street space was vacated almost immediately.

In 1940, Marvin's Drug was merged into the Skillern's chain, and the lobby drugstore was expanded and remodeled. For many years, the Skillern's banner graced the outside of the Gulf States building, which remained at the heart of downtown activity. By the 1960s, age and competition were catching up with the old structure.

In 1969, Hudson & Hudson Management Co. purchased the building from Southland Life, and in 1975, it was sold to another real estate company and then renamed the Collum Building. Amazingly, the building soon achieved 90 percent occupancy, including a Delta Air Lines ticket office on the ground floor.

The next couple of decades were unkind to the old building, and by the 1990s, the former Gulf States building was a decrepit, boarded-up eyesore with a basement full of water that reeked to pedestrians on the streets above. The building had passed into the hands of a Hong Kong investor who had forgotten it was in his portfolio. Demolition loomed until Alice Murray, project leader of the Kirby Building redevelopment across the street, got the absentee owner to substantially lower his price. She borrowed the money for reconstruction and then rolled up her sleeves to convert the old building into more than sixty luxury apartments. In 2006, the Gulf States Building reopened as part of the Third Rail Lofts development.

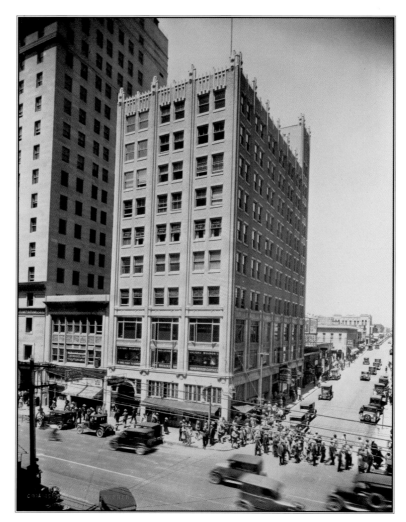

Above: *Marvin (Gulf States) Building, c. 1928. Marvin's Drug store and Jas. K. Wilson's Victory-Wilson clothing store were major tenants when the building opened.*

Right: *Intersection of Main and Akard on a rainy afternoon in 1932.*

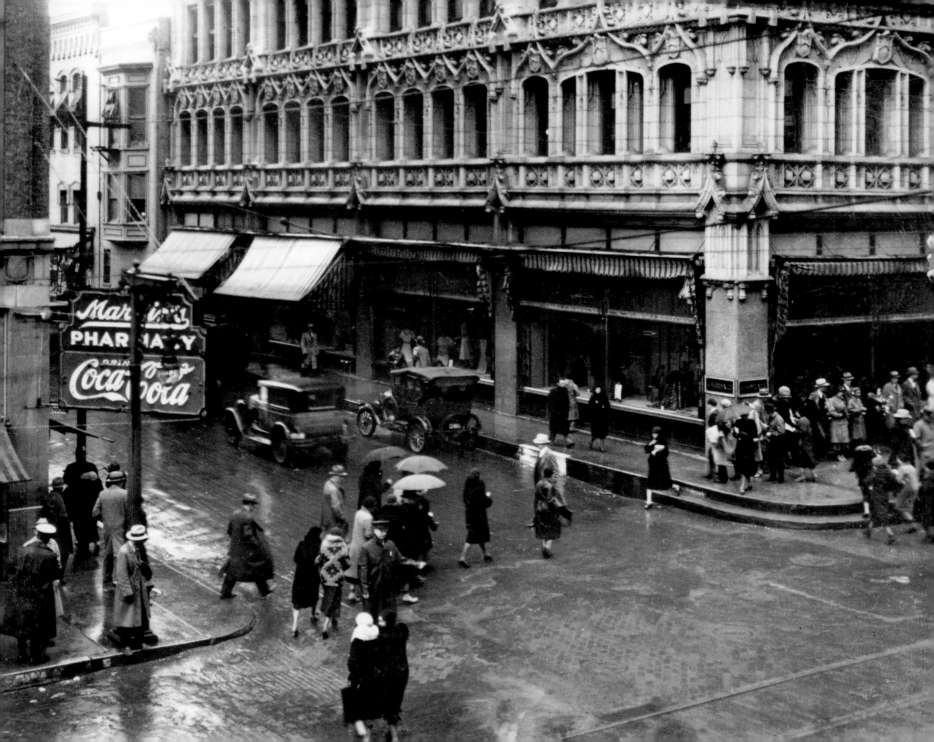

Dallas County Records Building

—509 Main Street—

•

By the mid 1920s, the old red courthouse was bursting at the seams. The growth in Dallas County and its government had made it difficult to house all county offices within the courthouse. The commissioners decided to build a "hall of records" rather than incur the expense of constructing an all-new courthouse. Certain county offices, especially those requiring voluminous record storage, would move to the new building. A site was chosen on the east side of the Criminal Courts Building on Main Street. The Records Building would face Jefferson Street to the east and extend from Main to Elm. (Jefferson Street no longer exists downtown.)

Architects Lang & Witchell were asked to design the building. They responded with a six-story, neo-Gothic Revival structure fronted with a limestone facade. The building was intended to be modern, efficient, and most of all, fireproof. The only wood allowed in the building was the furniture. A large basement provided vaults to house county records. Total cost for the structure was $860,000.

In early 1927, work got under way, and in July 1928, it was completed. The County Tax Assessor-Collector, County Clerk, County Treasurer, and certain courts transferred over from the courthouse. By the 1950s, the Records Building itself was bursting at the seams. In late 1953, a $2 million annex along Elm Street was started, and in 1955, it was occupied. The top three floors were occupied by a new jail facility that housed over 450 inmates. Most of the District Courts were also housed in the new facility.

The building is still in constant use today, housing county tax, treasury, and clerk functions.

Telephone Buildings

—Jackson and Akard Streets—

The massive, five-building AT&T complex spanning four city blocks in downtown Dallas started out in 1898 as a solitary little building prosaically known as the Telephone Building. The original structure of two stories plus a basement was situated on the southeast corner of Jackson and Akard streets and featured a facade of red brick and stone. The handsome Jackson Street entrance was flanked by polished marble pillars. Atop the cornice at the crest of the building was a large American eagle carved from stone. Designed by H. A. Overbeck for the Southwestern Telegraph and Telephone Company, the facility was ready for use in February 1899. The basement provided repair facilities for telephone equipment, while the ground floor was divided into management offices. The upper floor housed the telephone exchange, containing switchboards, other equipment, and the nineteen operators needed to serve one thousand Dallas subscribers. A total of twenty-five long-distance circuits flowed from the city. As telephone usage expanded, the tiny building grew crowded;

an addition of two stories was completed in 1903.

By 1911, subscriptions to local phone service had risen to nearly twenty thousand. Overhead wiring and telephone poles had begun to be removed from city streets and placed in underground conduits. An exchange on Haskell Street was taking much of the load away from the downtown building. A site at Akard and Wood streets, just south of the four-story Telephone Building, was secured for future expansion. In 1927, Lang & Witchell were retained to design a thirteen-story structure of buff brick and terra-cotta. The 270,000 square foot building was to contain an auditorium, an emergency hospital, and a roof garden. It was proposed to cost $2.6 million.

Once completed, the building featured a main entrance on Akard Street. An arched doorway led to a first floor lobby devoted to customer service activity. The entrance was framed in gray granite and topped by a large stone bell symbolizing the company name. Lobby ceilings were nearly

twenty-eight feet tall and decorated with fancy molded cast plaster. Walnut woodwork and Tavernelle marble counters highlighted the lobby. Patterned marble floors and marble columns were also featured. Elevator doors were embossed with the company logo. Ornate stairways led from the lobby to the mezzanine floor, which was used for clerical purposes. The remainder of the building was devoted to telephone equipment and offices, including the state headquarters of Southwestern Bell Telephone, which had occupied several floors in the Fidelity Building for the last few years. In November 1928, the new building was occupied.

Shortly after completion, work began on moving the original Telephone Building twenty feet to the east to conform to the line of the new building. This would allow for eventual widening of Akard Street. Several months of preparation were required for the day when the relocation would begin. The building was braced inside and out and then placed on steel rollers resting on steel rails. Five hundred and ninety jacks elevated the building three-fourths of an inch for moving. Once preparations were complete, the forty-two hundred ton building required thirty-six hours and $75,000 to move.

The company had always planned to replace the original Telephone Building with a larger structure, and in 1961, they moved in that direction with their announcement of an addition to the 1928 building that would triple its size. The twenty-three-story, $9 million addition would adjoin the present building on its north side and require the demolition of the 1899 building. In May 1961, after sixty-two years of service, the little Telephone Building was demolished with little fanfare. Then, the 1928 building was raised in height to conform to the new addition. The enlarged building also featured two basement and two penthouse levels. Completion was scheduled for 1963.

The construction of the building was plagued by several accidents, including one fatal plunge by a fifty-three-year-old ironworker. The unfortunate man was using a hook to pull metal decking into position when the hook broke free, sending him over the edge of the twenty-third floor. Undaunted, the ironworkers kept up the pace and completed the building on schedule. Three decades later, this building would become known as Three Bell Plaza.

In 1976, Southwestern Bell's real estate holdings expanded across Akard Street with the purchase of the twenty-two-story Life of America Building at the northwest corner of Jackson

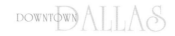

and Wood. The tower had been built by Central Industries in 1948, the first major office building erected downtown after World War II. It was originally named the M & W Tower after company principals McCright and Williams. Over one-third of the space in the $3 million building was leased by Southwestern Bell, constricted for space by wartime restrictions. The building frame was riveted steel, and the gymnastics of the ironworking crew provided a lunchtime spectacle for throngs of downtown office workers who had not seen a major building erected since the Mercantile Bank Building in 1942. The high-wire act performed by rivet heaters, catcher and riveters, and bucker-uppers was loud but endlessly entertaining. The structure was faced in light-colored brick and Indiana limestone above a base of rose and black granite. The lobby was finished with rose travertine wainscoting and a base of Italian green marble. The stainless steel doors were monogrammed with the M & W crest. After only three years, the building was purchased and renamed when Life Insurance Company of America moved their offices to Dallas from Ft. Worth.

After Southwestern Bell's purchase of the building, it was remodeled to conform to their building across Akard Street.

It would eventually become Four Bell Plaza, after Southwestern Bell had erected the modern One and Two Bell Plaza buildings along Commerce Street. Today, the Southwestern Bell (now AT&T) complex occupies a massive four-block area bounded by Commerce, Wood, Akard, and Browder streets.

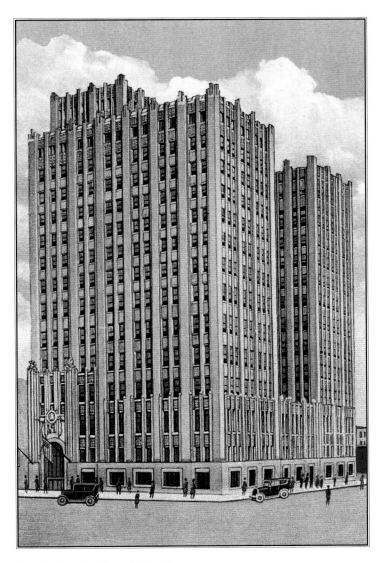

1928 Southwestern Bell Telephone Building.

Titche-Goettinger & Company

—Main, Elm, and St. Paul Streets—

•

Edward Titche came from a merchant family. Before he arrived in Texas in 1894, he had spent most of his twenty-eight years helping out in his father's store or working at other retail establishments. Titche came to Texas to take over his uncle's store after the uncle was slain by robbers. The small store at 508 ½ Elm Street became the Edward Titche Company and the foundation of a retailing legend. Titche later befriended Max Goettinger, a manager for another Dallas department store. In 1901, they ran across each other on a buying trip back East and decided to visit the Pan American Exposition in Buffalo, New York. President McKinley made an appearance at the event, and while they watched in horror from a distance of fifty feet, a Polish anarchist gunned him down. Titche and Goettinger stayed awake late into the night talking, and they resolved to form a partnership upon their return to Dallas. In 1902, Titche and Goettinger opened their new store on the southwest corner of Elm and Murphy, but this was quickly outgrown.

In 1904, they moved to the newly completed Wilson Building at Main and Ervay. Titche-Goettinger occupied the basement and first two floors of the building. Entering from Ervay Street, the first thing the shopper saw was the grand stairway to the second floor. The stairway was constructed with marble steps, wrought iron railings, and mahogany handrails. The balcony around the second floor was liberally gilded. At the top of the grand staircase was a rest area and writing room for ladies known as "The Palms." It featured easy chairs, mahogany tables with stationery, and enormous palm plants. Another rest area for female shoppers was pagoda-shaped and decorated with Japanese furnishings. Throughout the store, display fixtures were of mahogany and glass.

By 1910, the store had outgrown the available space. The upper floors of the Wilson Building were already leased to doctors and other professionals, so a narrow, twelve-story addition to the Wilson Building was built for Titche-Goettinger on Elm Street. Designed by Sanguinet & Staats, it adjoined the

original building on the west side. The brickwork for the annex matched the original structure and was decorated with ornamental stone and terra-cotta. In 1911, the annex opened with the department store occupying all floors.

As the company prospered in the late 1920s, a much grander store was envisioned. The architectural firm of Greene, LaRoche & Dahl was called upon to design the seven-story, two-basement structure occupying the corners of Main, Elm, and St. Paul streets. Approximately $2.5 million was required to build the grand new Florentine Renaissance building, as well as two million pounds of west Texas white stone quarried in Lueders, Texas. Arched entrances lined with travertine marble led into the store from Elm, St. Paul, and Main. Ornamental seals decorated each archway. Interestingly, a likeness of the city's supposed namesake, George Mifflin Dallas, was above the Elm Street entrance. Exterior wall sconces allowed floodlighting of the building's exterior.

The interior of the store was equally impressive. The first floor featured eighteen-foot ornamental ceilings supported by cast-iron columns topped with ornamental crowns. Patterned terrazzo marble floors were underfoot. Wood-paneled executive offices were located on the sixth floor, and an auditorium seating six hundred people was located on the seventh floor. On the fifth floor, where furniture and interior decorating galleries were housed, the elevators opened into a Mediterranean foyer with textured plaster walls and a ceiling of antiqued oak and cypress beams. A vaulted monastery walk, copied from one in Spain, led to the interior decorating gallery. Modeled after a palace in Seville, this gallery featured an antique decorated, oak-beamed ceiling. The entrances were tiled, and the corner fireplace was copied from a Florentine palace. Period rooms showcased different styles of furniture, including a French-themed room similar to Marie Antoinette's at Fontainebleau.

The public was dazzled. Founders Titche and Goettinger were on hand for the grand opening but not as active owners. Earlier in the year, they had sold out to Hahn Department Stores. The two men formed an investment partnership and then moved across the street to the Tower Petroleum Building. Titche died in 1944, followed by Goettinger in 1959.

In 1953, downtown retailing was still vibrant, so a large addition was undertaken on the east side of the structure, expanding the store to five hundred thousand square feet. Thomas, Jameson & Merrill designed the addition using

Indiana limestone that closely matched the original building. To save costs, no windows were provided above the first floor. A massive floodlit Titche-Goettinger sign stretched 175 feet across the face of the building next to a forty-eight ton cartouche depicting Texas under six flags. The massive limestone emblem was carved by hand in an Indiana quarry and transported to Dallas in sections. Escalators to all floors were installed. The gigantic store needed three restaurants. One of them, a tearoom, featured mink-coated models parading while customers dined. The auditorium seated sixteen hundred people and was made available for use by women's clubs. In March 1955, the addition opened.

In 1978, the Titche-Goettinger stores became part of the Joske's chain, and it was under this name that the downtown store operated until 1986. After nearly sixty years of continuous operation, the old Florentine palace was shuttered for good. Many worried that the historic structure would not survive, but rising interest in downtown residential properties allowed the building's rebirth as 1900 Elm, comprised of 129 apartments in the original 1929 portion. Oglesby-Greene Architects designed the renovation, which was completed in 1997. A consortium of area universities leased three floors in the 1955 addition on the east side of the building for downtown educational facilities.

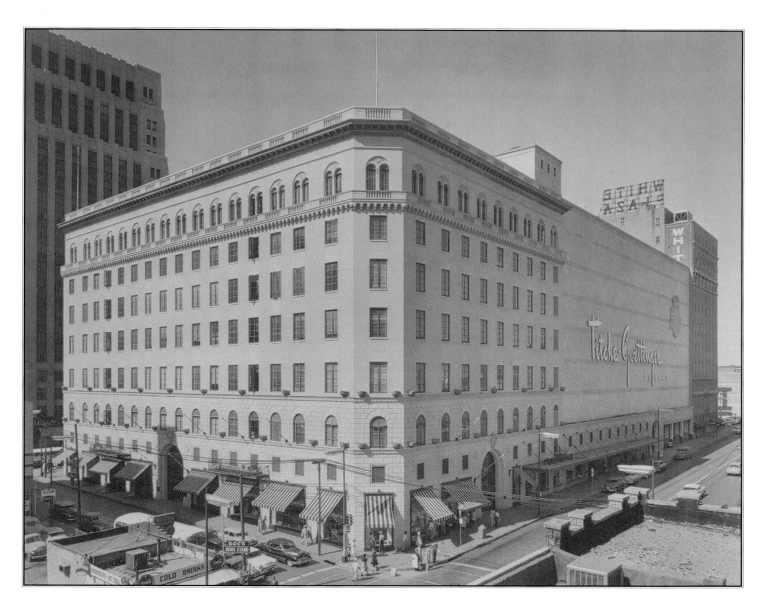

The Dallas Times Herald Building

—Pacific Avenue and Griffin Street—

•

For more than a century, the city of Dallas enjoyed a spirited competition between its two leading newspapers—the *Dallas Morning News* and the *Dallas Times Herald*. The *Dallas Morning News* got its start in 1885; the *Dallas Times Herald* began publishing in 1888 after a merger between two older papers. Originally known as the *Dallas Daily Times-Herald*, the paper was published in a three-story building adjoining the police station on Commerce Street, just west of the 1889 city hall and fire station. The building was erected by C. H. Huvelle, a French immigrant. His original Dallas home occupied the site of the future Adolphus Hotel.

The paper struggled through its early years, experiencing numerous ownership changes while the rival *Dallas Morning News* surged forward under the leadership of Colonel Alfred Belo and George B. Dealey. In 1896, the *Dallas Daily Times-Herald* began to reverse its fortunes when it was purchased by Edwin J. Kiest, a native of Chicago. Kiest had grown up in modest circumstances and sold newspapers as a small boy in order to help support his family. As a teenager, he was fasci-nated by the newspaper trade and learned the business from the ground up. He later secured a job with a company that supplied newsprint and printing supplies to the newspaper industry. In 1891, when he was thirty years old, the company sent Kiest to run their Dallas office. After studying the newspaper industry in Texas for a few years, Kiest secured financial backing and purchased the struggling *Dallas Daily Times-Herald*. It would become a labor of love.

In 1901, a fire on the third floor did considerable damage to the small Commerce Street building. A few years later, the growing newspaper moved to a new location at 1305 Elm Street. It had a grand entrance featuring Corinthian columns and a blackboard for posting the latest sport results. The paper remained there for the next twenty-three years. During these years, the quality and acceptance of the paper grew. The *Dallas Daily Times-Herald* remained an afternoon paper, and in those years before television, many Dallas residents subscribed to both the *Dallas Morning News* and the *Dallas Daily Times-Herald* in order to get the latest news coverage.

Kiest was a careful and deliberate man, and he made the Elm Street building suffice while he planned and saved for a more fitting home.

In 1929, his opportunity came when he was able to erect a $1 million three-story building at Pacific and Griffin from cash on hand. The *Dallas Daily Times-Herald* now enjoyed a circulation of over sixty thousand newspapers and also owned KRLD radio.

Designed by Lang & Witchell, the new building featured a minimalist facade of brick and limestone with a primary entrance on Pacific Street. The first-floor business offices were lavish, with patterned terrazzo floors, wainscoting and counters of verde marble, and ornamental ceilings and light fixtures. The new building served the paper for the remainder of its existence. In 1941, Kiest died a millionaire after bequeathing land to the city for Kiest Park. His beloved paper was then achieving a circulation of nearly one hundred thousand. In future years, the *Dallas Daily Times-Herald* would add a morning edition to offset declining afternoon readership fueled by the advent of evening television news broadcasts. The paper's official name was also changed to the *Dallas Times Herald*.

Over the years, the *Dallas Times Herald* generally came to be seen as the more liberal, working class paper for Dallas while the *Dallas Morning News* developed a reputation as a conservative, white-collar publication. After years in the shadow of the older paper, the *Dallas Times Herald* came close to achieving parity with the *Dallas Morning News* during the 1970s, but the triumph was short-lived. Declining suburban circulation during the 1980s threw the *Dallas Times Herald* far behind the *Dallas Morning News*, and in 1991, the A. H. Belo Corporation, publisher of the *Dallas Morning News*, bought out the *Dallas Times Herald*. After 103 years, the city's second newspaper was discontinued, and its 1929 headquarters building was demolished.

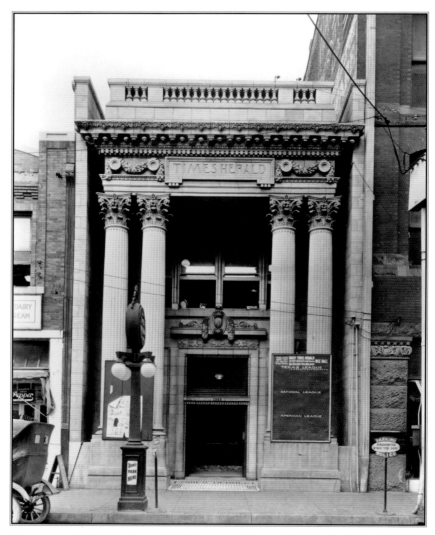

Above: *1305 Elm, home of the Dallas Times Herald from 1906 to 1929.*

Right: *Dallas Times Herald lobby, c. 1930.*

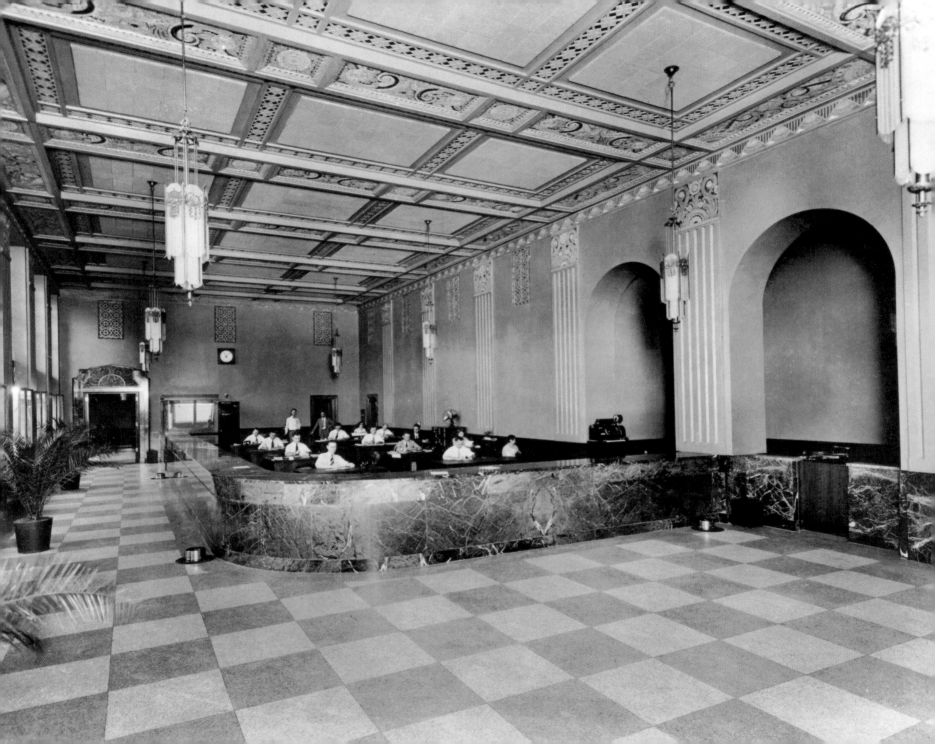

Volk Bros. Building

—1812 Elm Street—

•

Another of Dallas's lost treasures is the Volk Bros. building that was erected in 1930. The handsome building stood at 1810–12 Elm Street, near the corner of St. Paul.

In 1889, Leonard Volk came to Dallas from Baltimore and went to work for a local shoe store. He had learned the shoe business from his father, a custom boot maker. The following year, Volk opened his own small shop on the west end of Elm Street next to E. M. Kahn. A year later, Volk's older brother, George, joined him in the business. The store prospered, and after twenty years in the original location, Volk Bros. moved a little farther east on Elm, close to Field Street. George Volk served as company president until his death in 1922.

In 1929, Volk expanded again, planning a six-story building with a basement on Elm near St. Paul. Leonard Volk was still active in the business, but his son, Harold, was now vice president and had been groomed to succeed his father. In addition to shoes, the new location featured men's, women's, and children's apparel. The architectural firm of Greene, LaRoche & Dahl was tapped to design the $500,000 building. They created a French Renaissance gem. The building featured a limestone facade above a base of rose-colored marble with black and gold marble at the bottom. A green copper roof with dormer windows crowned the structure. Tall Roman-arched windows graced the second floor outside the ladies' fine shoe salon. Along the front of the building were show windows executed in cast iron and bronze, with rare woods used on the backs of the displays. A distinctive cast iron and glass canopy extended the length of the building. In the interior, the ground floor featured a terrazzo surface, and the elevator lobby was finished in Roman travertine marble.

On August 18, 1930, the new store opened with great fanfare. Leonard Volk died five years later, and his son, Harold, continued to oversee the growing business. In 1936, Volk Bros. became the first downtown merchant to pioneer a suburban outlet when they opened their Highland Park Village store. Over the next three decades, other suburban stores followed. Harold Volk became an important industry figure and civic

leader and served on the Dallas Citizens Council. In 1970, as he approached his forty-fifth year as president, the company was nearing its eightieth anniversary. It was sold to Colbert's, a growing women's wear chain. The name was immediately changed to Colbert-Volk.

With the growth of suburban shopping, the flagship store began to lag behind the chain's other locations. In 1971, the downtown store was remodeled, but the changes could not reverse its sliding fortunes. In 1973, Colbert-Volk was forced to close the downtown headquarters. In 1978, the historic building was sold to the McLendon Company, which remained vague about plans for the structure. Preservationists were wary about the company's intentions, and their suspicions were justified. On a Saturday night in 1980, McLendon quietly began demolition. In a short period of time, the beautiful structure was reduced to rubble, effectively ending any dissent. Developer Cadillac Fairview wanted to build a new office tower on the site, and agreeing to buy the raw land beneath the building allowed them to stay out of the fray. Within a few years, the Momentum Place tower, soon to be Bank One Center, rose on the site.

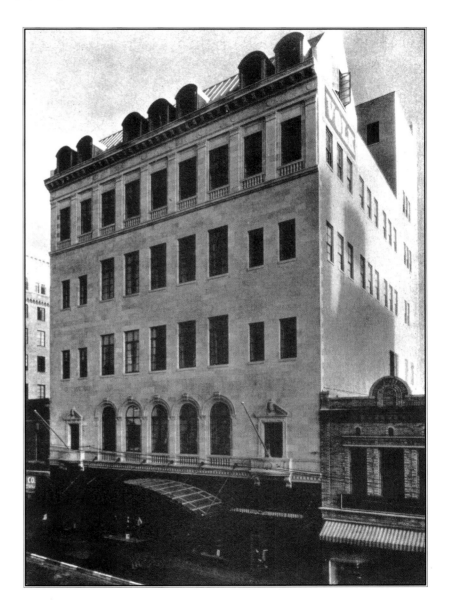

Dreyfuss & Son

—Main and Ervay Streets—

•

Girard Dreyfuss tried his hand at just about everything before finding success in the Dallas clothing business. In 1871, Dreyfuss left his native France at the age of eighteen, found his way to Louisiana, and clerked in a small store owned by a cousin. His youthful wanderlust then took him on a variety of pursuits to New York, Virginia, Iowa, and Leadville, Colorado, where he hoped to find his fortune in a silver mining camp. Lady Luck did not favor young Dreyfuss in Leadville, so in 1879, he came to Dallas. He formed a partnership with another young man and went into the men's clothing business across from the St. George Hotel on Main Street. For a time, Dreyfuss merged with E. M. Kahn, but in 1911, he went out on his own again, setting up shop at the northwest corner of Main and Murphy.

Dreyfuss and his son, Sol, occupied the ground floor and basement of the three-story building just west of City National Bank. It was a booming corner, and by 1916, Dreyfuss was successful enough to take a ten-year lease on the entire building. Sol was an extremely creative promoter. In 1928, he booked "Shipwreck" Kelly, a flagpole sitter, to spend one hundred hours balancing and chain-smoking while perched on a small disc atop the flagpole that rose high above the Dreyfuss store and the street below. Thousands came to watch

Kelly during his four-day exhibition. Later that year, Woolf Brothers of Kansas City bought out Girard and Sol Dreyfuss. By that time, the newly acquired firm had outgrown their quarters. They decided to build a new store in another location farther uptown. The old four-story Lansing Building (1889) was at the northeast corner of Main and Ervay, and Dreyfuss planned for a six-story building on the site. In the fall of 1929, demolition got under way on the Lansing Building.

Erection of the Dreyfuss & Son building was contemporaneous with the construction of the Volk Building nearby and the new Post Office and Federal Building on Bryan. Alonzo H. Gentry, a Kansas City architect associated with Lang & Witchell, was chosen to design the building. The five-story structure with a basement was described as "classical empire" in style, with a facade of native limestone and polished granite. Decorative stonework details and floodlights accented the handsome exterior, which featured large terra-cotta vases mounted on the roof. Green spandrels accented by ram's heads were placed beneath the fourth-floor windows. Carved pilasters climbed from the third floor through the fifth. A coved cornice of brown glazed terra-cotta finished the skyline of the building. The store's interior was finished in imported travertine

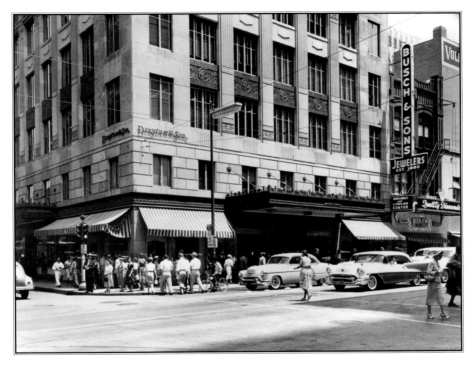

marble and a variety of rare woods including fixtures of Makassar ebony, zebrawood, and claro walnut. A grand staircase led from the ground floor to the mezzanine level.

In May 1930, the building was completed, and thousands of Dallas residents queued up to view the opening of the new store. The gleaming structure was quickly honored by the American Institute of Architects with a brass plaque mounted on the exterior citing its outstanding design. The proud store was a fixture in Dallas retail for many years, even weathering the erosion in downtown shopping.

Although the store was always known as a leader in menswear, ladies' clothing and salons were added to the new downtown location, vastly expanding the client base.

In 1973, Woolf Brothers consolidated all of their stores under their own name, reluctantly dropping the Dreyfuss & Son label. The classic building hung on until 1985 when Cadillac Fairview Corporation, a Canadian developer, demolished the structure for a planned downtown mall that never materialized. In 1987, the sixty-story Momentum Place (later Bank One Center) was built on the site.

Dallas Power & Light Building

—1506 Commerce Street—

•

Dallas Power & Light Company built its new head-quarters during the 1930–31 Depression years, a time of intense high-rise activity in Dallas. The Continental, Tower Petroleum, and Lone Star Gas buildings were also erected during this period, and all exhibited aspects of the art deco styling in vogue at the time.

Lang & Witchell Associates were chosen to design the building. Due to the narrow frontage available on Commerce Street, the main tower had to be sited closer to Jackson Street with its primary entrance on Browder. A three-story customer service lobby faced Commerce Street and connected with the main building. In 1930, construction got under way with a $1.5 million budget for both land and structure.

The construction process was unique in that the Dallas Power & Light Company building became the tallest structure in the world utilizing an electrically welded steel framework. Welding offered several advantages over riveting. Noise was greatly reduced, greater rigidity was afforded, and the cost of the manufactured steel was somewhat less. The main tower was eighteen stories with a basement. Flood lighting in red, white, and amber illuminated the building's exterior.

The main building was faced with buff brick trimmed in terra-cotta, with a black granite base. The black granite was also used to frame the main entrances. The Zigzag Moderne design featured major offsets at the fourth and twelfth floors. The elevator lobby in the main tower featured polished marble walls with a vaulted metallic ceiling and bronze elevator doors. Art deco murals also decorated the lobby. The Commerce Street customer lobby featured a limestone facade above a black granite base. Among its numerous art deco accents were carvings of electrical pioneers Edison and Steinmetz and an outstanding stained-glass allegorical panel above the bronze doors at the Commerce Street entrance.

A few days after Thanksgiving 1931, the Dallas Chamber of Commerce celebrated the grand openings of several new buildings with live remote radio broadcasts. Special floodlights illuminated the buildings for Dallas Power & Light, Lone Star Gas, Tower Petroleum, the Republic Bank Annex, and the downtown YMCA.

Many years later, Dallas Power & Light expanded into the Texaco (Continental) Building next door, and a few years later, it was melded into the Texas Utilities Corporation, eventually abandoning the Commerce Street structures. In 2003, Denver-based Hamilton Properties, who had redeveloped the Davis Building, bought the structures from Texas Utilities Corporation and began converting the buildings into residential units known as DP&L Flats. An outstanding job of restoration and conversion has been performed on these historic properties.

Tower Petroleum Building

—Elm and St. Paul Streets—

•

By the decade of the 1920s, Dallas was becoming a major hub of the burgeoning petroleum industry. America had fallen in love with the automobile, and the east Texas oil fields, just over a hundred miles from Dallas, were more than capable of meeting the growing need for gasoline and oil. In 1922, Magnolia Petroleum Company, a pioneer in the industry, had built its magnificent headquarters building in Dallas.

There were dozens of independent oil companies needing suitable office space in Dallas. In 1930, a group of these oilmen got together and made plans for an office tower that would be designed exclusively for the needs of the petroleum industry. Their expressed aim was to make Dallas the national capital of the industry. As Ft. Worth already had a Petroleum Building, it was originally suggested that the Dallas structure be called the Petroleum Tower Building. Dallas architect Mark Lemmon was chosen to design the structure, although he had no prior experience with skyscraper design.

Constructing major buildings of any kind was risky in 1930. The 1929 stock market crash and the developing Great Depression did not inspire confidence in the financial future of America. For several years, the Empire State Building in New York, which was under construction at that time, remained virtually empty, but in Dallas,

a downtown building boom was under way. In 1930–31, the Tower Petroleum Building, Lone Star Gas, Dallas Power & Light, Republic National Bank annex, and the downtown YMCA were all under construction.

This was the dawn of the art deco era, and the Tower Petroleum design was a prime example. The structure was twenty-two stories, with setbacks occurring at the eighteenth and twenty-first levels. Framed in steel, the building featured a black granite base on the first two floors, and light-colored brick above, with the setbacks capped in terra-cotta. Art deco accents were in evidence everywhere on the stonework face of the building. Revolutionary new Browne windows were chosen, folding vertically inward to allow greater airflow and designed to allow for cleaning from the inside. Forty-six floodlights housing 1000-watt bulbs were positioned to illuminate the five uppermost stories of the building. In August 1930, excavation began.

One year later, the building opened. The public was wowed during the three-day grand opening celebrations. From the bronze doors at the Elm Street entrance, visitors stepped onto patterned marble flooring. They walked to the elevators and passed walls of light-colored Cipollini marble and Philippine mahogany. When opened, the build-

ing was already 70 percent leased. It featured a geological library and hosted the Dallas Petroleum Club meetings. On the day after Thanksgiving 1931, the Tower Building's owners participated in a joint radio broadcast celebrating the five new buildings.

Mark Lemmon's stylish new skyscraper was a huge success, but for several years afterwards, it was plagued by suicide jumpers. For some unknown reason, the building became the place of choice for these fatal leaps. The first incident occurred only months after its opening when a real estate man plunged twenty-one stories to the street below. In April of 1932, a female concert pianist leapt from the sixteenth floor. Four years later, despite precautions, a troubled World War I veteran managed to jump from the twenty-second floor, landing on the roof of the Melba Theater. And in February 1937, another Dallas woman died when she jumped from the sixth floor to the roof of the new Tower Theater. Psychologists at that time could only explain the phenomenon in terms of a copycat mentality, but that did little to comfort the building's frustrated management.

In February 1937, the Tower Theater opened alongside the northeast side of the skyscraper. It had an entrance on Elm Street, and extended through to Pacific Street. It seated fifteen hundred patrons in the ground floor and mezzanine. The Tower Theater remained open until the 1970s.

In 1951, the seventeen-story Corrigan Tower was built on the north side of the Tower Petroleum Building. Developer Leo F. Corrigan had owned the Tower Petroleum building since 1942, so the interior corridors of his two structures were connected, giving the combined buildings 325,000 square feet of floor space. Many years later, a pedestrian bridge connected the complex to the 1700 Pacific Building across St. Paul Street. As the years progressed, the Tower complex struggled to compete with newer properties not afflicted with small floor plates, tiny lobbies, and old mechanical systems. During the 1990s, the building fell vacant and then was closed for good. The building remains a prime candidate for conversion to downtown housing.

YMCA Building

—Ervay and Patterson Streets—

•

The first substantial home for the Dallas YMCA was located at 1910 Commerce Street, near the southeast corner of Commerce and St. Paul. In 1909, the five-story facility was completed. It contained a gymnasium, a suspended cork-surface running track, handball courts, a basement pool, bowling lanes, and fifty-four dormitories. When this facility was outgrown, the YMCA purchased a tract of land along N. Ervay Street between Patterson and San Jacinto. Under the leadership of E. R. Brown, YMCA president and head of Magnolia Petroleum, a fourteen-story facility was planned that would become the largest YMCA facility in the Southwest. It was to contain a gymnasium, running track, handball and squash courts, a swimming pool, coffee shop, barber shop, and other amenities, plus dormitory facilities for 260 young men.

Anton Korn, architect of many exclusive Dallas homes, was chosen to design the $850,000 building. In October 1930, excavation work got under way. Korn designed an art deco structure of light-colored brick in vertical lines with setbacks,

dominated by a square central tower with a pyramidal green lead roof. One innovation was placing the swimming pool on the third floor rather than in the basement, allowing for plenty of natural light and ventilation. In 1931, the grand opening was celebrated by a radio broadcast that rotated from the YMCA to each of the other four major buildings completed in 1931—Lone Star Gas, Dallas Power & Light, Tower Petroleum, and the Republic Bank annex.

The YMCA Building was a Dallas landmark for five decades but became expendable in the early 1980s when a more modern facility was built. The old YMCA was razed, and the site is now occupied by the Lincoln Plaza Building.

Dealey Plaza

—Main, Commerce, Elm, and Houston Streets—

•

The city of Dallas had its earliest beginnings in the area known today as Dealey Plaza. The Trinity River flowed just west of today's triple underpass where Main, Commerce, and Elm are funneled under the railroad bridge on the western edge of downtown. Once established, the city had grown outward from John Neely Bryan's settlement on the eastern riverbank. Starting in the 1920s, a series of massive flood control projects began the process of restraining the river between levees and relocating it slightly to the west. This presented an opportunity to improve the western approach to the city from State Highway 1 by realigning jumbled streets, clearing dilapidated old buildings, and creating urban park space.

In 1934, the city voted to purchase the two blocks between Commerce, Elm, Houston, and Broadway streets. Architect Otto Lang created the master plan that essentially exists today. From Houston Street, gentle curves allowed Main, Elm, and Commerce to descend and converge gradually toward a triple underpass that carried rail traffic above the busy streets below. The entire area was landscaped, and a large equestrian statue of Robert E. Lee was planned as a centerpiece of the project. Approximately $40,000 was privately raised for the Lee Memorial, and a total of $1 million was expended on the underpass and plaza. It was decided to call the project "Dealey Plaza," in honor of George B. Dealey, publisher of the *Dallas Morning News*. A fight erupted between the park board and the monument sponsors over placing the Lee Memorial in Dealey Plaza, so it was eventually sited in Oak Lawn Park, which was then renamed Lee Park. Franklin Roosevelt unveiled the monument when he visited Dallas for the 1936 Texas Centennial Exposition.

Funds for the plaza construction were available through the WPA, and extra labor was provided through the National Youth Administration. In May 1936, thousands attended when Dealey Plaza was dedicated just in time for the 1936 Texas Centennial Exposition celebrations. Further modifications were desired, so George L. Dahl, architect for the Texas Centennial Exposition, was commissioned to design landscape improvements throughout. He also added reflecting basins on the eastern edge of the plaza. Twenty-five-foot granite pylons were recommended to straddle Main Street but never built. In 1940, landscape architects Hare & Hare completed the project with curved sheltering pergolas near the railroad tracks, and concrete peristyles adjacent to the reflecting basins.

In 1946, after George Dealey's death, a monument to the newspaper publisher and civic leader was proposed. Felix de Weldon, famed sculptor of the Iwo Jima Memorial, was commissioned to design

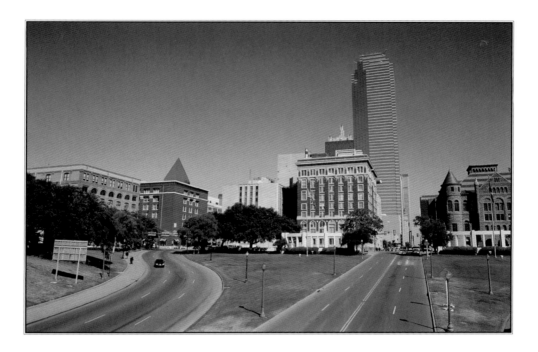

a twelve-foot bronze statue of Dealey. The three-ton statue was placed on an eight-foot forty-ton base of Texas pink granite. Bas-relief panels depicting Dealey's interests were mounted behind the statue, facing Houston Street. In November 1949, the memorial was dedicated with Dealey's widow and family present.

Dealey Plaza became infamous in later years with the assassination of President John F. Kennedy on Elm Street, just beneath the Texas School Book Depository on the Plaza's north side. On November 22, 1963, the president's motorcade was completing its route through downtown Dallas when it entered Dealey Plaza from Houston Street, turning slowly onto Elm. As the open limousine accelerated toward the triple underpass, shots rang out, felling the president. Gunfire echoed off the buildings flanking the plaza while confused and terrified bystanders flattened themselves upon the grassy slopes. The act stained the city of Dallas for many years, and Dealey Plaza became forever identified with the Kennedy assassination. Today, Dealey Plaza is the site of constant activity, much of it associated with curious visitors wanting to see the assassination site. The Sixth Floor Museum occupies a portion of the Texas School Book Depository, commemorating the life of President Kennedy and the events of that fateful day in 1963.

•

At its peak in the 1940s, Dallas's Theater Row stretched for four blocks along the north side of Elm Street. Starting just east of Akard, neon theater signs extended all the way to Harwood. The Telenews, the Mirror, the Capitol, the Rialto, the Palace, the Tower, the Melba, and the Majestic enticed Dallas residents and rural visitors to this brightly lit stretch to see first-run Hollywood releases.

Most of these movie houses started out in the days of silent films and vaudeville troupes. Ornately designed and expensive, many featured pipe organs, performance stages, and orchestra pits. The earliest Elm Street venues, including the Hippodrome, the Jefferson, and the Old Mill, were built before World War I. In 1921, the Majestic and the Palace opened, and they became two of the city's most enduring theaters.

The Majestic, at 1925 Elm Street, was built by the Interstate Amusement Company, which was headed by Karl Hoblitzelle, a St. Louis impresario. With an ornate terra-cotta facade and a lavishly decorated interior, the theater seated three thousand people, and cost $2 million to build. It was designed by John Eberson, a noted theater architect. The Majestic operated continuously from 1921

to 1973 before succumbing to competition from suburban theaters and high operating costs. Fortunately, the shuttered theater was not demolished, and in 1983 the City of Dallas restored it for use as a live performance venue.

The interior of the smaller but equally lavish Palace Theater was characterized by ornate vaulted ceilings, crystal chandeliers, ornamental niches, marble columns, and bronze fixtures. C. D. Hill, a prolific Dallas architect, designed the Palace. It was built at a cost of $1 million. At the end of 1970, it was forced to close, and then the beautiful theater was demolished. Today, the Thanksgiving Tower sits on the former site of the Palace.

In 1922, the six-story Melba Theater was constructed at 1913 Elm Street. The million-dollar, 2,000–seat structure of brick and terra-cotta extended through from Elm to Pacific and included the ground floor auditorium, a mezzanine level, a balcony, and several floors of office space above. The Melba was so well-known that several couples named their daughters after the theater, receiving season passes in the process. It could never quite compete with the grander Majestic, whose long ticket lines often blocked the entrance to the Melba. After thirty-seven years of operation, the venue was remod-

eled, and on Christmas day 1959, it opened as the Capri Theater. It operated for another twelve years before closing its doors. The Pacific Place office tower occupies the site today.

In 1922, the Capitol Theater opened at 1521 Elm. It did not possess the elaborate interiors of the Majestic or Palace, but it was nonetheless impressive. Seating twelve hundred on one level, the Capitol had a spectacular marquee and a multistory facade that led into a lobby with a lighted fountain. In 1959, the Capitol closed and then was demolished to make way for a parking lot. A few years later, the LTV Tower (now 1600 Pacific) opened on the site.

The venerable Old Mill Theater at 1525 Elm was next door to the Capitol. It operated under that name for two decades, and then in 1935, it became the Rialto. LaRoche & Dahl, well known Dallas architects, redesigned the exterior, and Nena Claiborne redesigned the 1,400 seat interior. This was the heyday of Hollywood premieres and spectacular grand openings, so the Rialto was bathed in flood lights on opening night while celebrities and dignitaries mingled with patrons. In 1959, the struggling, aged Rialto was scheduled for demolition, but then it burned. Like the Capitol, it was replaced by the LTV Tower.

In 1913, the Jefferson Theater was built at 1517 Elm Street near the northeast corner of Elm and Akard. Over the years, it was renamed the Garden, then the Pantages, and then, finally, the Mirror. In 1941, the theater suffered a catastrophic fire and subsequently was replaced by a two-story commercial building. The site is now a parking garage.

The Telenews Theater at 1515 Elm was next door to the Mirror Theater to the east. It flourished during World War II. In those days before television, the only way to get up-to-the-minute news was from newspapers, radio, and newsreels. The Telenews featured an all-newsreel and short subject format. The face of the theater featured a large revolving porcelain globe with major capitals identified by blinking lights. After the war, interest in the newsreel format waned, and the name was changed to the Dallas Theater for a short time before closing.

The Tower Theater at 1907 Elm was a relative latecomer to the Theater Row scene. In 1937, it was built just behind the Tower Petroleum Building. It had a small Elm Street entrance attached to the Tower Building, as well as access from Pacific Street. It was part of the Interstate chain, along with the Majestic, Melba, Palace, Rialto, and Capitol theaters. The 1,400-seat theater was built for a modest $125,000. The lobby was decorated with murals from an artist who had just completed work for the 1936 Texas Centennial Exposition grounds. In February 1937, the theater opened with the customary klieg lighted premier and attending dignitaries. Like the Majestic and Palace, the Tower was closed at the dawn of the 1970s.

Today, the Majestic is the only survivor of a glamorous era on Elm Street when Dallas could boast of a "Theater Row."

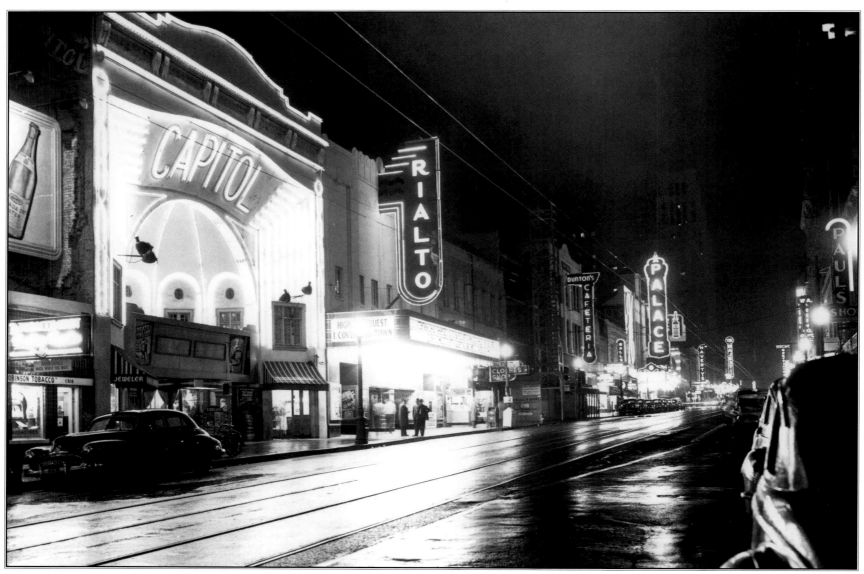

Theater Row, 1947.

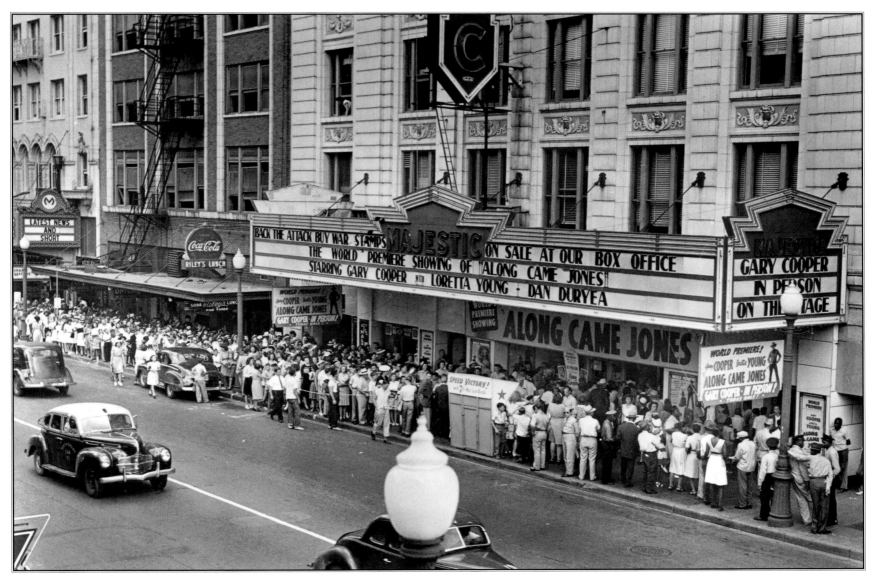

The Majestic Theater hosts the national premier of Gary Cooper s movie Along Came Jones *in June 1945. Cooper personally appeared on the Majestic stage. More than 2,000 patrons were turned away.*

Continental Building

—1512 Commerce—

•

In 1903, the Crowdus Drug Co., later known as McKesson-Crowdus, erected this building as a five-story headquarters and distribution facility. In 1930, the company vacated the building for a location in the west end warehouse district at Ross Avenue and Orange Street.

Plans were made to erect the thirty-one-story National Building on the site, but the project never got under way. Instead, the Continental Supply Co., a St. Louis–based oilfield supply firm, bought the building in 1933 and relocated to Dallas. They remodeled and air-conditioned the structure before occupying the lower three floors. As it was the only air cooled building in the city, leasing the top floors to several oil firms was not difficult. In 1935, a sixth floor was added to the structure.

By 1939, Continental was ready for further expansion. An eight-story addition was placed atop the existing building. T. P. Roberts designed the addition, remodeling the brick exterior with a stone facing. The expanded building was again filled with petroleum companies. Seaboard Oil, an independent, rapidly growing oil producer, was one of the first to come aboard. In 1958, Seaboard Oil was acquired by the Texas Company, better known as Texaco, who set the building up as a division headquarters. The building was renamed the Texaco Building when Continental Supply, now Continental-Emsco, vacated the building for new quarters.

In 1965, Texaco announced the relocation of their offices to Houston. The building stayed under the Texaco name even as it changed hands a couple of times. Finally, in 1980, next-door neighbor, Dallas Power & Light, bought the building for administrative offices. Years later, as Dallas Power & Light merged with Texas Utilities, both structures were vacated. Texas Utilities (TXU) sold the buildings to Hamilton Properties, who had recently renovated the Davis Building. Hamilton Properties converted the buildings to downtown residential and retail space, to be known as DP&L Flats.

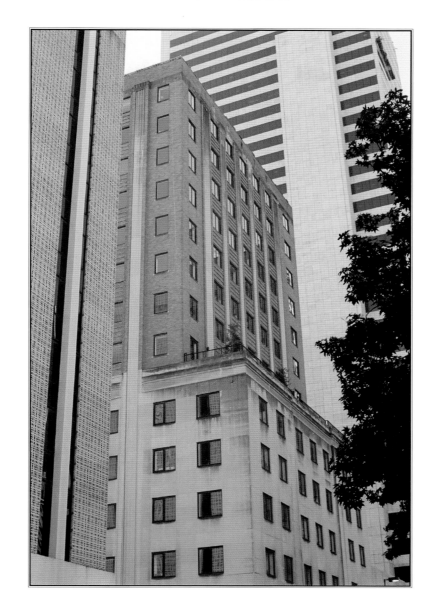

Mercantile National Bank Building

—Main, Commerce, and Ervay Streets—

•

R. L. Thornton was nothing if not ambitious. Born in 1880 into a rural family of tenant farmers, he spent his early years picking cotton, selling candy, and clerking in general stores around North Texas. He later dabbled in the mortgage business. He was largely self-taught, shrewd, and driven. In 1916, at the age of thirty-six, he spotted an opportunity and decided that Dallas needed a bank on the west end of town, near the courthouse.

The bank got its start with four employees, including Thornton. One of his partners put up $6,000 in cash, and the bank had $13,000 in notes. They opened at 704 Main St. in an old restaurant space. The little bank took in $12,000 in deposits on its first day. They were innovative in loaning money for auto financing when other banks advised against it. Within a year, the name was changed to Dallas County State Bank, and by 1920, the bank was secure enough to sign a ten-year lease on the ground floor of a new twelve-story building at Main and Lamar. In 1923, the name was changed to Mercantile Bank & Trust. In 1925, the bank earned a national charter, and the name was changed to Mercantile National Bank.

By the end of the decade, the prosperous bank outgrew its old location, and at the beginning of 1930, it moved into the relatively new Magnolia Building, occupying an existing bank space that had been vacated when the North Texas National Bank was merged into Republic National Bank. As World War II approached, the bank continued to thrive. Thornton became active in civic affairs, heading up the annual state fair, and leading the Dallas Chamber of Commerce. He was also the prime mover in bringing the 1936 Texas Centennial Exposition to Dallas.

Throughout the 1930s, Mercantile operated in the Magnolia Building, but by 1941, Thornton was ready for his own building. The bank's assets then exceeded $50 million. A site was chosen at Main, Ervay, and Commerce where the old post office stood. Steel for the thirty-story structure was ordered before wartime restrictions took effect, so the project was exempted from war rationing. In 1941, ground was broken. It became the only major structure built in Dallas during World War II. Architect Walter Ahlschlager, who had designed the Roxy Theater in New York, was imported to design the towering building. He used a setback architectural scheme and clad the structure in white brick. A huge clock crowned the central tower that faced Ervay St. The building allowed Thornton bragging rights for the tallest building in town, reaching 439 feet above the

streets below, not counting the illuminated tower. The top two floors provided executive lounges and dining room, and featured huge picture windows overlooking downtown. The second-floor banking lobby was paneled in walnut and featured large murals depicting the growth of Dallas and the Southwest. The war prevented importation of marble, so a supply for the teller areas was purchased from a Chicago mausoleum. In November 1943, the $5 million structure was completed and occupied. Soon after completion, the US government commandeered ten floors of the building for wartime use.

During the postwar boom years, the bank enjoyed tremendous growth and expanded several times. In 1949, the Mercantile Dallas Building joined the complex, which now covered the full city block bounded by Ervay, St. Paul, Main, and Commerce streets. In 1950, Dallas gained its first subterranean parking garage when Mercantile opened the Commerce Building, (later known as the Continental Building), across Commerce Street. Four levels of underground parking were topped by three aboveground floors.

In 1953, Thornton became mayor of Dallas, and his famous slogan was "Keep the Dirt Flying." He practiced what he preached at his own bank. In 1957, eight more office floors were added on top of the parking garage. An underground tunnel connected the expanded building to the main bank. Lobby areas were enlarged and improved. The clock faces on the main tower were replaced and enlarged, and the 115-foot spire atop the roof was equipped with a special light-

ing system that announced weather changes to downtown workers. Amplified chimes wafted music down from the top floor of the building. In 1963, the Mercantile Securities Building was acquired from unrelated Mercantile Security Life Insurance and tied in to the other buildings. The Mercantile complex had become a bustling city within a city.

In 1964, R. L. Thornton died at the age of eighty-four. Thornton was such a tireless civic booster that he had become known as "Mr. Dallas." As one of the organizers of the Dallas Citizens Council, Thornton had been a major force in creating the cooperative model between local businesses and city government that made Dallas work and gave it an edge over other cities.

In 1976, Mercantile purchased the Vaughn Building at 1712 Commerce Street and occupied it for their rapidly expanding banking operations. It became the Mercantile Commerce Building, joining the Mercantile Continental, Mercantile Dallas, Mercantile Securities, Mercantile Bank Tower, and Mercantile Jackson buildings. Trying to navigate the "Merc" complex had gotten a little confusing. In addition to all this real estate, the bank was soon leasing space in other buildings.

For several decades, Mercantile National Bank continued to prosper. In the 1970s, the bank became the flagship of Mercantile Texas Corporation, a holding company. A decade later, this became MCorp, and the bank changed its name to MBank. In 1985, construction began on

a sixty-story office tower across Main Street that would consolidate bank operations. Capitalizing on a longtime ad campaign, the headquarters was designated "Momentum Place," becoming one of the city's finest modern buildings. The soaring structure was designed by Philip Johnson, and in 1987, it was completed and occupied just as Dallas's overheated banking environment began to collapse. Failed real estate loans humbled all of the big three banking legends in the city. Republic National Bank, First National Bank, and Mercantile National Bank struggled to remain solvent. MBank eventually merged with Bank One Corporation, which later merged with Chase.

The lonely old Mercantile Bank complex was purchased by a developer who planned to convert the property into a downtown mall. Leases were not renewed, and by 1988, the complex was down to one diehard tenant. By 1992, the lights were completely out. The vacant buildings began the inevitable process of deterioration. Passersby could glimpse the marbled lobbies, the silent escalators that led to the second-floor banking areas, and the gold tiles peeling off the face of the building. Multiple efforts to redevelop the properties came and went, always falling apart for one reason or another.

Finally, in 2005, the complex was purchased by Forest City Development of Cleveland, and redevelopment into residential units began. The original Mercantile Bank tower and the Mercantile Continental building were to be restored, while the rest of the complex was scheduled for demolition.

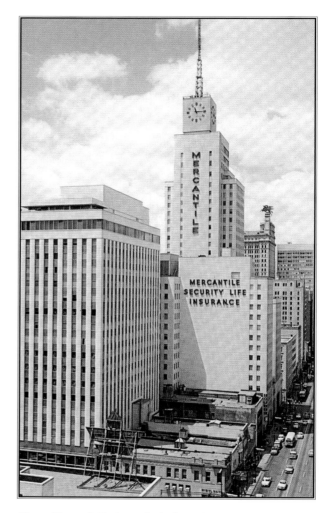

Above: *Mercantile Bank complex in the 1950s.*

Right: *Passing the Mercantile National Bank building, General Douglas MacArthur acknowledges the cheers of the 400,000 Dallas citizens lining the parade route during his triumphant 1951 visit.*

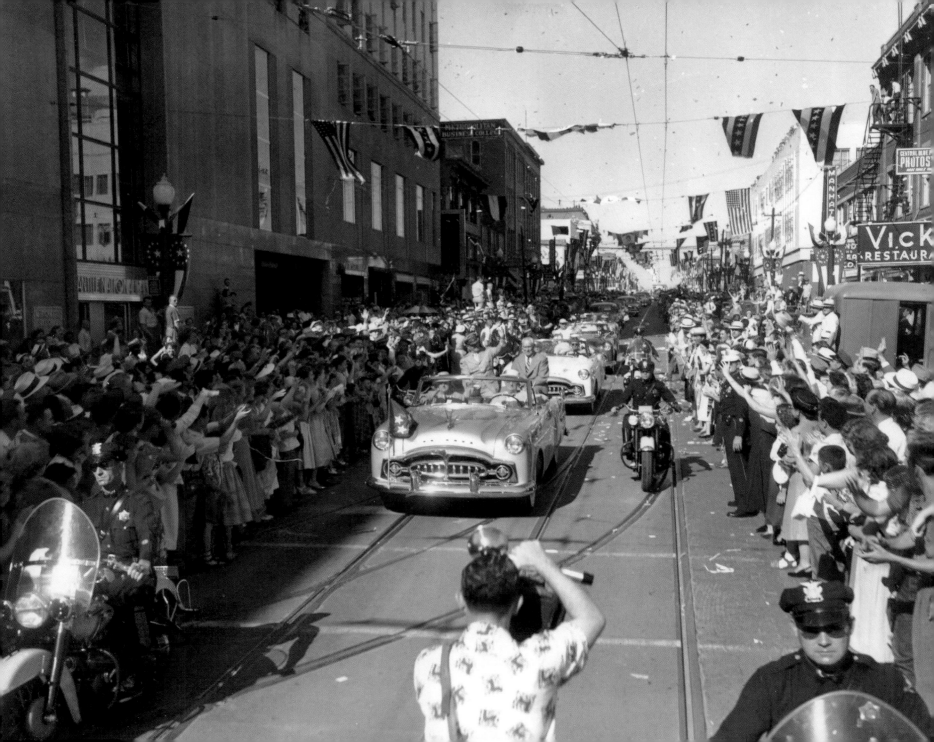

Jas. K. Wilson Store

—1515 Main Street—

Pedestrians traveling the 1500 block of Main Street near Akard often notice a large heraldic crest embedded in the sidewalk. It depicts a courtier on a bay charger raising a trumpet to his lips. The terrazzo inlay represents the logo of Hart, Schaffner & Marx and indicates the site where the Jas. K. Wilson Clothing Company operated for nearly four decades.

James K. Wilson came to Texas as a young man, working first as a $5-per-week clerk in a Temple clothing store. In 1914, he moved to Dallas and opened his own shop. Before he was thirty years old, he parlayed it into a chain of discount clothing stores known as Victory-Wilson. In 1935, after operating the chain for fifteen years, Wilson sold his interest and then opened the Jas. K. Wilson Clothing Company. Wilson's store became a major outlet for the suits of Chicago-based Hart, Schaffner & Marx. Later, the two firms merged.

After many years at Main and Field streets, Wilson capitalized on the postwar boom to build a flagship store at 1513–15 Main Street. Grayson Gill was engaged to design the four-story and basement structure. The limestone, granite, and glass facade fronted fifty feet on the north side of Main, with the store extending back one hundred feet. The building sported the Hart, Schaffner & Marx logo and name in the sidewalk and across the facade, while another fifty-foot vertical sign spelled out the Jas. K. Wilson brand. The new store provided twenty-seven thousand square feet of floor space and cost over $300,000. Opening in February 1947, the store became a Main Street landmark for generations of Dallas men and, eventually, women.

In later years, the company opened numerous suburban stores. James K. Wilson became a tireless civic leader, active in the Chamber of Commerce, state fair, Salesmanship Club, Boy Scouts, Kiwanis, and Masonic Order. In 1972, Wilson died at eighty years of age and was succeeded as president by his son, James K. Wilson Jr. In the 1980s, the old Main Street store was superseded by a new location in the Plaza of the Americas development, but the company was struggling with changing times and a stodgy image. The stores continued on as a unit of Hartmarx Specialty Stores until the early '90s when the last locations closed. In 1990, the famous Main Street store was purchased and remodeled by the Dallas Legal Aid Foundation.

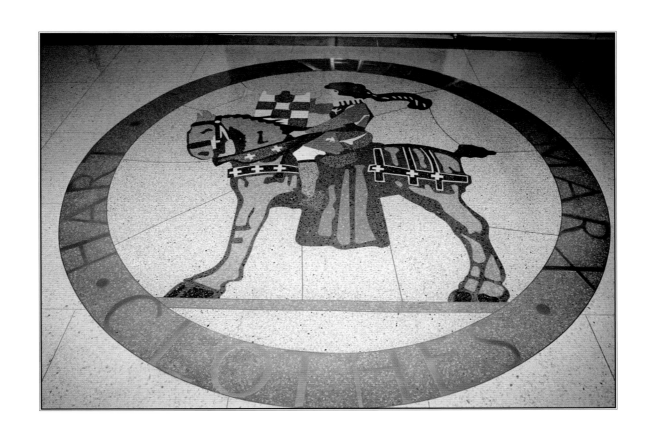

Republic National Bank Towers

—Pacific, Ervay, and Live Oak Streets—

•

In November 1950, intense competition was in full swing between First National Bank, Republic National Bank, and Mercantile National Bank. That same year, Republic National Bank broke ground on their new tower, intending to make a statement with a building that would soar nearly six hundred feet above Pacific Avenue, a scale that had never before been seen in Dallas.

Republic's management went out of state for architectural talent to design the structure. They chose Wallace K. Harrison and Max Abramovitz, designers of the United Nations Building in New York. Grayson Gill and George F. Harrell of Dallas were tapped as associate architects. The revolutionary aluminum-clad building contained over 870,000 square feet of space. The huge excavation for the foundation required one hundred thousand sticks of dynamite to blast out eighty-five thousand cubic yards of rock. Four basement floors were topped by thirty-six floors above street level. The 448-foot main structure was crowned by a 150-foot ornamental tower supporting a massive search beacon that was five feet in

diameter. It contained a 2,500-watt mercury lamp with half a billion candlepower. The beacon made a complete rotation every five seconds and could be seen for 120 miles. The massive ornamental light tower was faced with contrasting shades of aluminum. It was fitted with internal stairways and ladders and could be serviced from within by means of removable panels. The tower was covered with two miles of red, white, and blue Lumenarc tubing that illuminated the entire structure at night.

The building's 2,735 blue-green Solex windows reduced heat and could be reversed and cleaned from the inside. The one-eighth-inch-thick gray aluminum panels on the building were embossed with the Republic Bank star, and they were twelve times lighter than similar masonry construction. Two refrigeration units were the heart of the air-conditioning system. Each was driven by a one thousand–ton steam turbine, and they were located eighty feet below street level. The main vault door weighed forty tons and took half a day to unload from a railcar onto a flatbed truck. It was specially

fabricated from hardened steel that resisted blowtorches or drills. The door was so perfectly balanced that a child could easily swing the massive door on its hinges. Twenty-three high-speed elevators were required to service the building.

The open, two-story bank lobby was just short of one hundred yards in length, and contained nearly an acre of floor space. A 333-foot balcony soared above the main banking floor and was covered with three thousand square feet of gold leaf. Imported marble, terrazzo, and rare woods were used to decorate the lobby area. Forty-one tellers worked the main banking floor.

This $25 million modern masterpiece took four years to complete. On December 1, 1954, the dedication took place. Week-long festivities were capped by a 4,500-person extravaganza at Fair Park and was attended by bankers and executives from around the country. Bob Hope and other luminaries provided entertainment. Visionary President Fred Florence died six years after the opening of the grand building.

In the early 1960s, as the bank continued its explosive growth, plans were laid for a second tower to be connected to the 1954 structure by an arcade. In the spring of 1962, construction began on the new fifty-story tower, and work continued for nearly three years. The tower rose 598 feet above the streets below, the maximum allowed by FAA regulations for a building in the flight path of Love Field airport. The addition added nine hundred thousand square feet to the complex, bringing the total to 1.7 million square feet. Architects chosen were Harrell & Hamilton, Thomas, Jameson & Merrill, and Grayson Gill.

In January 1965, the $26 million tower officially opened. It featured a two-story lobby made of glass and travertine marble. The tower used six different types of marble and four types of granite. In all, 435 tons of marble were used. The new boardroom included a forty-foot by twelve-foot conference table made of Honduran mahogany, with contrasting woods used to inlay a massive Republic Bank silver star in the middle. It was capable of seating over thirty directors.

Republic National Bank continued to operate from this landmark location for more than two decades. In the late 1980s, the bank was fatally weakened by failed real estate loans. The bank was forced to seek a merger with their archrival, First National Bank, in a desperate attempt to stay solvent. After the merger, the two banks became known as First Republic Bankcorp, but the new bank failed and did not survive the decade.

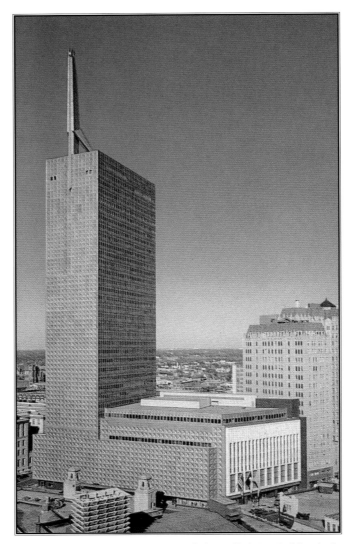

Republic National Bank in the 1950s, with the Medical Arts Building in the background.

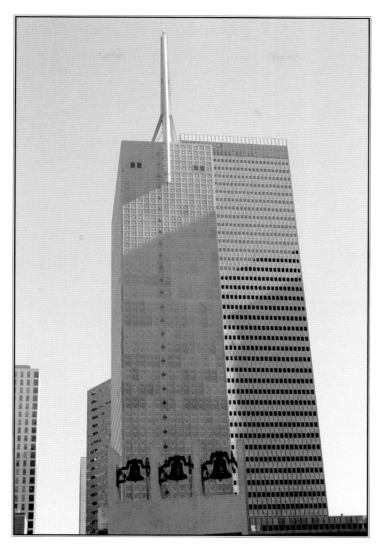

Republic Center today.

The Last of the Trolleys

·

In Dallas's early days, mass transit consisted of small trolley cars pulled by pairs of snorting mules. Beginning in 1871, two street trolleys traversed downtown streets, covering a three-mile route in forty-five minutes. One of them was named for Dallas founder John Neely Bryan. This system ran for over two decades until an electrical streetcar system could be devised with sufficient reliability and speed.

By the turn of the century, several electric trolleys were plying the streets of Dallas. The number would grow through the years, until over three hundred streetcars were in operation. In 1926, buses made their first appearance, but their loud, exhaust-belching, internal combustion engines became objects of ridicule. As buses were improved, it became apparent that they were faster, more cost-effective, and far more maneuverable than streetcars. The number of trolleys steadily declined, and by 1950, only 121 remained in service.

In 1954, a decision was made to retire the old streetcars from their transit duties. The number of buses was steadily increased, and by the beginning of 1956, the trolleys' swan song was at hand. At high noon on January 13, an aging trolley car led a parade of forty-four, brand new Dallas Transit buses on a parade through downtown Dallas. Mayor Thornton was on hand for the festivities, as was John W. Carpenter of Southland Life, who had served as a Corsicana trolley operator in his youth. Motorman John Lampkin, with over forty years of experience, steered the trolley on its final run. When the parade reached Pearl Street, the old trolley continued eastward toward the car barn and oblivion, while the buses turned back to pick up passengers. An era had ended. In the weeks ahead, the city's fleet of trolley cars was dismantled and sold for scrap.

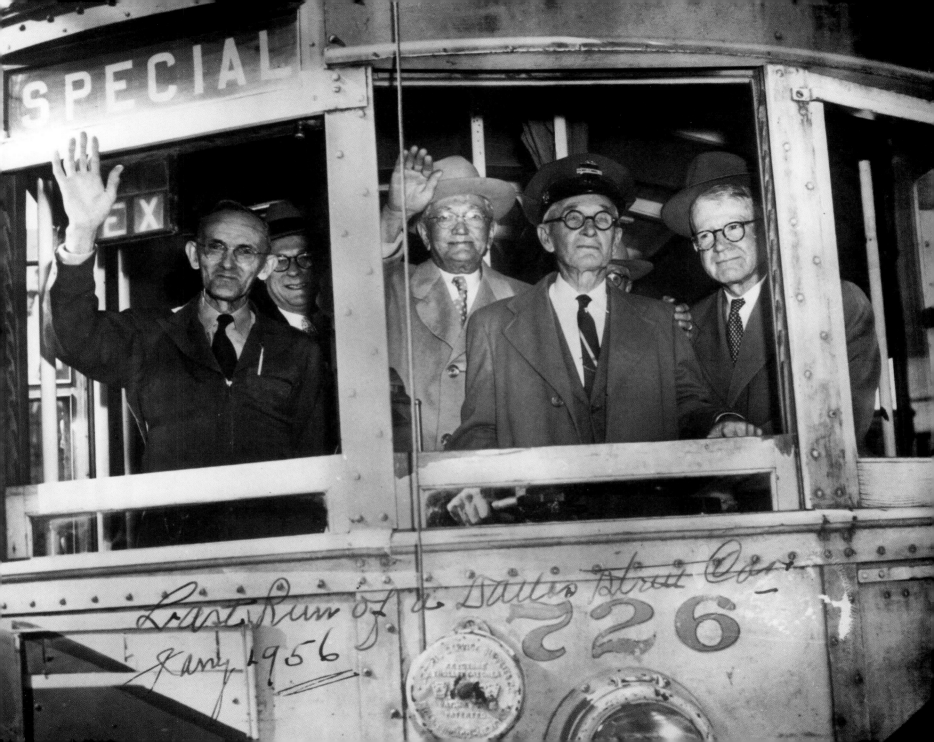

Southland Center

—Live Oak, Olive, Bryan, and Pearl Streets—

•

By 1955, Dallas-based Southland Life Insurance Company was approaching its fiftieth year in business and had $1.2 billion of insurance in force. One of the top fifty life insurance companies in the country, it had outgrown its headquarters building at 1416 Commerce. Planning began for a $35 million mixed-use development on the northeast side of downtown, with the new Southland Life Building as the centerpiece.

The project required the full city block bounded by Live Oak, Olive, Bryan, and Pearl streets, and included a retail arcade, a forty-two-story office building, and the twenty-eight-story, 600-room Sheraton Hotel. A five-level, 2,500-car parking garage was excavated beneath the project. Foundations were poured for a future third tower on the site. A heliport sat atop the office tower where Southland Life occupied fifteen floors. A public observation deck was on the forty-first floor.

The Sheraton–Dallas hotel was the chain's first venture in Texas, designed to compete with the brand new Statler-Hilton nearby. The hotel occupied the second-and third-floor central base of

the structure, as well as the twenty-eight-story tower, with the second floor dominated by the hotel lobby and a 10,500-square-foot ballroom. John W. Carpenter, Chairman of Southland Life, had been instrumental in bringing the Statler-Hilton to Dallas a few years earlier, and he wanted the new Sheraton in order to add luxury hotel capacity for the growing city.

Architect Albert C. Peterson of Welton Becket and Associates, Los Angeles, designed the project in association with Mark Lemmon of Dallas. The main tower soared 550 feet above the streets below, giving the city bragging rights for the tallest roof west of the Mississippi. The nearby Republic National Bank Building was slightly taller, but the bank had accomplished the feat with an ornamental tower rather than usable space.

The building's curtain walls were constructed of aluminum panels faced with imported blue-green Italian glass mosaic tiles. The end walls were of precast concrete with quartz accents. At the thirty-sixth and thirty-seventh levels, the floors were cantilevered out eight feet to provide spectacular views for patrons of the private club and restaurant facilities on these

floors. Interior finishes included Italian travertine marble and emerald pearl granite from Norway.

On New Year's weekend 1956, the first shovelful of dirt was turned, and completion was scheduled for 1958. Governor Allan Shivers joined Mayor R. L. Thornton, former Mayor Woodall Rodgers, banker Fred Florence, and various officials of Southland Life and Sheraton Hotels at the groundbreaking celebration. Ben H. Carpenter, a Southland Life executive vice president, headed the building committee with the assistance of W. H. Oswalt, another Southland Life executive who had trained as a civil engineer and city manager. During 1957–58, the construction phase was the subject of much attention due to the project's size and height. Finally, after more than three years and two construction-related fatalities, the building was ready.

On Sunday, April 12, 1959, more than five thousand people attended a multidenominational religious dedication ceremony on the building's plaza. The official ribbon-cutting ceremony for Southland Center was held the next day with Governor Price Daniel in attendance.

 The Sheraton–Dallas grand opening was even more spectacular. In addition to Governor Daniel, celebrities included Hollywood actors Randolph Scott, Johnny Weismuller, James Garner, and Dorothy Malone. John W. Carpenter, who guided Southland Life to so much success, died on June 16, 1959, just months after the Southland Center opening. In the months ahead, Dallas residents flocked to the new building to get a view from the observation deck on the forty-first floor. On clear days, Ft. Worth could be plainly seen. Predictably, many critics opined that the Dallas skyline would "level off" now that the forty-story threshold had been crossed, and it would simply be too expensive and too frivolous to go higher. (Within six years, First National Bank was opening a new fifty-story tower.)

The Ports o' Call restaurant and the private Chaparral Club, two legendary entertainment venues, occupied the thirty-sixth and thirty-seventh floors for many years. Ports o' Call was an Asian-themed restaurant with different sections depicting Saigon, Singapore, Macao, and Tahiti, and serving up local cuisines along with spectacular views. The Chaparral Club, as the name suggested, was Southwestern in theme and decor and offered dining and dancing for club members. Ground-floor retail occupants included Neiman Marcus ladies' wear and Reynolds-Penland menswear.

By the 1970s, the owners of Southland Life had formed a holding company in order to diversify into real estate development

and financial management. Southland Financial, the parent company, was responsible for the massive Las Colinas undertaking in Irving, Texas. The insurance company then operated under the umbrella of the holding company.

In 1981, the long-planned third tower was erected on the north side of the Southland Center complex. Known as Skyway Tower, it featured thirty-one stories above Bryan Street and gave the office portion of the complex 1.2 million square feet. By 1983, Southland Life had over $8 billion of insurance in force and had become an attractive acquisition target. The following year, Franklin Life of Illinois acquired the company, and in 1987, Southland Life vacated its downtown Dallas headquarters and then moved to Plano, Texas. Like many companies, Southland was seeking cheaper operating costs and easier recruiting. (In later years, the company was merged out of existence.)

In the late 1980s and early 1990s, the downtown complex struggled with increasingly high vacancy rates during a real estate slump, and by 1995, the office towers were vacant and closed. The Chaparral Club had closed the same year, citing high downtown vacancy rates. Southland Center endured multiple sales and threatened foreclosures. In 1990, the hotel had ended its affiliation with the Sheraton chain. It became the Southland Center Hotel, and still later, the name was changed to the Harvey Hotel.

Then, in 1996, HBE Corporation, developer of the Adam's Mark hotels, bought the entire complex and spent two years and $150 million redeveloping and modernizing the property. The forty-year-old wall panels had an epoxy sealer and gray paint applied, and the windows were resealed and tinted. Granite facings were applied over some of the concrete. A three-story convention center was built across the street. The result was an updated 1,800-room hotel that could handle the largest convention groups and extended the life of Southland Center well into the twenty-first century.

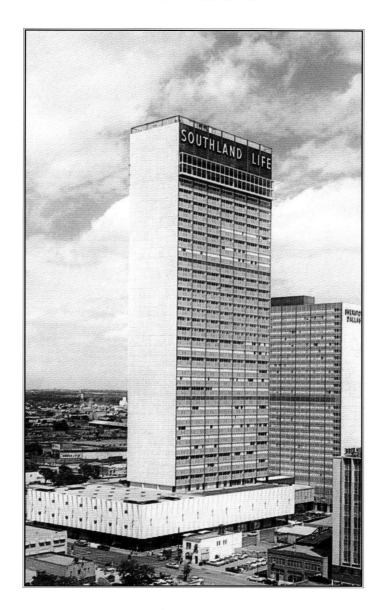

•

Leo F. Corrigan possessed little formal education, but he had enormous drive, energy, ambition, and a high tolerance for risk. In 1895, Corrigan was born in St. Louis. Seventeen years later, he arrived alone in Dallas with only a grammar school education and ten dollars in his pocket.

Corrigan found a job selling real estate ads for the *Dallas Dispatch*. He stayed for five years, deliberately learning the business. By 1917, he was selling downtown real estate properties for a commercial brokerage. He soon bought and developed his first small property, a previously vacant lot at Lemmon and Wycliff. Before long, he was buying and leasing suburban shopping properties. After a few years, he graduated to buying commercial buildings and apartments.

Corrigan's speed in closing a deal was legendary. One afternoon in 1942, he learned that the Tower Petroleum Building was for sale. By the next morning, he had purchased the property for $750,000. Six years later, he owned controlling interest in the Adolphus Hotel and was planning to expand

it. It was often rumored that he tried to buy the New York Empire State Building. Before he was through, he owned the Corrigan Tower, Tower Petroleum Building, Adolphus Hotel, Adolphus Tower, 211 North Ervay Building, and other Dallas properties, as well as the Los Angeles Biltmore and the Emerald Beach Hotel in the Bahamas. He also had apartment properties across the United States. Corrigan was the largest stockholder of the Mercantile National Bank of Dallas. Apart from his real estate empire, Corrigan served for many years as president of the Dallas Central Business District Association, and was a major benefactor to SMU and other institutions. In 1975, Leo F. Corrigan died at the age of eighty.

In 1914, Trammell Crow was born in Dallas's Lakewood area. During World War II, Crow served in the US Navy. He lost an older brother to a fighter plane crash. Crow soon married Margaret Doggett, a Highland Park heiress whose parents had been killed in a tragic highway accident after visiting her at the University of Texas. Her father had been a successful grain dealer, maintaining a downtown office building known

as the Doggett Building. After the war, Crow set up shop in the family building and began building his astounding real estate empire.

Like Leo Corrigan, Trammell Crow was incapable of standing still or resting on his laurels. At first, he focused on industrial development, and building and leasing warehouses. In the late 1950s and early 1960s, Crow really made his mark when he collaborated with John and Storey Stemmons in the development of commercial structures along the new Stemmons Freeway corridor. The Dallas Market Center was a massive, years-long development that included the Home Furnishings Mart, the Dallas Trade Mart, Market Hall, and the Marriott Motor Hotel. The Apparel Mart, the World Trade Center, and the massive Anatole Hotel followed.

Stemmons Towers were another collaboration between Crow and the Stemmons family. Crow developed shopping centers, industrial parks, and office buildings, not just in Dallas, but nationwide. Even Brussels, Belgium, was the site of a Trammell Crow–developed Trade Center. As a founding partner of Lincoln Property Company, Crow was involved in the development of the landmark Willow Creek and Village apartment communities in Dallas.

Crow's downtown office building developments included the 1960 Hartford Building and the 1972 Bryan Tower. In the late 1970s and early 1980s, he built a cluster of high-profile towers in the northeast quadrant of downtown. Diamond Shamrock Tower (now the KPMG Building), San Jacinto Tower, and the Trammel Crow Center (originally the LTV Center) were multimillion-dollar jewels in the vast Crow portfolio.

Like most large commercial landlords in the late 1980s, seventy-five-year-old Trammell Crow was staggered by a slumping Texas real estate market. The Crow organization recovered and remains today a vital player in Dallas real estate.

LTV Tower

—1525 Elm Street—

•

In late 1961, when the new LTV Tower was announced, it was designed to house one very new company and one very old one. The thirty-one story building was a joint development between Ling-Temco-Vought Corporation and the National Bank of Commerce.

National Bank of Commerce dated all the way back to 1878 and had been situated at the corner of Elm and Poydras streets for more than eighty years. In 1956, after the death of Jean Baptiste Adoue Jr., who had served as bank president for over thirty years, the bank became a prime candidate for acquisition. In 1960, controlling interest in the historic bank was secured by thirty-eight-year-old James J. Ling of LTV Corporation, along with partners James H. Bond and Troy V. Post.

LTV Corporation arose from a series of events following World War II. In 1947, twenty-five-year old Jim Ling, a whiz-kid master electrician and service veteran, started Ling Electric, an electrical contracting and engineering firm specializing in high-end commercial applications. About the same time,

the Texas Engineering & Manufacturing Company (TEMCO) leased space at the recently vacated North American Aviation facility in Grand Prairie in order to produce airframes, aircraft parts, and other fabricated metal work. One year later, Chance-Vought elected to move its aircraft production from Connecticut to Texas, using another part of the North American facility to build navy jets in place of the previous P-51 Mustangs. Within a few years, Ling, TEMCO, and Vought came together in an unforeseen way.

During the 1950s, Ling entered the electronics industry through the acquisition of a California firm involved with testing devices for the nation's guided missile program. Ling soon acquired TEMCO, which had been moving away from aircraft manufacturing into aerospace ventures. In 1961, Ling's big move came when Ling-TEMCO merged with Vought Aircraft, creating an aerospace giant known as Ling-Temco-Vought, or LTV.

In December 1961, the new conglomerate began plans for a

worthy headquarters facility to house LTV Corporation and National Bank of Commerce, as well as related companies and regular tenants. Architects Harwood K. Smith and Dales Y. Foster designed a twenty-eight-story tower rising from a three-story base. Three basement levels were also included. National Bank of Commerce occupied the base of the $16 million building, along with a retail arcade extending between Pacific and Elm. The wide faces of the tower were sheathed with dark glare-resistant glass, with the ends finished in light brick and black marble. The building lobby was finished in black marble and granite. The thirty-second floor become home to the Lancers Club, an elegant private dining and dancing facility decorated in a medieval motif.

One of the building's unusual features was a gigantic "signboard" behind the glass panels of the structure, allowing management to spell out advertising, civic, or seasonal messages. On October 15, 1964, another unusual and unforeseen feature was a massive bulge that developed in the exterior masonry on the west side of the building, causing a thirty-by-six section of bricks to cascade from the twentieth floor. The bricks pierced the roof of a pool hall next door, seriously injuring one man and just missing several others. (This

masonry problem would reoccur twenty years later.)

In May 1964, before their new building was completed, National Bank of Commerce began an exodus from their home of eighty-four years at the corner of Elm and Poydras streets. Two elderly customers were chosen to ride with officers and directors in an antique car motorcade to the new location. There, the women were allowed to personally transfer their accounts—one had first been opened in 1888 and the other had been opened in 1891. Only three years after the move, National Bank of Commerce absorbed the Empire State Bank, creating an institution with $122 million in assets.

The building's other major tenant, LTV Corporation, was growing at a feverish pace. James J. Ling was an ambitious man, and he had big plans for his company. During the late 1960s, Ling went on an acquisition binge, and his targets were not restricted to aerospace companies. Before long, LTV owned a major steel company, a meat packing company, Wilson Sporting Goods, National Car Rental, and even the holding company for Braniff Airlines. Ling had overreached, and soon, the highly leveraged company was beset with financial problems and antitrust litigation. In 1970, Jim Ling was forced from the company, along with Troy Post. The

organization refocused, averted bankruptcy, and attempted to concentrate on core competencies.

Neither LTV nor National Bank of Commerce was fated to exist into the new century. In 1985, LTV Corporation moved into the beautiful new Trammell Crow building at Ross Avenue and Harwood Street. The fifty-story building was christened the LTV Center in recognition of its lead tenant, but by 1986, the troubled company had filed for Chapter 11 Bankruptcy. Cheap imports of Japanese steel were creating huge losses in their steel division. The reorganized company eventually moved to Cleveland, and its Dallas headquarters was renamed the Trammell Crow Center.

Also in the 1980s, National Bank of Commerce had become part of the BancTexas holding company. The company struggled first with failed energy loans, only to be wracked later by a Texas real estate crisis. Like many home-grown Texas banks, BancTexas became insolvent and then was shut down by federal regulators. A century of banking history for National Bank of Commerce came to an end.

In the 1990s, the former LTV Tower was eventually rechristened 1600 Pacific, but the building struggled to attract tenants in the difficult downtown leasing environment. In 2005, plans were announced to redevelop the mostly vacant structure into downtown housing overlooking Thanksgiving Square.

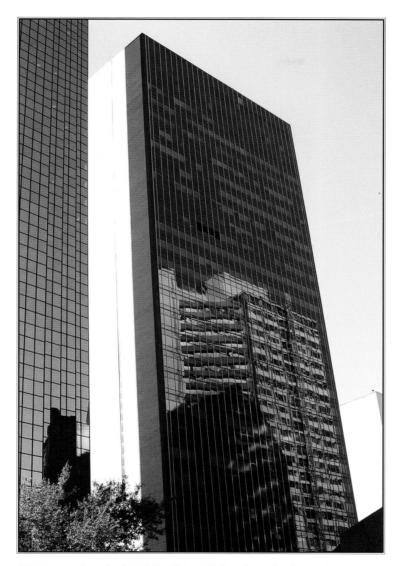

LTV Tower reflects the old Fidelity Union Life Complex on its glass surface.

First National Bank Tower

—Elm, Akard, Field, and Pacific—

•

Nathan Adams had been the legendary president of First National Bank during the 1930s and 1940s. Ben Wooten had succeeded him in the 1950s. In 1951, a president for the future was identified when Robert H. Stewart III went to work for the bank as an assistant cashier. His grandfather had once been chairman of the board, and his father had also served on the board for many years. Robert later served as an assistant vice president and senior vice president. In January 1960, the thirty-four-year-old was elevated to the office of president of the $800 million bank.

Within a year of his promotion, First National acquired an entire city block for the construction of a magnificent new headquarters just to the north of their Main Street building. Republic National Bank, their archrival, had already been in their new tower for six years, and First National Bank was ready to make a statement with their new building. The proposed site covered two full acres bounded by Elm Street, Field Street, Pacific Avenue, and Akard Street. No southwestern bank occupied a site so large. First National Bank's ten-story motor bank already occupied part of the block, which would have to be completely cleared for the new project.

The bank interviewed twenty-two firms before choosing architects Thomas E. Stanley and George L. Dahl to design the structure. Stan-

ley had recently completed the Mayflower Building (Fidelity Union Tower), the Adolphus Tower, the Cotton Exchange, and several other downtown buildings. Dahl's most recent works included the Dallas Public Library, Dallas Memorial Auditorium, and the *Dallas Morning News* building.

Initial designs provided for a fifty-story tower rising over seven hundred feet above the streets below, but conflicts with the FAA over flight paths into Love Field airport led to a reduction in height to 628 feet. Even with the reduction, First National could claim the title as the state's tallest building, rising twenty-two feet higher than Houston's Humble Building. It would also be the tallest building west of the Mississippi. The soaring tower would offer 1.6 million square feet of floor space, and cost over $30 million. In October 1961, site clearing started. Ironically, Republic National Bank was soon erecting their second tower just blocks away.

The new First National Bank Building rose from an eight-story base of sculptured marble measuring 200 feet by 375 feet, and covering the entire block. The white Pentelic marble was quarried near an ancient battlefield in Marathon, Greece. The same marble was used for the slender columns rising nearly fifty feet to support the marble base, enclosing floors six, seven, and eight. Behind the columns, floors one

through five were enclosed by solid glass, including the two-story main banking floor on levels four and five. The unique six-sided tower was sheathed in solar-gray glass panes with wide mullions of marble and Plexiglas rising vertically up the entire height of the tower. The mullions housed 2,250 fluorescent lighting tubes that illuminated the building at a cost of less than seven dollars per night. Atop the eight-story base and surrounding the tower was a spacious roof garden generously decorated with trees and planter boxes. An observation deck was featured on the fiftieth floor, six hundred feet above the streets below. Beneath the building, an underground parking garage accommodated eight hundred cars. The ground-floor elevator lobby was finished with Burmese teakwood, travertine marble, and black granite. The main banking hall was floored with white marble, and paneled with the same Burmese teak.

In January 1965, the bank held the grand opening of their stylish new building that had cost $35 million. First National Bank occupied the first ten floors, and floors eleven through forty-nine were 82 percent leased when the building opened.

Within seven years, flush with cash and confident about the future, First National Bank began construction of an even larger headquarters to the west of their 1965 building. As the flagship bank of the newly formed First International Bancshares holding company, First National Bank erected a tower rising fifty-six stories and over seven hundred feet above Elm Street. When completed, the First International Building cemented the bank's title to Dallas's tallest building, but the glamour was short-lived. In just over a decade, First National

Bank and Republic National Bank were driven to merge in a desperate bid to survive a Texas real estate crisis. Neither historic institution survived.

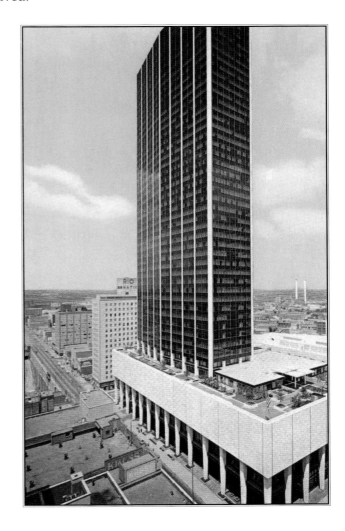

One Main Place

—Main, Elm, Field, and Griffin Streets—

●

During the late 1950s, Dallas civic leaders watched with concern as the downtown area grew to the north and east, leaving the older, western portions of the city center to age and decay. Between the county government complex along Houston Street and the heart of downtown to the east of Field Street lay a collection of aging brick buildings, many of them dating back to the early 1900s. Hotels that had once been fashionable deteriorated into transient hangouts. Bars and parking lots proliferated. Determined to avoid the urban blight common to older northeastern cities, a group of downtown business leaders studied the problem and then quietly acted.

W. W. Overton Jr. chairman of Texas Bank & Trust, was one of the concerned businessmen located in the blighted area. Overton's bank was located at Main and Lamar, where it had operated since Mercantile National Bank moved out in 1922. Overton approached Clint Murchison Sr., a wealthy oilman, about jointly acquiring properties in the affected area with the purpose of creating a master-planned project to revitalize the area. In 1956, Overton and Murchison formed the Dallas, Texas Corporation, and over the next few years, seventy-four pieces of land were acquired. As things progressed, Murchison handed the project off to his sons, John and Clint Murchison Jr. (Clint would become the owner of the Dallas

Cowboys football franchise.) The group then approached Columbia University's school of architecture about creating the master plan for redevelopment of the area. Three major buildings were envisioned in the Columbia plan.

New York architects Skidmore, Owings, and Merrill were chosen to design the structures in association with Harwood K. Smith & Partners of Dallas. It was to be the largest development in the history of downtown Dallas. The initial component of the project would be the $41 million One Main Place, a thirty-four-story, 450-foot tower in which reinforced concrete columns served as both structural support and architectural exterior. Each floor included nearly thirty thousand square feet of space, a huge advantage for tenants needing large, contiguous work areas. The mixed-use development included a large, sunken plaza on the west, complete with decorative fountain, restaurants, retail shops, and a mini-bank. Anchor tenants included Overton's Texas Bank & Trust and the Henry S. Miller real estate company.

The first building was to be followed quickly by Two Main Place, an ambitious project involving a forty-five-story office tower that would span Main Street and cover the entire area from Commerce to Elm. The third phase of the complex would consist of a large

department store crowned by a 400-room hotel. A total of $150 million was expected to be spent.

In January 1965, work got under way. Several structures, some of which had historic value, were demolished to make way for the new building. Excavators had to burrow eighty feet below street level in order to accommodate three underground parking levels, a service level for trucks, and a pedestrian plaza level. Excavation work for the one million-square-foot building required the rest of 1965. In early 1966, actual construction began.

In January 1967, progress was slowed when a massive cave-in occurred along the Elm Street side of the construction site. Underground soil instability caused a yawning 200-yard fissure to open, dropping the pavement as much as fifteen feet below surface level. Once the soil was stabilized, construction proceeded through 1967 and 1968. In November 1968, One Main Place finally opened.

The sunken plaza soon became home to Brennan's Restaurant, a New Orleans institution famed for French cuisine and power breakfasts. For many years, Dallas's own power brokers found their way to business meetings at Brennan's. Talk of beginning the second Main Place tower began almost as soon as the first one was finished, but securing tens of millions in additional financing to build the second tower proved difficult. The site for the new structure had already been cleared, and Atlantic Richfield Corporation was committed to leasing several floors in the building, but it was never started. The Main Place story ended with the original building, which has remained successful as it approaches its fortieth anniversary.

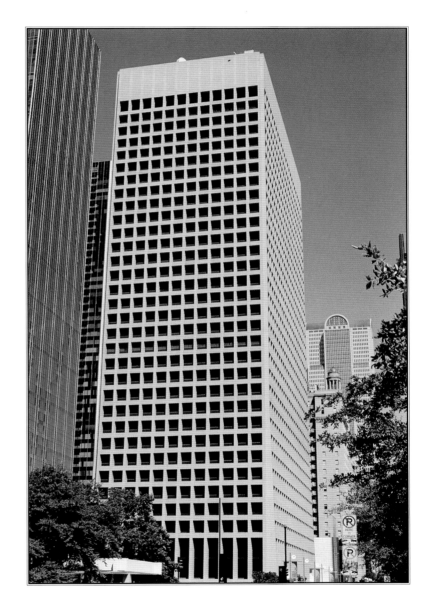

Kennedy Memorial

—Commerce and Market Streets—

•

After the November 22, 1963, assassination of President John F. Kennedy on a downtown Dallas street, the city entered a period of introspection and self-recrimination. A great deal of criticism, some deserved, much of it undeserved, was heaped on what was called the "city of hate." Many Dallas citizens reacted defensively, or with shame, wishing the tragedy had never marred their largely innocent city. The desire to atone in some way was strong, and by early 1964, plans were under way to raise money for a local memorial of some kind to the fallen president. During the summer of 1964, over $200,000 was raised from fifty thousand individual donors at over five hundred Dallas firms.

Dallas County bought and donated a memorial site just east of the Old Red Courthouse, between Main and Commerce at Market Street, near where President Kennedy's motorcade had passed within minutes of the assassination. The location was valuable and unoccupied by structures that would hamper development plans. The area was known as the John F. Kennedy Memorial Plaza.

Stanley Marcus recommended Philip Johnson, a prominent New York architect, to design the memorial, not only because of his architectural prowess, but because he was also a friend of the Kennedy family. Johnson agreed to take on the project without com-

pensation. Local Dallas firms, including McKee Construction and Texas Industries concrete, worked for cost. Johnson designed a controversial cenotaph, or "empty tomb," of pre-cast vertical concrete panels open to the elements. Many Dallas residents, who expected something more conventional and less somber, were disappointed at the austere design. The Kennedy family, however, approved the memorial plans and ended any debate.

Construction of the memorial was delayed for several years when Dallas County commissioners elected to build a much-needed, four-level underground parking garage beneath the memorial. Once the memorial was in place, construction plans would have been complicated, so in May 1968, work on the 475-car garage got started.

In the meantime, two large bronze plaques had been installed in Dealey Plaza, detailing the events and aftermath of November 22, 1963. Even this gesture was mired in controversy when local officials sought to dilute the content of the plaques with other highlights from Dallas history. When completed, the extra material had been deleted, and the plaques were installed for the third anniversary of President Kennedy's death.

In April 1970, when the county's underground parking garage was

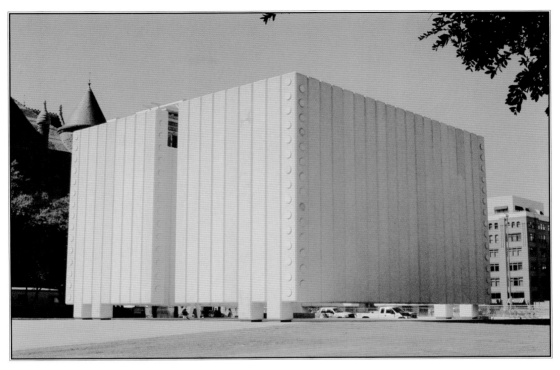

completed, construction proceeded rapidly on the Kennedy Memorial. Seventy-two precast concrete slabs, thirty feet tall and weighing between twenty-two and twenty-seven thousand pounds each, were installed and connected by steel rods. Within the fifty-foot square defined by the concrete walls, an eight-foot-square black granite marker was placed, simply bearing the slain president's name.

On June 24, 1970, the Kennedy Memorial was dedicated with architect Philip Johnson in attendance. No members of the Kennedy family were present, although a few days later, Sargent Shriver passed through Dallas and viewed the memorial. Nearly seven years had passed since the tragedy of 1963. Reaction to Johnson's creation was muted because emotions were no longer as intense.

In 1999, a vandal defaced the interior of the monument with spray-painted graffiti, but the Kennedy Memorial was already badly in need of restoration. The ivory-colored concrete slabs had grown dingy, and the entire structure needed cleaning and maintenance. A thorough renovation was undertaken, removing thirty years of grime and restoring the memorial to its original appearance.

"Men are only as great as the monuments they leave behind."

—Napoleon—

•

Napoleon knew a little about monumental thinking. While Dallas may not be blessed with an abundance of monumental structures, there are certainly enough to be proud of.

Some of the city's most noteworthy historic buildings, including the Old Red Courthouse and the original Adolphus Hotel, were designed by out-of-state architects. Yet even a cursory review of downtown buildings often turns up the names of legendary, local talent. While the list that follows is by no means complete, it celebrates the enduring accomplishments of the city's best and most prolific commercial architects during the historic years covered in this book.

C. D. Hill, born and raised in Illinois, trained in architecture at Indiana's Valparaiso University and later attended the Chicago Art Institute. Returning home in 1897, Hill practiced architecture in Edwardsville, Illinois, for six years. In 1903, he moved to Ft. Worth to work for Sanguinet & Staats, and then two years later, moved to Dallas to establish the offices of Sanguinet, Staats, and Hill. In 1907, Hill entered into partnership with D. F. Coburn and H. D. Smith, forming C. D. Hill and Company. Over the next two decades, Hill designed a succession of notable buildings, most of which are extant. The Wilson Building (1903), First Presbyterian Church (1913), the Sumpter Building (1913), the old Municipal Building (1914), Oak Lawn Methodist Church (1916), the Melrose Hotel (1924), and the Davis Building (1926), among many others, bear witness to his gifts. Hill was particularly confident with classical forms. He also designed several noteworthy residences for the power brokers of the city. In early 1926, fifty-two-year-old C. D. Hill tragically had his life cut short by a stroke.

Otto Lang was even more prolific. He was born in Germany and trained there in both architecture and engineering. In 1888, Lang visited Dallas on his wedding trip and was so impressed by the possibilities of the rambunctious city that

he decided to stay. Lang worked at various architectural and engineering pursuits, including fifteen years with the Texas & Pacific Railroad, until 1905 when he met Frank Witchell. They formed the architectural partnership of Lang & Witchell, destined to transform the Dallas skyline over the next three-and-a-half decades. The firm was responsible for the designs of the Dallas High School, the Southwestern Bell Building, Sanger Bros., the American Exchange National Bank Building, Southwestern Life, Dallas Power & Light, Lone Star Gas, the Cotton Exchange Building, the Gulf States Building, the Dallas Athletic Club, Dreyfuss & Son, the Records Building, Hotel Jefferson, the Adolphus Annex, the Fidelity Building, Southland Life, the Hilton Hotel, the Sanger Hotel, Hotel Lawrence, the Higginbotham-Bailey company, the Western Union Building, and many more. In his spare time, Mr. Lang served for several years as Dallas's Commissioner of Streets and Public Property, and he set up the city engineering department. Otto Lang retired in 1942 and five years later, died at the age of eighty-two.

In 1879, Frank O. Witchell, Otto Lang's longtime partner, was born in England. His family immigrated to Texas where Witchell attended San Antonio public schools until the fifth grade. The boy went to work as a draftsman for a local architect. As a young man, Witchell moved to Dallas where he apprenticed for Sanguinet & Staats. In 1905, at the age of twenty-six, Witchell affiliated with the older Otto Lang, and their incredibly successful partnership was born. After his retirement in 1938, Mr. Witchell was made the only living honorary member of the Dallas chapter of the American Institute of Architects. In 1958, Frank Witchell died at the age of seventy-eight.

In 1861, Harry A. Overbeck was born in Cincinnati. He received his education at the Ohio Architectural and Mechanical Institute before moving to Omaha for several years. Before the turn of the twentieth century, he arrived in Dallas and soon had plenty of architectural commissions in the bustling city. In 1898, the Linz Building was his first triumph. Overbeck was the supervising architect on the project, working with James Riely Gordon. In 1899, he designed the Telephone Building, and in 1903, he designed the Corinthian-styled Elks Building on the eastern end of Main Street. The Katy Building, headquarters of the M. K. & T. Railroad, occupied Overbeck from 1911–1912. In 1913, he was asked to design a new county jail and criminal courts building, creating the innovative "skyscraper jail" that stands today on the corner of Main and Houston. Overbeck also designed the St. Paul

Sanitarium and many other buildings. After a long and distinguished career, eighty-year-old Harry Overbeck suffered an ignominious end. In 1942, after his car was stolen and found, Overbeck traveled alone to Conroe to retrieve the vehicle. On the trip back to Dallas, he was killed when his car overturned twice near Ennis.

In 1897, Herbert M. Greene came to Dallas after receiving his architectural degree from the University of Illinois. He practiced alone and then in 1900, became associated with James P. Hubbell, under the name Hubbell & Greene. Greene designed several important buildings, including the *Dallas Morning News* building, Temple Emanu-El, the Neiman Marcus store, the original Parkland Hospital, and the Scottish Rite Cathedral. In 1922, he succeeded Cass Gilbert as university architect for The University of Texas at Austin. Over the next few years, he designed a number of Beaux-Arts buildings. In 1925, Greene partnered with E. B. LaRoche, and the following year, they added George L. Dahl to the firm to help with an increasing number of commissions. In 1928, the firm became known as Greene, LaRoche, and Dahl, and they went on to design some of the most important buildings in Texas. In 1931, Greene died in Chicago at the age of sixty after accompanying his seriously ill wife to a hospital there. He was returned to Dallas for burial.

Edwin Bruce LaRoche was a driving force in the designs of many notable Dallas buildings, including Titche-Goettinger, the Volk Building, and additions to the Neiman Marcus store, the Dallas National Bank, and Parkland Hospital. LaRoche grew up in South Carolina, and attended college in Tennessee before receiving degrees from Cornell and MIT. In 1918, he joined the staff of Texas A&M College, eventually becoming head of the architecture department. In 1925, LaRoche came to Dallas where he soon entered into his successful partnership with Herbert M. Greene and George L. Dahl. In 1944, at the age of fifty-eight, LaRoche died from a heart attack. At the time of his death, he was architectural adviser to the state committee charged with erecting monuments to the heroes of World War II.

George Leighton Dahl, the son of Norwegian immigrants, grew up in Minnesota where he studied architecture at the state university. In 1920, after receiving his bachelor's degree, he earned a master's degree from Harvard before leaving for Europe on an American Academy fellowship. Dahl worked briefly in New York and Los Angeles upon his return, but by 1926, he was in Dallas at the invitation of Herbert M. Greene. Dahl plunged into the design of several buildings on the University of Texas campus. E. B. LaRoche had also joined

the team, creating the firm of Greene, LaRoche, & Dahl. Dahl was incredibly prolific and stylistically flexible. Among his local triumphs were buildings for Titche-Goettinger, Volk Bros., the *Dallas Morning News*, the Dallas Public Library, and the Dallas Memorial Auditorium. Perhaps his greatest contribution to Dallas architecture was the massive complex of art deco buildings at Fair Park for the 1936 Texas Centennial Exposition. Dahl and his team of architects, sculptors, muralists and builders worked impossible hours, and they overcame staggering challenges to meet the opening day deadline of the historic exposition. Dahl worked continuously through the 1960s and retired in 1973. Dahl was hardy, as well as productive. In 1987, George Dahl passed away at the age of ninety-three.

In 1899, Mark Lemmon was born in Gainesville, Texas. He originally studied to be a geologist. He later received degrees in architecture and engineering from MIT. During World War I, Lemmon served in France with an army engineering unit before returning to Dallas to work for architect Hal Thomson. He was soon designing notable public school buildings in Dallas and other Texas cities and was responsible for the beautiful Gothic Revival sanctuaries of Highland Park Methodist Church and Highland Park Presbyterian Church, as well as the Romanesque-style Third Church of Christ, Scientist. Lemmon also contributed important buildings to the campuses of SMU and the University of Texas. His downtown Dallas legacy includes the art deco–styled Tower Petroleum Building, the Cokesbury bookstore, and the Earle Cabell Federal Building, which was designed in association with George Dahl. In 1975, Lemmon died.

Graduating in 1921, Grayson Gill received his architectural training at the University of Michigan. He immediately moved to Texas to accept a position on the faculty of Texas A&M University. After four years, he moved to Dallas to work with Herbert M. Greene designing many of the buildings on the University of Texas campus. In 1934, Gill went into business for himself. The Mercantile Bank Building project during World War II presented Gill with an opportunity to work in association with Walter W. Ahlschlager, designer of the Roxy Theater in New York. In the 1940s, Gill designed the Great National Life Building on Main Street, the James K. Wilson store across the street, and the Southwestern Life annex at Main and Akard. In the early 1950s, Gill was an associate architect for the massive Republic Bank project. He later designed additions to the Southwestern Bell Building, the Federal Reserve Bank, the Praetorian Building, and the

Lone Star Gas complex. Grayson Gill died in 1982.

Born in 1894, Arthur Thomas was a native of Crockett, Texas, who later attended the University of Texas at Austin. Thomas soon arrived in Dallas, where he would live for fifty-four years. He was one of many capable architects who assisted George Dahl in preparing the Texas Centennial Exposition in 1936. He would later form the successful firm of Thomas, Jameson, & Merrill, which was extremely active in the 1950s and 1960s. The Titche-Goettinger addition, Republic National Bank building, Children's Medical Center, and Baylor University Hospital were prominent accomplishments. Arthur Thomas died in 1973.

In 1917, Thomas E. Stanley was born in South Carolina and raised on a cotton farm. He studied architecture at Calmest College. Stanley later worked for the Wyatt C. Hedrick firm, assisting with the design of the Fidelity Union Life Building. During the 1950s, he assisted with several of Leo Corrigan's projects before going out on his own. Although Stanley designed buildings all over the world, he made his local mark with three structures—the First National Bank Building, the closely-matched Sanger-Harris store, and Lovers Lane United Methodist Church. Stanley's hallmark was his liberal use of white marble and glass with delicate, soaring arches. In 2001,

Thomas E. Stanley passed away at the age of eighty-three.

Harwood K. Smith was a contemporary of Thomas E. Stanley. Smith liked to think of himself as more of an artist than an architect. In 1913, he was born in Chicago, and later as a boy, he attended the Chicago Art Institute. He was able to channel his talent for design into the architectural field, and after attending Texas A&M, he pursued a job with George Dahl in Dallas. By 1939, Smith was on his own, designing exclusive homes in the Highland Park West development and graduating to small commercial buildings. In 1956, after forming a partnership with Joseph M. Mills, Smith's firm designed the Dallas City Hall in association with Mark Lemmon. When the new Southland Center was erected, Smith designed the Chapparal Club atop the building. Major commissions for the Zale's Building and LTV Center followed, and it was Smith's firm that supervised the huge One Main Place development, which was designed by Skidmore, Owings and Merrill. Later, Harwood K. Smith & Partners designed the fifty-six-story First International Building. In the late 1970s, they designed Reunion Arena. Smith retired soon afterward and passed away in 2002, but his successful firm continues on as HKS, Inc.

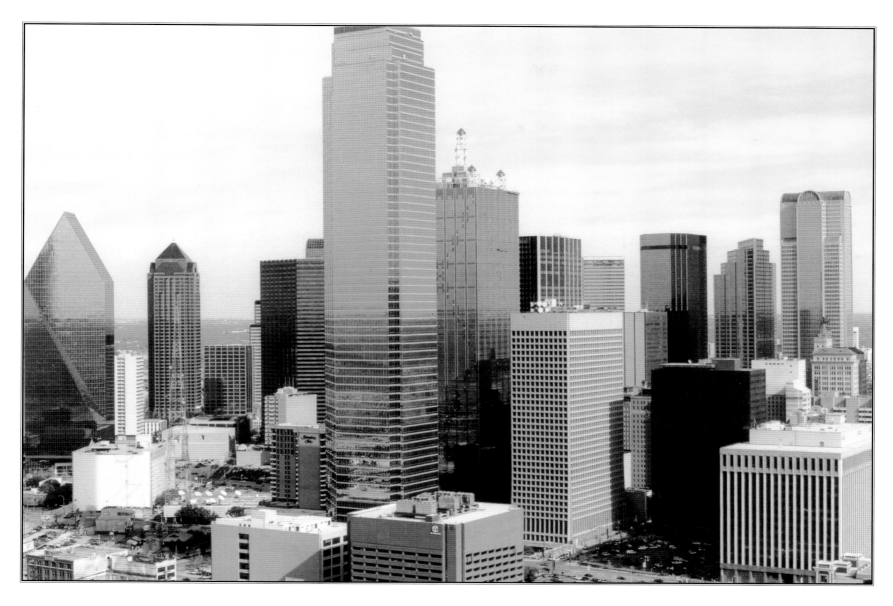

Downtown Dallas today, as seen from Reunion Tower.

SELECTED REFERENCES

•

Acheson, Sam. *Dallas Yesterday*. Dallas: SMU Press, 1977.

Crumpler, Jeanette. *Street of Dreams: A History of Dallas' Theater Row*. Dallas, 2003.

Dallas Chapter/American Institute of Architects. *Guide to Dallas Architecture*. Dallas, 1999.

Dallas Morning News archives, various articles, 1885–1977.

Dillon, David. *Dallas Architecture* 1936–1986. Austin: Texas Monthly Press, 1985.

McDonald, William L. *Dallas Rediscovered*. Dallas: The Dallas Historical Society, 1978.

Payne, Darwin. *Dallas: An Illustrated History*. Woodland Hills, CA: Windsor Publications, 1982.

INDEX

•

Page numbers in italics refer to illustrations.